D0912962

THE

DUCHAMP

DICTIONARY

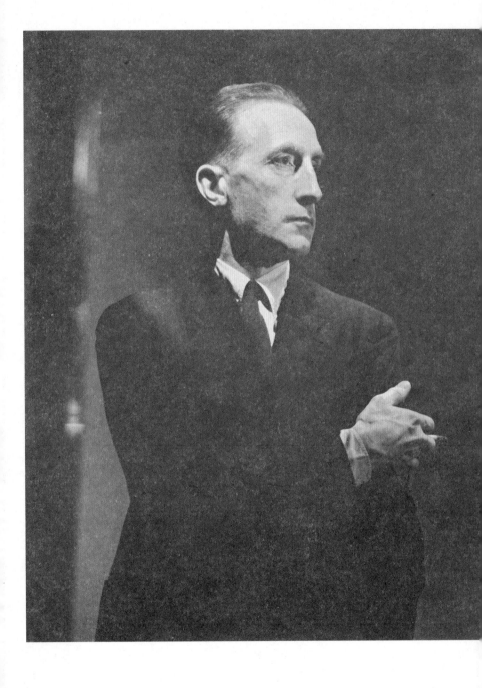

Thomas Girst

THE

DUCHAMP

DICTIONARY

64 illustrations by Heretic

Editorial Note

Cross-references to related dictionary entries are in bold text.

Quotations from Marcel Duchamp are highlighted.

In memory of Serge Stauffer (1929–89)

Frontispiece: Marcel Duchamp photographed *c.* 1934.

Photo Lusha Nelson. © Condé Nast Archive/Corbis

The Duchamp Dictionary © 2014 Thames & Hudson Ltd, London

Text © 2014 Thomas Girst

Illustrations © 2014 Luke Frost and Therese Vandling (Heretic)

Designed by Therese Vandling

First published in 2014 in hardcover in the United States of America by

Thames & Hudson Inc., 500 Fifth Avenue, New York, New York 10110

thamesandhudsonusa.com

Library of Congress Catalog Card Number 2013950848

ISBN 978-0-500-23917-9

Printed and bound in China by Everbest Printing Co. Ltd

CONTENTS

INTRODUCTION:
A B C DUCHAMP

In 1772, Denis Diderot (1713–84) and Jean le Rond d'Alembert (1717–83) completed their *Encyclopaedia or a Systematic Dictionary of the Sciences, Arts and Crafts* – an enormous undertaking of twenty-eight volumes comprising over 70,000 entries – and in so doing altered the perception of how knowledge might be explored, structured and categorized. In time, artists and writers began to recognize that the dictionary format offered exciting possibilities not just for the gathering of knowledge but also for its subversion. A century after Diderot, the writer Gustave Flaubert (1821–80) dreamed of writing a dictionary that would expose the general folly and fatuousness of his society. In his *Dictionary of Received Ideas*, he strives to expose the futility of human intelligence, the vanity involved in our eternal quest for wisdom, as well as the nonsense and disappointment that come with humankind's attempts to ultimately make sense of it all. In Flaubert's dictionary, under the heading 'Artist' we find observations such as 'One has to laugh about everything that they say', 'Make loads of money but throw it out of the window', 'What they do cannot be considered "work"', 'Are often invited to dinner' and 'All of them are pranksters'.[1]

Fellow Frenchman Marcel Duchamp (1887–1968), another Norman native, might have found Flaubert's quotes about artists amusing. After all, he himself had a highly developed sense of the absurd and a taste for provocation of all sorts, so much so that his particular brand of modernist art became renowned in his own time – and far beyond it – for its ironic subversions and sophisticated wit. Most famously, perhaps,

Duchamp abandoned painting in favour of signing mass-produced objects that became known as 'readymades' – everyday objects that even today continue to elicit controversy and debate. Their essential iconoclasm, and the permission they seemed to grant to both artists and viewers in terms of what art could be, point to Duchamp's most powerful legacy for later generations. American painter Robert Motherwell (1915–91), for example, saw Duchamp's manifold forays into experimental artistic practice as an awe-inspiring force of sabotage.[2]

Duchamp's works and thought processes are so complex, refined and multifarious that his influence has extended well beyond the art world to disciplines as varied as literature, dance, film, music, philosophy and graphic design. His renunciation of aesthetics, of mere visual pleasure, and of personal taste, and his embracing of eroticism, doubt, indifference, chance and modern machinery, put him at the crossroads of many movements and opposing forces – today almost more than ever, it seems, and not only within Western culture.

Duchamp had a profound mistrust of what he considered to be a general agreement on the meaning of words, and would no doubt have delighted in the fact that his artworks still elicit diverse responses and interpretations, questioning our very ideas about the nature of art itself. For him, art was not in need of verbal translation. He did not believe in language as such, which he saw at best as 'an error of humanity',[3] if not 'a great enemy'.[4] An exception to this, however, was the dictionary format, in which Duchamp took a lifelong pleasure and for which he nurtured his own, unrealized, ideas. His close friend

Gabrielle Buffet-Picabia (1881–1985), with the readymades clearly in her mind, once commented that to Duchamp 'the visual world becomes a dictionary of subjects which he isolates by the mere act of choosing them.'[5] The photographer Denise Browne Hare (1924–97) remembered that when Duchamp and his wife Teeny visited 'there was a lot of looking up words in the dictionary. I had an old, classic Larousse, and at some point Marcel would nearly always get it out. He loved the format, the little illustrations on every page.'[6]

In 1967, a year before the artist's death, a New York gallery published *À l'infinitif*, Duchamp's limited edition box containing facsimile reproductions of seventy-nine scattered notes and jottings, a number of which were collected in a folder under the heading 'Dictionaries and Atlases'. Here, Duchamp added his own twist to the idea of the dictionary, challenging the widely held belief that this particular literary form might be able to convey axiomatic truths. Among his notes, he advised his reader to 'Look through a dictionary and scratch out all the "undesirable" words. Perhaps add a few – Sometimes replace the scratched out words with another.'[7] In 1934, he had published another note in an earlier box, proposing a wonderfully absurd 'search for "prime words" ("divisible" only by themselves and by unity).' He also reminded himself to 'take a Larousse dictionary and copy all the so-called "abstract" words, i.e., those which have no concrete reference.' Thus, Duchamp arrived at an entirely new 'sort of grammar' by 'composing a schematic sign designating each of these words', while a 'grouping of several signs' would in turn 'determine' a 'new alphabet'.[8]

The idea of the dictionary clearly appealed to Duchamp, as it did to the Surrealists, many of whom were his close friends. Georges Bataille (1897–1962) included entries for his *Critical Dictionary* within the pages of his Surrealist magazine *Documents* between 1929 and 1930. In 1938, Paul Éluard (1895–1952) and André Breton (1896–1966) published the *Dictionnaire abrégé du surréalisme* on the occasion of the *Exposition Internationale du Surréalisme* at the Galerie des Beaux-Arts in Paris. With regard to writings about Duchamp, the multi-volume catalogue of his first retrospective in Paris in 1977 – the inaugural exhibition of the Centre Georges Pompidou – brought together twenty alphabetical entries from 'Alchemy' to 'Villon' in its third volume, titled *Abécédaire*. In art historical reference books and encyclopaedias, the importance of an artist is often measured by the number of lines they are granted, which is why those writing on Duchamp are often so eager to maximize the space allotted to him. When the scholar and art dealer Francis M. Naumann (b. 1948) was asked to write the entry on Duchamp for Macmillan's *Dictionary of Art* in the mid-1990s, for example, he insisted on an unrestricted word count, successfully arguing that, whatever he wrote, it should have the right to be as long as the entry for Picasso. Nowadays, with the multilingual, free internet encyclopaedia Wikipedia often the first research website of choice, it seems appropriate that Duchamp should finally get his own dictionary in the form of a digital, as well as a printed, book.

This publication introduces new research on Duchamp and broadens our knowledge and understanding of him, in

entries that are presented in a concise and entertaining way. For too long, art historical discourse has kept a broader public from enjoying the life and work of one of the most intellectually stimulating individuals of modern times. When he was only twenty-five years old, his avant-garde friend Guillaume Apollinaire (1880–1918) predicted that, above all, Duchamp would manage to 'reconcile art and the people'.[9] Since then, almost no other artist has been scrutinized as much as Duchamp. From Hindu rituals to incest, from psychoanalysis to post-structuralism, no theory or idea has been overlooked in attempting to explain the inner workings of his mind. True to Apollinaire's pronouncement, *The Duchamp Dictionary* aspires to do away with these theories, to break through the impenetrable vocabulary of much of the writing on Duchamp, and to make him and his work as accessible as they deserve to be – without ever straying from the facts. Indeed, the greatest liberty taken within these pages is in calling Duchamp an artist: he much preferred his own term, 'an-artist', itself an entry included here, 'meaning no artist at all'.[10] From his dislike of body hair to his unrequited love for his best friend's wife, from his fascination with scientists and philosophers such as Henri Poincaré (1854–1912) and Max Stirner (1806–56) to eroticism as an integral part of his oeuvre – love, life and work, so often inextricably intertwined – all are to be found within this dictionary.

Research for the publication was mainly conducted at leading Duchamp scholar Serge Stauffer's (1929–89) archives at the Staatsgalerie Stuttgart and at the collection and library

of Rhonda Roland Shearer's (b. 1954) Art Science Research Laboratory, New York. In addition, many treasure troves of information have become available online in recent years. The historic newspapers digitized by the Library of Congress in Washington DC and the documents made public by Yale University's Beinecke Rare Book & Manuscript Library are just two examples of invaluable sources tapped into while writing this book. Further studies at the New York Public Library and New York University were helpful for yielding new research, fact-checking and tracking down information from almost a century ago. The Philadelphia Museum of Art and the Association Marcel Duchamp provided important details, and my continuous, almost two-decades-long, exchange with many international Duchamp scholars has greatly benefited *The Duchamp Dictionary*.

The deeper one delves into the complexities of an artist's work, the more thought-provoking, surprising and playful it may turn out to be. The more one knows, however, the more one also realizes what one does not know. Exploring Duchamp's own writings, notes and interviews is often demanding and yields many contradictory findings, but it is incomparably more beneficial than getting to know the artist through secondary literature alone. It was Duchamp who challenged our understanding of art and thus forever changed the course of art history. Scholarship on Duchamp should remain subversive enough to transform art historical writing as well. Indeed, it may also be fun.

When Marcel Duchamp was born on 28 July 1887, the son of a notary, in the tiny farming village of Blainville-Crevon north-east of Rouen, no one could have foreseen that less than a century later he would be regarded as one of the most significant artists of the 20th century. There is a great divide, however, between the frequency with which his name appears as a placeholder, or shorthand – whether for iconoclasm, the avant-garde, or radical notions of what constitutes art – and even a peripheral knowledge of his actual life, art and thought. *The Duchamp Dictionary* hopes to finally bridge this gap for all those interested in the work, ideas and attitudes of this extraordinary artist, as well as in his legacy for the art of today. Duchamp was nothing if not contradictory: a highly sought-after artist who cherished silence and solitude; a prankster who could nonetheless be serious in his intellectual intent; a man for whom art was central yet who spent at least a decade almost solely dedicated to the game of chess. This book, while navigating a clear, jargon-free path through these contradictions, also delights in celebrating them.

ABSTRACT EXPRESSIONISM

While Duchamp had stopped **painting** by 1918, he continued to follow developments within the genre closely. He appreciated **Pop Art**, but dismissed Abstract Expressionism, another post-war American art movement, as 'acrobatics, just splashes on canvas'.[1] Although he championed Jackson Pollock (1912–56), in Abstract Expressionism as a whole he saw 'academicism, the adoption of new canons, especially with the addition now of money transactions' as well as a serious 'danger of any new movement'.[2] To Duchamp, 'the proof of good painting comes when **intelligence** is part of it. Abstract Expressionism was not intellectual at all for me. It is under the yoke of the **retinal**. I see no gray matter there A technique can be learned but you can't

learn to have an original imagination.'[3] (**grey matter**). The feeling was certainly mutual. In the early 1950s, Barnett Newman (1905–70), one of the greatest proponents of Abstract Expressionism, referred to the **readymades** as mere 'gadgets' guilty of the 'popularizing role of entertainment' within a museum setting. In a feud with the painter Robert Motherwell (1915–91), Newman went further: 'I want particularly to make clear that if Motherwell wishes to make Marcel Duchamp a father, Duchamp is his father and not mine nor that of any American painter that I respect.'[4]

ABSTRACTION [illustration p. 16]

Although Duchamp dismissed abstract art as mere **retinal** painting created

to please the eye instead of engaging the mind, recent scholarship has suggested that he should nevertheless be regarded as a key player in the history of non-figurative artistic expression. By establishing the 'artwork as idea' with his **readymades**, and by producing text in his **notes** and **boxes** 'integrally linked yet held apart' from his work, it is Duchamp's oeuvre more than anybody else's that 'makes clear that the fact of abstraction would change the terms of artistic practice for the century to come.'[5] While in **Munich** in 1912, Duchamp at least partly read and annotated *On the Spiritual in Art*, **Wassily Kandinsky**'s

(1866–1944) groundbreaking treatise on abstraction, which had been published earlier that year. Duchamp's view was that perception is not a solid entity but one that perpetually changes and evolves: what is considered abstract today may no longer be seen that way fifty years hence.' Whether in his readymades, **optical** devices or his semi-abstract **film** *Anémic Cinéma* (1926), Duchamp frequently embedded highly personal **humour** and **eroticism** in his works, but never participated in the ambitious quest for purity emotion and transcendence of his fellow abstract artists.

ALCHEMY [illustration p. 18]

What the **fourth dimension** is to **mathematics**, alchemy is to **science**: a hotchpotch of ideas and ideologies for the uninitiated, an invaluable testing ground for experiments or an entire belief system for the obsessed both inside and outside the field. Alchemy as the key to understanding Duchamp's life and work was first introduced by **Arturo Schwarz** (b. 1924) in the late 1960s. While the assumption that Duchamp's work is a riddle, rebus or secret in need of mono-causal decoding is a dead end, presumably finding that alchemical signs and symbols abound throughout his oeuvre does not add much of value to Duchamp scholarship either. 'If I have practiced alchemy, it was in the only way it can be done now, that is to say without knowing it',[7] is how Duchamp phrased it. The warring factions that gather around the pros and cons for the claim of an alchemistic thread connecting Duchamp's works may be reconciled by the ancient Greek myth about a certain Phrygian king. 'The Midas touch was his', as **Richard Hamilton** (1922–2011) light-heartedly wrote about the **readymades**, as all Duchamp needed to do was 'simply to point a god-like finger, to bestow on any object the nearest thing to immortality we know.'[8]

AMERICAN WOMEN

When he arrived in New York in 1915, Duchamp was more widely known in the United States than almost any other European contemporary artist, which is why the media was eager to convey his thoughts on everything from Auguste Rodin (1840–1917) to Cubism and from America to the size of skyscrapers. After only three months in the city, the artist had the following to say about American women: 'The American woman is the most intelligent woman in the world today – the only one that always knows what she wants, and therefore always gets it. Hasn't she proved it by making her husband in his role of slave-banker look almost ridiculous in the eyes of the whole world? Not only has she intelligence but a wonderful beauty of line is hers, possessed by no other woman of any race at the present time. And this wonderful intelligence, which makes the society of her equally brilliant sisters of sufficient interest to her without necessarily insisting on the male element protruding in her life, is helping the tendency of the world today to completely equalize the sexes, and the constant battle between them in which we have wasted our best energies in the past will cease.'[9] In subsequent decades, Duchamp got to know many American women as friends, patrons and **lovers** (or all three things combined). In 1954, he married **Alexina Sattler** (**Teeny**; 1906–95), the former wife of art dealer Pierre Matisse

(1900–89), who was the son of the painter Henri Matisse (1869–1954).

AN-ARTIST

I am against the word "anti" because it's a bit like atheist, as compared to believer. And the atheist is just as much of a religious man as the believer is, and an anti-artist is just as much of an artist as the other artist. An-artist would be much better, if I could change it, instead of anti-artist. An-artist, meaning no artist at all. That would be my conception. I don't mind being an an-artist.'[10] Duchamp certainly did not mind the homophonic resemblance between 'an-artist' and 'anarchist' either.

ANATOMY

Duchamp spoke of the 'visceral forms'[11] that he depicted in his painting *Bride* (1912), and referred to the bride within the *Large Glass* (1915–23) as a 'skeleton'.[12] His heightened interest in human anatomy came when he began juxtaposing it with mechanical operations. At that time, anatomical museums with mechanical models and wax figures with dozens of removable pieces were a major tourist attraction, entertaining both the educated visitor and the voyeur. Duchamp also explored anatomy in the painting *The Passage from Virgin to Bride* (1912). It is unlikely to have escaped his attention

that female genitals in the 'virginal' as well as the 'de-virginized state'[13] were part of the standard repertoire of every 'adults-only' anatomical display since the late 19th century.

From the early 20th-century works to his **erotic objects** and his final major piece, *Étant donnés* (1946–66), Duchamp seems to have been preoccupied with the presentation of the most intimate parts of the female body. It is therefore highly unlikely that a problem with the casting process for the torso at the centre of *Étant donnés*, which Duchamp modelled on three women (**Alexina Sattler (Teeny)**, **Maria Martins**, **Mary Reynolds**), 'accounts for the anatomical inaccuracies and gender ambiguity of the mannequin'.[14] Instead, it is the way Duchamp plays with the sexes (**Rrose Sélavy**) in much of his oeuvre as well as his interest in elaborate forms of representation far exceeding the merely visual (**grey matter, fourth dimension**) that make this depiction of the female body consciously transcend a precise anatomical rendering. To Duchamp, 'distorting the object'[15] or 'systematic distortion'[16] had been 'my way since 1900 and probably before that even'.[17] For the artist, this meant to 'take any liberty with anatomy'.[18]

GUILLAUME APOLLINAIRE

Guillaume Apollinaire's (1880–1918) criticism of Duchamp's works turned from bashing his 'very ugly nudes' in

early 1910 to acknowledging his 'interesting exhibits'[19] in late 1911. From then on, Apollinaire was hooked; so was Duchamp. Seven years younger than the avant-garde poet, playwright, promoter, pornographer and patron saint of **Surrealism**, the artist appreciated the attention, but he also mistrusted Apollinaire's literary wordiness – to Duchamp, painting was a language in itself that did not need to be translated into letters and syllables. Apollinaire included Duchamp as one of only ten painters in his book on *Les Peintres Cubistes* (1913), in which he predicted that 'it will be the task of the artist as detached from aesthetic preoccupations and as intent on the energetic as Marcel Duchamp, to reconcile art and the people.'[20] It was with Apollinaire and **Francis Picabia** (1879–1953) that Duchamp saw **Raymond Roussel**'s (1877–1933) stage adaptation of his novel *Impressions d'Afrique* (1910), and it was with them that he went on an infamous road trip (**automobiles**). Both events were key experiences in Duchamp's life. His enigmatic semi-**readymade** *Apolinère Enameled* (1916–17), an altered advertising sign for the industrial paint brand Sapolin Enamel that depicts a young girl painting the vertical bars of an empty bed frame, was an homage to the poet that the latter never had the chance to appreciate. Apollinaire died in 1918 from the Spanish flu and complications from serious war wounds.

ARCHITECTURE

'Does architecture interest you?'
'Not at all.'[21]

WALTER AND LOUISE ARENSBERG

The poet, patron and cryptographer Walter Arensberg (1878–1954) and his wife Louise (1879–1953) became Duchamp's most important collectors after they met him in 1915. Throughout his life, the Harvard-educated Walter Arensberg would dwell over Dante and try to prove that Shakespeare was really Francis Bacon, a detail-obsessed pastime of meticulous rigour that certainly appealed to Duchamp. The first encounter of the two kindred spirits proved 'a kind of magical spell', with Duchamp as 'the spark plug that ignited Arensberg'.[22] The artist became the centre of the Arensbergs' avant-garde poets' and artists' circle that frequently convened at their two-floor Upper West Side apartment. However, with prohibition setting in and with the return home of many European artists after the end of the First World War, the heyday of the open-house salon slowly came to a halt. Extramarital affairs by both Walter and Louise, combined with his drinking problems and increasingly bad investments of their joint family wealth, lead to the Arensbergs' move to California in the early 1920s and to their permanent settlement in Hollywood in 1927. Their

vast collection of pre-Columbian and modern art, including some forty works by Duchamp, among them his most significant, was donated to the **Philadelphia Museum of Art** in 1950.

that time, at the age of twenty-seven, Duchamp had already abandoned painting and conceived his first **readymades**. When he set foot on American soil, he was one step ahead, yet again.

ARMORY SHOW

There is no doubt that Duchamp's painting *Nude Descending a Staircase No.2* (1912), shown at New York's Armory Show in 1913, is the basis for his recognition and visibility today. Four paintings by the artist were included in the more than 1,000 works presented in this seminal exhibition, which introduced European and North American modern and avant-garde art to the broadest public possible. During the course of the show's run between February and May, including its tour to Chicago and Boston, all of Duchamp's works were sold to American collectors. As Milton W. Brown (1911–98), the exhibition's minute chronicler, writes, the Armory Show 'had been calculated from the beginning as a mental jolt to stir America out of its long esthetic complacency'.[23] In this it succeeded and, to this day, Duchamp is famous for his very own brand of iconoclasm, his humour and his fascinatingly complex works. In the summer of 1915, upon the suggestion of the art scholar and artist Walter Pach (1883–1958), one of the show's organizers, Duchamp followed his *Nude*, as well as his friend **Francis Picabia** (1879–1953), to New York. At

ART

In 1913, while in his mid-twenties, Duchamp wondered: 'Can one make works which are not works of "art"?'[24] Never one to believe in absolutes, definite theories or **progress**, he questioned whether art could ever be 'adequately defined because the translation of an esthetic emotion into a verbal description is as inaccurate as your description of **fear** when you have been actually scared.'[25]

ART HISTORY

In an **interview** with art historian George Heard Hamilton (1910–2004) and artist **Richard Hamilton** (1922–2011), Duchamp made it clear that in his opinion 'art history is not art'.[26] He believed in the mortality of painting and sculpture and was aware that 'art history has consistently decided upon the virtues of a work of art through considerations completely divorced from the rationalized explanations of the artist.'[27] In an interview for *Vogue* in 1963, he reiterated what he had written to his sister Suzanne (1889–1963) and her husband Jean Crotti (1878–1958), both artists, about a decade before: the

'smell of the flower',[28] or of 'any fragrance ... evaporates very quickly',[29] thereby losing its 'soul'.[30] Whatever is left will be 'classified by the historians in the chapter "History of Art"'.[31] **Posterity**, not an artist's own contemporaries, will thus judge that artist's significance. Duchamp said of art history that 'anything systemized becomes sterile very soon'.[32] 'The History of Art is what remains of an epoch in a museum, but it's not necessarily the best of that epoch, and fundamentally it's probably even the expression of the mediocrity of the epoch, because the beautiful things have disappeared – the public did not want to keep them.'[33]

ARTIST

'I don't believe in art. I believe in the artist.'[34]

ART MARKET

Duchamp did not think highly of **galleries**, **dealers**, **criticism** or **art history**, and was most of all put off by the **commercialism** that he believed was the biggest threat to creativity. Therefore, he made sure that his own works ended up in the hands of just a small number of collectors, who would then donate them to only a few museums. This is the reason why Duchamp, contrary to his status as one of the most important artists of the 20th century, plays almost no part in the art market. If at all, the works that can still be bought are mostly editions and rarely major originals. Francis M. Naumann (b. 1948) remarks that he 'was not only successful in thwarting attempts to commercialize his work in his lifetime', but that 'his efforts continue to have an effect to this very day'.[35] Almost to today, in fact. For example, in the late 1990s, a signed **edition of 1964–65 of** *Fountain* (1917) could still be bought for less than a million dollars, but prices rocketed in 2008 when the **readymade** perfume bottle *Belle Haleine* (1921) sold for $11.4 million, and in 2012 a small preliminary study of its label fetched nearly $2.5 million.

ASSOCIATION MARCEL DUCHAMP

When Duchamp passed away in October 1968, it was his wife **Alexina Sattler** (**Teeny**; 1906–95) who guarded his legacy and created an archive with the works and documents he had left behind. According to Francis M. Naumann (b. 1948), the artist's estate was valued at around $360,000, whereas **Pablo Picasso**'s (1881–1973) was estimated at $312 million when he died in 1973.[3] Duchamp's stepdaughter and the granddaughter of Henri Matisse (1869–1954), the artist Jacqueline Matisse Monnier (b. 1931), put together the last sixty or so unassembled *Boxes-in-a-Valise*, which her mother then signed. With a rubber stamp signature of Duchamp's

or her own, Teeny sometimes endorsed numbered editions of his work, such as the *Anaglyphic Chimney* (1995). She also allowed the posthumous publication of almost 300 **notes** that she had discovered. In close collaboration with the **Philadelphia** Museum of Art, to which she generously continued to donate many of Duchamp's works and documents, she issued certificates of authenticity, such as for the **readymade** of the licence plate of her Volkswagen car (**automobiles**).

After Teeny's death in late 1995, Monnier took over from her mother and in 1997 became founding president of the Association Marcel Duchamp, which 'is devoted to the protection, preservation, publication, administration, and the collection of rights related to the work of Marcel Duchamp.'[37] When it comes to research, exhibitions or the use of Duchamp's visual vocabulary by other artists, the Association is generous, caring and genuinely interested – none of which should be taken for granted. The Association reserves the right to take legal action against unsigned, undated and unnumbered samples of readymades from the **edition of 1964–65**. In 2000, it supported the creation of the annual Prix Marcel Duchamp, awarded by the Centre Georges Pompidou in Paris to young artists living in France. In 1998, the Association pour l'étude de Marcel Duchamp was founded to encourage the development of studies focused on the artist. Its scholarly journal *Étant donné Marcel Duchamp* is published in both

French and English. Single volumes appear about every year and a half and often focus on one or two specific subjects as well as on the relationships between the artist and his closest friends and collaborators. Paul B. Franklin (b. 1967), president of the Association pour l'étude de Marcel Duchamp and editor in chief of *Étant donné*, is one of the foremost Duchamp scholars of our time.

AUTOMOBILES [illustration p. 24]

In the Futurist manifesto of 1909, Filippo Tommaso Marinetti (1876–1944) hailed the beauty of speed and declared a 'roaring motor car' to be 'more beautiful' than the Louvre's famous Greek marble sculpture *Winged Victory of Samothrace*.[38] Young artists in the early 20th century were certainly enthralled by automobiles and Duchamp had a lifelong fascination with them. His drawing *2 personnages et une auto* (1912) blends eroticism with mechanical forms, and the abstract with the figurative. In the same year, one of his more famous **notes** mentions a roadtrip from the Jura Mountains back to Paris together with his artist friend **Francis Picabia** (1879–1953), among others, who was an avid collector of automobiles. Duchamp rather poetically describes the 'headlight child' as a 'comet in reverse', which has 'its tail in front' and 'absorbs by crushing (gold dust, graphically) this Jura-Paris road.'[39] His notes on the upper half of the **Large Glass** (1915–23),

known as the Bride's Domain, often read like an anatomical dissection of car parts, including the engine, spark plug, gear lever and cooling system. It is here that an electric 'desire motor'[40] with 'quite feeble cylinders'[41] is 'activated by the love gasoline, a secretion of the bride's sexual glands and by the electric parts of the stripping'.[42] The 'blossoming of the bride' is likened to an 'image of the motor car, climbing a slope in low gear. (The car wants more and more to reach the top, and while slowly accelerating, as if exhausted by hope, the motor of the car turns over faster and faster, until it roars triumphantly).'[43] Such a preoccupation with auto-eroticism (**onanism**) is found throughout Duchamp's work. A less well-known jotting, published posthumously, refers to the car in both a strangely blasphemous and a morbidly comic way: 'The christ glued on an automobile carriage window with the paw serving for lifting the glass.'[44]

In June 1927, Duchamp married **Lydie Sarazin-Levassor** (1903–88), the daughter of a well-known Parisian car manufacturer whose family included several famous race drivers. Duchamp never learned to drive so their honeymoon travels were spent with Lydie behind the wheel of a Citroën. In the 1950s, when he was married to **Alexina Sattler** (**Teeny**; 1906–95), the vehicle of choice was her Volkswagen Beetle. In 1945, on the publication of his first monograph as a single issue of Charles Henri Ford's (1913–2002) avant-garde literary and art

magazine, Duchamp subtly changed the title on the cover from *VIEW* to *VieW*, so that only 'VW' appeared in capital letters. His last **readymade** was the red-and-white licence plate of Teeny's VW Beetle, which he signed and inscribed around 1962 for a friend, Grati Baroni de Piqueras (b. 1925). Its title, *Faux Vagin*, is a **pun** based on the French pronunciation of Volkswagen, which in turn sounds just like 'false vagina'. In an etching five years later, Duchamp employed a related visual pun, likening a falcon (French: 'faucon') to a 'false cunt' (French: 'faux con') and it may be that both of these are allusions to the anatomically incorrect female sex at the centre of his *Étant donnés* (1946–66).

On a more practical level, Duchamp was a visionary of car-sharing initiatives. **John Cage** (1912–92) remembered that 'early in the century he proposed the use of private cars for public transportation – people driving cars wherever they liked and just leaving them; other people would take the same cars and drive on.'[45]

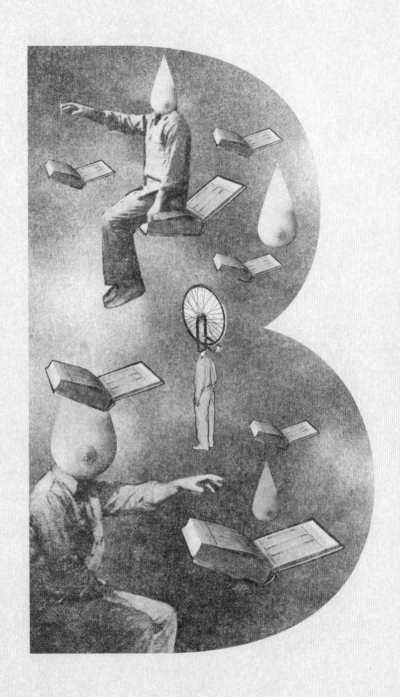

BIBLIOTHÈQUE SAINTE-GENEVIÈVE

In 1913, after enrolling on a course in library science, Duchamp became a librarian at the Bibliothèque Sainte-Geneviève in Paris. He secured the job through his good friend **Francis Picabia** (1879–1953), whose uncle ran the library at the time. Put off by the dogmatic infighting of **Cubism**, Duchamp said he got a job not only to 'make a living' but also 'to rid myself of a certain milieu, a certain attitude'.[1] Apparently, he earned enough money and had fewer than four hours of low-stress work a day, which made it possible for him to spend his time there wandering around reading whatever he liked. It is probable that he delved into the vast collection of optical treatises and books on the **science** of **perspective** (**optics**), which were of great interest to Duchamp and informed his work.

BICYCLE WHEEL

Two years before Duchamp coined the term **readymade**, the very first one came into existence, in Paris in 1913, when he mounted a bicycle wheel onto an upside-down fork, which was fixed to a white kitchen stool. In 1912, during his trip to Munich, Duchamp had seen ordinary and industrial objects exhibited at the Deutsches Museum as well as at the Bavarian Trade Fair. The French government envoy to Munich declared the mass-produced articles on display 'entitled to be considered works of art just as painting or a stone sculpture.'[2] Back in Paris later that year, during a visit

to an aviation show, Duchamp purportedly asked Fernand Léger (1881–1951) and **Constantin Brâncuși** (1876–1957), 'Painting is over and done with. Who could do anything better than this propeller. Look, could you do that?'[3] As for the *Bicycle Wheel*, its spokes turn around a central axis similar to a propeller. Duchamp, who had once referred to it as 'interior decoration'[4] and never thought of exhibiting it for the first four decades of its existence, enjoyed the movement of the wheel, as the reflected light reminded him of a fireplace. Later on, he would refer to the choice of readymades as devoid of aesthetics and **taste**, involving **chance**, **humour** and **indifference** instead.

Incidentally, just like its second version made in New York in 1916, the original *Bicycle Wheel* was lost too. The third version, from 1951, previously owned by the well-to-do art collector **Sidney Janis** (1896–1989), has a story attached to it. In August 1995, a young man walked into MoMA and took the *Bicycle Wheel* from the second floor gallery in which it was permanently exhibited. The thief managed to leave the building unnoticed, returning the artwork the next day by throwing it over the wall of the museum's sculpture garden.[5]

THE BLIND MAN

The father of **Beatrice Wood** (1893–1998) was extremely worried that his daughter might go to jail because of *The Blind Man*,

'this filthy publication',[6] which she was co-editing with her close friends **Henri-Pierre Roché** (1879–1959) and Marcel Duchamp. He was utterly convinced that Wood was 'out of her mind'.[7] The only two numbers of this slim – and ultimately harmless – **Dada** magazine rolled off the press in April and May 1917. Instead of a third number, two months later a unique issue of their magazine *Rongwrong* appeared in New York. Including covers and advertisement spreads, the combined number of pages of these journals barely exceeded thirty. *The Blind Man* was published for four years before the single issue of Duchamp's and **Man Ray**'s (1890–1976) *New York Dada* magazine appeared. Its second number is best remembered today, as it contains **Louise Varèse**'s (née Norton; 1890–1989) and Beatrice Wood's defence of Duchamp's urinal *Fountain* (1917) and features the artist's *Chocolate Grinder, No. 2* (1914) on its cover. The short essays, poems and artists' vignettes (including one about the American painter **Louis Michel Eilshemius**, 1864–1941) celebrate the independence and anti-commercialism of new art and those behind it – and celebrate they did. 'The Blindman's Ball', held on 25 May 1917 at Webster Hall in New York, was billed as an 'ultra-bohemian, pre-historic, post-alcoholic' wild dance party with costumes.[8] A drunken Duchamp climbed onto a chandelier in front of everyone, and in the early hours of the morning he ended up in his apartment's bed with four men and women.[9]

BOREDOM

In 1966, Duchamp was sure that 'the principle factor of art today is boredom'[10] – his own **philosophy** revolved around his fear of dying of boredom if he took life too seriously. He struck a slightly more conciliatory note a few years later when assessing the shenanigans of Fluxus and Neo-Dada: 'The public comes to a happening not to be amused but to be bored', which he conceded was 'quite a contribution to new ideas'.[11] To Duchamp, the 'shocking, annoying and boring' was an 'element of esthetic value' just as much as 'pleasure' – at opposite ends, yet of 'the same general concept'.[12]

BOXES [illustration p. 30]

Duchamp's interest in printing, binding, typography and **graphic design** can be traced back to his time as an apprentice at the Imprimerie de la Vicomte in Rouen in 1905. For what came to be known as the *Box of 1914*, executed in an edition of five, Duchamp published sixteen photographic facsimiles of his **notes** as well as one of his drawings mounted on matboards. The seemingly random, ephemeral notes do not have a specific order and the *Box of 1914* constituted the first box in art history as well as an entirely new genre of artistic expression.

Twenty years later, after four years of work, his *Green Box* (1934) was published in an edition of 320, comprising almost 100 facsimile notes, drawings and photographs. To achieve complete authenticity, Duchamp used zinc stencils to cut the reproductions to the correct shapes from the original types of paper where they were still available. Titled *The Bride Stripped Bare by Her Bachelors, Even* the *Green Box* bears the same alternative name as the ***Large Glass*** (1915–23), the magnum opus that he left unfinished about a decade before. It is to this work that most of the notes included in the 1934 box refer. To Duchamp, the *Green Box* remained a 'very incomplete realization of what I intended. It only presents preliminary notes for the *Large Glass* and not in the final form which I had conceived as somewhat like a Sears, Roebuck catalogue to accompany the glass and to be quite as important as the visual material.'[13] Just as the 'accumulation of ideas' that is the *Large Glass* was meant as 'a wedding of mental and visual reactions',[14] so is the *Green Box* an essential component of the work.

In 1967, in an edition of 150, Duchamp published *À l'infinitif*, or the *White Box*, containing facsimiles of seventy-nine additional notes mostly relating to the *Large Glass*. Upon the suggestion of its translator, Cleve Gray (1918–2004), the notes were grouped in seven black envelopes entitled 'Speculations', 'Dictionaries and Atlases', 'Colour', 'Further References to the Glass', 'Appearance and Apparition', '**Perspective**', and 'The Continuum'. The Plexiglas cover of the *White Box* contained an original silkscreen miniature

print of the 'glider' from the Bachelors' Apparatus of the *Large Glass*. Its movements back and forth were, according to a note from the *Green Box*, made up of, among other things, 'slow life', 'vicious circle', 'eccentrics', 'junk of life' and '**onanism**'.[15]

BOX-IN-A-VALISE

With his *Boîte-en-valise*, or *Box-in-a-Valise*, Duchamp embarked on one of his more ambitious projects: a portable museum of miniature **replicas** and facsimiles created with the help of elaborate reproduction techniques such as *pochoir* (a type of hand stencilling) and comprising his most important works. Conceived in the mid-1930s and consisting of up to sixty-nine items, it was first released in 1941 and continued to be assembled in various editions until after his death, with the final seven different series totalling about 300 items. However, only the limited de luxe edition of the first twenty boxes was actually contained within a leather valise. An original artwork was included in each of these, usually mounted on the inside of the valise lid. The very first *Box-in-a-Valise* went to **Peggy Guggenheim** (1898–1979) who displayed its contents within a specially designed viewing device at her Art of This Century gallery in New York. 'Everything important that I have done can be put into a little suitcase',[16] Duchamp said, and everything important about that little suitcase may

be found in Ecke Bonk's (b. 1953) *Marcel Duchamp: The Portable Museum* (1989). From **Rrose Sélavy**, listed by Duchamp as a co-creator of the box, to the order in which his miniatures, especially those of his **readymades** – the glass ampoule *Air de Paris* (1919), the typewriter cover *Traveller's Folding Item* (1916–17), and *Fountain* (1917) – are placed in relation to the **Large Glass** (1915–23) at the centre of the back of the box, everything has been scrutinized by Duchamp scholars. Bonk called the *Box-in-a-Valise* 'the synthesis of his paradoxical principles, of his apparently – but only apparently – contradictory rationale. The manifold overlaps and cross-references in his work as a whole are reflected in the spatial construction of the *Boîte*, as well as in the arrangement of the reproductions. His artistic statements and achievements, in all their heterogeneous and many-sided profusion, are presented here by Duchamp as a carefully ordered whole.'[17]

Just as Duchamp made sure that virtually all of his most important artworks would eventually be permanently exhibited in the Philadelphia Museum of Art, so his *Box-in-a-Valise* (1941) allowed all of the miniatures of his works to be seen in one place, at a time when many of the originals had been lost or dispersed widely, with an uncertain future ahead in the midst of the Second World War. In 2014, the French artist Mathieu Mercier, winner of the Prix Marcel Duchamp in 2003, published the *Box-in-a-Valise* as a pop-up book.

CONSTANTIN BRÂNCUȘI

Almost ten years' Duchamp's senior, the Romanian sculptor Constantin Brâncuși (1876–1957) arrived in Paris just a short time before the artist himself in 1904 and they probably first met in the early 1910s. Duchamp and his later-to-be wife **Alexina Sattler** (**Teeny**; 1906–95) became good friends with the sculptor. The two artists' aloofness from the art world, their sense of humour and the recognition of their work, which was greater in the US than in their native Europe, were just a few of the things that they had in common. Works by both were exhibited at the **Armory Show** and when, in the autumn of 1926, a New York customs official classified a sculpture by Brâncuși under 'kitchen utensils and hospital supplies' rather than art, which made it subject to a major import tax instead of the no taxation policy on artworks, Duchamp rushed to the defence: 'To say that the sculpture of Brâncuși is not art is like saying that an egg is not an egg.'[18] At a second show of Brâncuși's works at Manhattan's Brummer Gallery in 1933–34, Duchamp was full of praise about the joy and power of his friend's sculptures, speaking of his obsession with form and his in-depth examination of the materials used.[19] Much later, in 1951, the artists exhibited together at the **Sidney Janis** gallery, and Duchamp helped organize several shows of Brâncuși's sculptures, among them a major retrospective at the Guggenheim Museum in New York in 1955. Throughout his life, Duchamp bought and sold his friend's works (**dealer**) and helped place them in important private and public collections. Within their correspondence, both frequently signed off as 'Morice', a name that 'according to Brâncuși could be used only among those who possessed a pure heart and soul, which, apparently, were qualities he felt they shared.'[20]

BREASTS [opposite]

For the cover designs of the numbered de luxe edition catalogue of the Paris exhibition *Le Surréalisme en 1947* (**curating**), Duchamp used over one thousand pink foam-rubber breasts. A collaboration with his friend and fellow artist Erico Donati (1909–2008), each catalogue's cover consisted of a falsie pasted onto the pink cardboard flap, surrounded by a rough circle of black velvet. The back cover read 'Prière de toucher', or 'Please touch'. Before deciding on falsies, Duchamp experimented with plaster cast breasts modelled on his lover **Maria Martins** (1894–1973), a process that he developed further while working on *Étant donnés* (1946–66) over the next two decades. Casts of breasts were not new in the realm of art and terracotta breasts were used as offerings and good-luck charms throughout antiquity. Later they also served as intricate artefacts for anatomical studies.

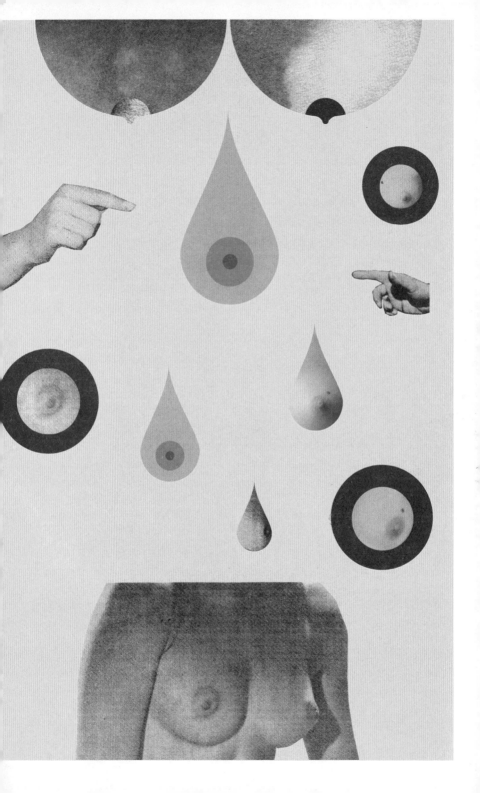

Breasts appear frequently through-out Duchamp's oeuvre. For example, *In the Manner of Delvaux* (1942) is a small enigmatic collage based on *Women Trees* (1937), a painting by the Belgian Surrealist Paul Delvaux (1897–1994) in which breasts feature prominently. The little-known work (not listed in his catalogue raisonné) punningly titled *For Sitting Only* (1957) consists of a ring-shaped toilet seat cover decorated with seven falsies – all nipples tinted pink – and was presented by **Rrose Sélavy** and **Alexina Sattler** (**Teeny**; 1906–95) as a wedding gift to Duchamp's friends Jean (1912–2003) and **Julien Levy** (1906–81).

ANDRÉ BRETON

When it comes to contemporary displays or studies of **Surrealism**, its mercurial founder, André Breton (1896–1966), is often denigrated. However, Surrealism would not exist or stand as tall without Breton, an uncompromising, inspir-ing force of utmost integrity whose obsessions and insatiable enthusiasm for anything from folk art to utopian thought make him one of the more inter-esting figures of 20th-century art. At a time when nationalism raged in Europe, he embraced its diverse cultures, chas-tised colonialism, denounced the mighty societal forces of religion and early on warned against Nazism as well as the Socialist Realist doctrine of communism.

Through his movement's forays into th subconscious, he returned the dream the nonsensical and poetry to a militam world of economic bonfires and techno logical progress, often devoid of hope and rather distrustful of feelings.

Unfortunately, Duchamp reaffirmed some of the negativity surroundin Breton. Although he felt a 'sympathy o individuals' towards him – 'man to man not of an intellectual but rather 'of sensual kind' – he did 'not approve of hi way of thinking' and reprimanded him for his 'chameleonisms'.[21] Duchamp neve understood why Breton could not jus laugh things off or contradict himsel (**contradictions**). According to the artis Surrealism's inhibited founder was tragic figure, a vulnerable 'post coitun animal triste',[22] while 'the Surrealists ar a sad lot, they who stand up in defens of **humour**, with "theory".'[23] Ducham gave him credit for the 'incredible nerv it took to lead Surrealism for forty year but he regarded the task 'a strang ambition' that required 'extraordinar egoism'.[24] In private correspondenc with his lover **Maria Martins** (1894 1973), he wrote that 'André can be reall very vulgar at times and his Hitlerit attitude is often synonymous with imb cility.' Yet, despite this, of all the artist Breton championed throughout his lif time, there was not one he revered mor than the ever-elusive Duchamp, whon he thought beautiful, a poet and th most intelligent man of the 20th centur Without ever having seen the *Larg*

Glass (1915–23), he wrote his essay 'The Lighthouse of the Bride' (1935) using photographs of the work and the artist's **notes**. It was the first study on what Breton named one of 'the most significant works of the twentieth century'.[26] He was in awe of this 'trophy of a fabulous hunt through virgin territory, at the frontiers of **eroticism**, of philosophical speculation, of the spirit of sporting competition, of the most recent data of **science**, of lyricism and of humor'[27].

Duchamp and Breton first met in Paris sometime between late 1919 and 1921 and they jointly conceived several major Surrealist exhibitions in Paris and New York. From cover designs and window displays for many of Breton's publications to the design of the door of his Gradiva gallery, Duchamp supported him in numerous projects. Yet theirs was not 'a miraculously uncompromised friendship',[28] as Duchamp's biographer Calvin Tomkins (b. 1925) has it. As early as 1929, within the pages of the second Surrealist manifesto, Breton subtly chided a detached Duchamp for his silence as well as for playing **chess** instead of creating art. Later in life, Breton took it personally when Duchamp sided with Roberto Matta (1911–2002), whom others blamed for the suicide of the painter Archile Gorky (1904–48) as he had run off with the latter's wife. Moreover, in the early 1950s, Breton's requests for Duchamp to write an article about 'Science and Surrealism' or to contribute to the controversial debate about Michel Carrouges's

(1910–88) *Les machines célibataires* (1954), in which the *Large Glass* features prominently, were never honoured by his artist friend. In 1960, Breton strongly disagreed with him for including **Salvador Dalí** (1904–89) in a Surrealist exhibition; Breton denounced Dalí as 'Hitler's former apologist, the fascist painter, the religious bigot, and the avowed racist'.[29] Breton also grew increasingly bitter about his refusal to sign a petition against three young painters, among them Eduardo Arroyo (b. 1937), who had jointly created a series of works depicting Duchamp's murder in 1965. A year later, the year in which Breton would pass away, he and Duchamp were still engaged in blame games about who should call whom and who was entitled to be angry about a missed appointment with the other.

Theirs was a lifelong courtship of sorts, petty fights included, between incompatible personas that could often make the greatest things happen together. In an **interview** after Breton's funeral, which Duchamp attended, he reserved some of the nicest things he ever said about anyone for the founder of Surrealism: 'I have never known a man who had a greater capacity for **love**, a greater power for loving the greatness of life, and you don't understand anything about his hatreds if you don't realize that he acted in this way to protect the very quality of his love for life, for the marvelous in life. Breton loved like a heart beats. He was the lover of love in a world that believes in prostitution.'[30]

BRIDE

Returning drunk from a **Munich** beer hall in the summer of 1912, Duchamp was haunted by a nightmare in which a giant beetle-like insect inflicted harrowing torments upon him with its jaws. At around the time Franz Kafka (1883–1924) composed his novella *The Metamorphosis* (1915), Duchamp – in part inspired by the dream – set out to paint his warm-hued, strange *Bride* (1915), a painting he later came to prefer over all his others. Sometimes using his bare fingers instead of a brush, he later said that he arrived at a 'very precise technique' that no longer lent itself to a 'realistic interpretation' but to 'my concept of the bride expressed by the juxtaposition of mechanical elements and visceral forms'.[31]

The *Bride* later reappears on the left side of the upper half of the *Large Glass* (1915–23), where all her rotating, expanding, contracting and electrically conductive elements already apparent on canvas are put to full use as part of the intricate mechanisms of the coital function within Duchamp's magnum opus. Duchamp gave the *Bride* to his friend **Francis Picabia** (1879–1953) with whose wife, **Gabrielle Buffet-Picabia** (1881–1985), he was both passionately and unrequitedly in love at the time. The *Bride* marks the culmination of Duchamp's creative powers in painting, his idiosyncratic technique and his perfection of a personal style free from all schools and 'isms'.

BUENOS AIRES

Duchamp lived in Buenos Aires, Argentina's capital, from September 1918 to June 1919, although he had originally planned to stay for a couple of years. Not knowing anybody in Buenos Aires, he left New York by ship together with his lover, Yvonne Chastel (1884–c. 1967). Duchamp's easygoing attitude towards journeys is legendary. In this case, his nomadic travels were a means of escaping the First World War and its militant patriotism, which had already brought him from France to New York in 1915. In 1918, his status as a non-citizen in the US did not entirely protect him from the draft. With Argentina, he had chosen a neutral country in which he could remain until after the armistice and then return safely to France. While there, he taught French, worked on studies of the *Large Glass* (1915–23) and played **chess** in a local club. He analysed the game thoroughly, even reading up on it at night.

He did not mind that outsiders were not welcome in social circles in Buenos Aires. Indeed, the isolation proved rather productive. Notably, he created a small work on glass, *To be Looked at (from the Other Side of the Glass) with One Eye, Close to, for Almost an Hour* (1918) (**perspective**), now the pride of the collection of the Museum of Modern Art, New York. He also designed a chess set with local craftsmen, further explored stereoscopy (**optics**) and instructed his sister Suzanne (1889–1963) in Paris to create an *Unhappy*

Ready-made (1919) by hanging a geometry book from a balcony (**readymade**), thus exposing it to the wear and tear of the elements. So much of Duchamp's work is ephemeral, not made or meant for exhibiting or sale. Just as this wedding present for Suzanne eventually vanished, so did his *Sculpture for Travelling* (1918), which he had initially brought to Buenos Aires from New York. Made of strips cut from coloured rubber bathing caps, cemented together at random intersections and hung by strings of different lengths from various walls of a room, the work was lost or simply disintegrated.

GABRIELLE BUFFET-PICABIA

Gabrielle Buffet Picabia (1881–1985) was married to **Francis Picabia** from 1909 to 1930 and, like her husband, she was a great friend of Duchamp's. Before this friendship truly prospered, however, the artist had been madly in love with her, unrequitedly as it turns out. There are many Duchamp scholars who see the *Large Glass* (1915–23) as, above all, an allegory of unfulfilled desire and unconsummated longing for the bride in the upper region of the work, i.e. Gabrielle Buffet-Picabia (*Bride*, **trains**). From a visit to see **Raymond Roussel's** (1877–1933) play, *Impressions d'Afrique*, to an **automobile** trip from the Jura Mountains back to Paris again, Buffet-Picabia was with Duchamp during what he later described as some of the most significant experiences of his **life**. It is thanks to Buffet-Picabia's many insights in her writings that we catch glimpses of the artist's work, life and character that would otherwise have been lost. For example, while Duchamp openly embraced **chance** and denounced logic, Buffet-Picabia nevertheless saw him 'possessed by a need for absolute logic, ceaselessly anxious for a perfection of which he is the only source and arbiter.'[32] As for chance, 'not one single item is left to chance; he seeks out, tracks down and ruthlessly eliminates everything which seems a remnant of show, emotion, sensation, personal sensitivity.'[33] Although the artist approved of **laziness**, his apparently 'strict discipline necessary to [his] self-control' bordered on the ascetic. His overall 'state of dissidence' was 'perhaps the key to Duchamp's work'.[34]

When Buffet-Picabia and her husband visited New York in 1916, she found that the young man who had been in love with her had grown up, become less timid and was much more confident around women. As for Duchamp's art, 'he was interested only in finding new formulas with which to assault the tradition of the picture and the painting; despite the pitiless pessimism of his mind, he was personally delightful with his gay ironies.'[35]

CADAQUÉS

Duchamp, **Man Ray** (1890–1976) and **Mary Reynolds** (1891–1950) first visited Cadaqués with **Salvador Dalí** (1904–89) in 1933. From 1958 onwards, Duchamp and his wife **Alexina Sattler** (**Teeny**; 1906–95) regularly spent their summers at the small fishing village on Spain's northernmost coast, close to Dalí's home at Port Ligat. Duchamp celebrated his eightieth birthday in Cadaqués, leaving only two weeks before he died in Neuilly-sur-Seine. While in Cadaqués, Duchamp often wore shorts or linen trousers and a local peasant's hat made from straw, and spent his time there catching up with his correspondence, attending the occasional bullfight or visiting friends and artists. Dalí's studio was within walking distance, and occasionally the Duchamps and the

Dalís would go on boat trips together. Duchamp could not swim and he often played **chess** at the Café Meliton or, with Man Ray, would 'watch and comment on the young women, bronzed and almost nude in their bikinis, on their way to the beach'.[1]

Many of Duchamp's important late works are linked to Cadaqués and the apartment overlooking the Costa Brava bay that he rented each year. For example, he built a windbreak, two chimneys and a device called *Bouche-Évier*, or *Sink Stopper* (1964). This small round sculpture was eventually cast in editions of stainless steel, bronze and sterling silver but was initially intended to plug the wastewater pipe of the apartment's bathroom shower. The bricks for the exterior of ***Étant donnés*** (1946–66) came from Cadaqués, while the large wooden **door** was shipped

from the village of La Bisbal, less than forty miles away. While in Cadaqués in 1959, he even collaborated with Dalí on a small collotype print edition from a collage of photographs showing the background landscape of *Étant donnés*, although this never materialized.[2]

JOHN CAGE

'Everything seen – every object, that is, plus the process of looking at it – is a Duchamp.'[3] 'One way to write music: study Duchamp.'[4] These sentences by John Cage (1912–92) speak of both the admiration and the indebtedness the avant-garde composer felt for the artist who was his senior by twenty-five years. Although Cage had known about Duchamp since the early 1940s, and they had met at many events, he did not dare to approach his idol until twenty years later – he asked the artist whether he would teach him how to play **chess**, to which Duchamp agreed. Both had exhibited together before. Duchamp considered it 'very fortunate'[5] that Cage wrote the score for his sequence in *Dreams That Money Can Buy* (1947), an experimental film by the Surrealist **Hans Richter** (1888–1976). Cage owned several works by Duchamp, including **Erratum Musical** (1913) and *Czech Check* (1966), the latter being the composer's membership card for the Czech Mycological Association, which Duchamp signed for him. In 1968, during an arts festival in Toronto, the two men,

together with **Alexina Sattler** (**Teeny**; 1906–95), played chess on stage for over four hours as part of a performance entitled *Reunion*. The games played on an electronic chessboard defined the form and content of an acoustical event enacted by live musicians and composers in attendance, while TV sets translated audio signals into abstract oscilloscopic visuals. What Duchamp later remembered most of all about the night was 'a tremendous noise'.[6] Cage's own innovative musical experiments owed as much to the artist's forays into **music** and **chance** as they did to Zen, Buddhism and Eastern thought.

Duchamp appreciated Cage's presence both at the chessboard and at his dinner table. He shared his 'spiritual empathy, and a similar way of looking at things'.[7] He welcomed the composer's light-heartedness and **humour** as well as his 'search for silence',[8] and considered Cage and himself to be 'great buddies'.[9] Cage returned this kindness tenfold: 'I love him and far more than any artist of this century he is the one who changed my life.'[10] For someone who once created a multi-piece visual work entitled *Not Wanting to Say Anything About Marcel* (1969), he certainly said it all.

CAUSALITY

In 1959, Duchamp created an ink drawing of the *Large Glass* (1915–23) with a landscape of hills and an electricity

pole pencilled in the background. Its title, *Cols alités*, or *Bedridden Mountains*, might tempt us to think of it as a **pun** on the word causality. When asked about the work by the Swiss Duchamp scholar Serge Stauffer (1929–89) in 1960, Duchamp refused to discuss the idea of a play on words but rather referred to his text in **Rendez-vous** (1916) in which he included the term 'colles alités', or 'bed-ridden glues'. Duchamp would not admit to the pun as he was eager to do away with the concept of causality. His own words of the time attest to this: he 'never believed in causality',[11] which he found 'very dubious. It has a doubtful character'.[12] Duchamp did not trust the notion of cause and effect or any laws that might be generated from it. To him, laws did not validate anything. Even 'the idea of **God** being the first one to do everything is another illusion of causality.'[13]

CHANCE [illustration p. 41]

'I respect it. I have ended up loving it',[14] is how Duchamp described to Pierre Cabanne (1921–2007) the intervention of **chance** when it came to his *Large Glass* (1915–23) shattering into hundreds of pieces while being returned to its owner, **Katherine S. Dreier** (1877–1952), after its first public display at the Brooklyn Museum in 1926–27. 'Chance is the only way to avoid the control of the rational',[15] chance alone could 'express what is unique and indeterminate about us',[16] as

the artist told Calvin Tomkins (b. 1925) in the 1960s. Duchamp took the credit for introducing chance to art (*Three Standard Stoppages*, 1913–14) and music (*Erratum Musical*). To help him escape from his own taste and sense of aesthetics, Duchamp welcomed accidents and coincidences. He acknowledged that many of his 'highly organized works were initially suggested by chance encounters'.[17] What held true for his oeuvre also played out in real life. **André Breton** (1896–1966) related the story about a nonchalant Duchamp deciding with a toss of the coin whether he should stay in Paris or leave for New York the next day (he went to New York).

CHEESE

During the Second World War, before he made it back to New York from German-occupied France in May 1942, Duchamp devised a scheme to transport the artistic materials needed for his *Box-in-a-Valise* (1941) out of Europe. On the way to the United States, he passed through Nazi checkpoints in Paris posing as a wholesale cheese merchant. Luckily he did not arouse any suspicion. This risky endeavour may have been Duchamp's inspiration for reproducing a greatly enlarged close-up of a slice of cheese for the cover design of the *First Papers of Surrealism* exhibition in New York in late 1942. In 2000, after some debate within the Duchamp community, it was agreed

that the cheese used for this cover image was Emmentaler and not Gruyère as it had been wrongly suggested for decades. On the back of an Excelsior Camembert cheese label, Duchamp once quipped that 'The bachelor grinds his **chocolate** himself', an onanistic reference pertaining to the lower half of the *Large Glass* (1915–23) (**onanism**).

CHESS [illustration p. 44]

If owing to his noteworthy musical talents James Joyce (1882–1941) has been referred to as a tenor who also wrote a few books, albeit of unparalleled significance, Duchamp may rightly be called a chess player who also created some important works of **art**. Duchamp once famously proclaimed that 'while all artists are not chess players, all chess players are artists'.[18] The game occupied him so much that, out of jealousy and frustration, his first wife, **Lydie Fischer Sarazin-Levassor** (1903–88), glued his chess pieces to the board. The **marriage** lasted for barely seven months. Duchamp created a large number of studies and artworks on the theme of chess, including: his important early paintings of 1910 and 1911; a late etching, *King and Queen* (1967); a chess sculpture of the same year with his own face and right arm cast in bronze; and the black-and-white chessboard linoleum floor onto which he placed *Étant donnés* (1946–66).

In avant-garde filmmaker **Hans Richter**'s (1888–1976) chess-inspired *8x8: A Chess Sonata in Eight Movements* (1952/57), Duchamp appears as the Black King, and he plays chess with **Man Ray** (1890–1976) on a Paris rooftop in René Clair's (1898–1981) film *Entr'acte* (1924). Throughout his life, Duchamp crafted chess figurines and boards, including a *Pocket Chess Set* in 1943, and designed the poster for the French Championship of 1925. 'Duchamp needed a good chess game like a baby needs his bottle',[19] remarked his close friend **Henri-Pierre Roché** (1879–1959), and it is no coincidence that one of the most iconic photographs of the artist shows him enjoying a game of chess with a nude young woman at his first retrospective in Pasadena in 1963.

Duchamp had played the game from childhood and did almost everything to nurture his friends' reproach that since the 1920s he had abandoned art for chess. He wrote numerous chess columns and played against the greats of his time – José Raúl Capablanca (1888–1942) (Duchamp lost, naturally), George Koltanowski (1903–2000) (Duchamp won) and Ksaweri Tartakower (1887–1956) (a draw!). He became a chess master in 1925 and was a member of the French team for the Chess Olympics, playing international competitions (**Q-e5**) and being awarded many prizes. In 1932 he won the Paris International Tournament, and in the same year, together with Vitaly Halberstadt, he co-wrote and designed

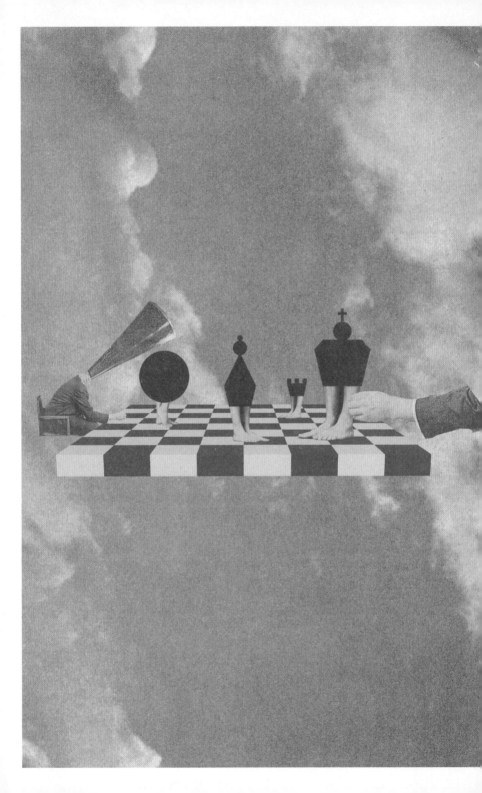

a book, *Opposition and Sister Squares are Reconciled*, about a rare endgame situation, which was published in French, English and German. To Duchamp, chess was a **science**, *his* science. In 1935 and 1939 he was the undefeated champion as the captain of the French team of the First International Chess by Correspondence Olympiad. Later in his life he raised substantial amounts of money for the American Chess Foundation, for which he served as chairman, through an exhibition and an auction.

In part, it is Duchamp's lifelong preoccupation with chess that helps us to understand his art – the perpetual games of hide and seek, of tongue-in-cheek, of rigid logic and its surprise suspension. His sense of observation and contemplation, the solemn anticipation of what is to come and who will make the next move, and when and why, are all inextricably intertwined with his love of the game. Indulgence in the pure mental state of being, the ability to concentrate and strategize, the silence, the purity of thought and the luxury of taking one's time – these are traits of Duchamp's character as much as they are prerequisites for a good game of chess. It also appealed to him that there was no money involved in chess. Duchamp needed strong opponents. He had taught a young **John Cage** (1912–92) the game, yet became annoyed when the composer did not try too hard not to lose: 'Don't you ever play to win?'[20] Above all, chess allowed Duchamp to pass his time

without actually working or creating art, while the game he described as a 'violent sport'[21] to him had metaphysical layers as well. 'To play is to live for. You play chess and you kill but you don't kill much. You live after being killed, you see, in chess, but not in normal wars. It's a peaceful way of understanding life. Play with life then you are just as alive and more alive than people who are only believing in religion and art.'[22] Regarding religion, Duchamp once proclaimed that Aaron 'Nimzowitsch [1886–1935] is my **god**',[23] referring to one of the 20th century's greatest chess masters and thinkers. This is probably as good as it gets when it comes to adoration by an agnostic.

CHILDREN

Duchamp's parents, the notary Justin Isidore (1848–1925, known as Eugène) and Marie Caroline Lucie (1863–1925), had seven children, one dying in infancy: Gaston (1875–1963, later known as Jacques Villon), Raymond (1876–1918), Henri Robert Marcel (1887–1968), Suzanne (1889–1963), Yvonne (b. 1895) and Magdeleine (1898–1979). Of all his siblings, only Marcel fathered a child, born out of wedlock during a love affair with a married woman, Jeanne Serre, who was the model for several of his paintings. Their daughter, later known by her artist name Yo Sermayer, was born on 6 February 1911. She never had any children. Duchamp's direct lineage ended with Magdeleine, the last

of his siblings to pass away, in 1979, and Sermayer, who died in 2003.

CHOCOLATE [opposite]

As far as we know, Duchamp loved chocolate. In his New York studio in the 1910s, 'there were always chocolate bars on the window sill.'[24] While visiting his parents in their hometown of Rouen, Duchamp was fascinated by the ancient chocolate grinder in one of the shop windows of the Chocolaterie E. Gamelin. Enthralled by the precision of such a complex machine, the encounter proved 'a very important moment in my **life**' and became 'a real point of departure'[25] for his future work. In fact, only a little later, the chocolate grinder was introduced as one of the main components of the Bachelors' Apparatus in the lower half of his major work the *Large Glass* (1915–23). In a note – 'the bachelor grinds his chocolate himself'[26] – Duchamp suggests an onanistic activity linked to the rhythmic movement of the grinder (**onanism**). In another note he envisions 'an object in chocolate' and 'the mould of a chocolate object' as 'the negative apparition of the surface'.[27]

Duchamp may have been the first artist to have used actual chocolate in an artwork. The small drawing *Moonlight on the Bay at Basswood* (1953) has a typewritten comment on the back stating, 'the heavy brown shadows in the pine trees were made with a chocolate bar'.[28] He once scribbled instructions about the assembly process of his ***Box-in-a-Valise*** (1941) on a fragment of the label from a Hershey's Cocoa tin and described parts of the Milky Way of the Bride's Domain in the upper half of his *Large Glass* on the back of a postcard bearing the caption 'Hershey "The Chocolate Town"'.

CITIZENSHIP

Born in France, Duchamp applied for US citizenship before marrying his second wife **Alexina Sattler** (**Teeny**; 1906–95), an American, in 1954. Upon the intervention of Alfred H. Barr Jr (1902–81), former director of the Museum of Modern Art, New York, as well as Nelson A. Rockefeller (1908–79), Duchamp took the oath of citizenship in late 1955, eighteen months after the wedding, at the age of sixty-eight. It is therefore both with great pride, as well as not inaccurate, that the wall labels adjacent to Duchamp's works throughout American museums define his nationality as 'French-American', or even just 'American'. Duchamp provided a whimsical answer as to why he no longer wanted to hold a French passport: 'Because it was easier to get my favorite cigars through customs.'[29]

COFFEE MILL

The *Coffee Mill*, created in late 1911 for his brother Raymond Duchamp-Villon's

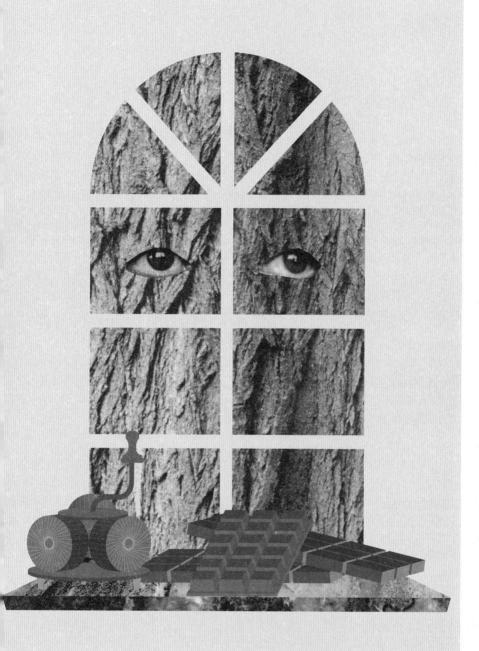

(1876–1918) kitchen, is a very small, unassuming painting and became a favourite of Duchamp's. From the handle on top all the way to a heap of ground coffee at the bottom, it shows the entire operation of a coffee mill at work, from different angles and perspectives. It pre-dates the mechanist examinations of **Dada** and includes many themes that would come to define the artist's work, such as the depiction of motion on canvas, his interest in diagrams and the interior workings of machines real or imagined, and even 'irony',[30] as Duchamp told friends in 1945. Soon, Duchamp would put the world of logos and engineering completely at the service of eros – possibly one of his greatest achievements as an artist – and within his oeuvre the **chocolate** grinder would take over from where the coffee mill left off. The Tate Gallery had the foresight to purchase the peculiar painting in 1981 from the daughter of Duchamp's lover, **Maria Martins** (1894–1973). To this day, no one has been able to disprove the artist's claim that *Coffee Mill* was the first painting to make use of an arrow to suggest movement.

COLLECTING

During his lifetime, Duchamp arranged for most of his major works to be placed in the hands of only a few collectors to whom he was very close. In his attempts to sidetrack the art market, he was then able to convince them to donate the works to the modern art collections of a small number of museums worldwide, with the **Philadelphia** Museum of Art being by far the most important. In a letter to his good friend Walter Pach (1883–1958) dated 28 September 1937, Duchamp wrote that 'because my production is on a small scale, I am convinced that it has no right to be speculated upon, that is, to travel from one collection to another and get dispersed.'[31] It is precisely because of this precaution that Duchamp still plays no major role in the art market, not for gallerists, auction-houses or private collectors. With regard to the latter, the artist thought of them as 'feelers, not intellectuals', who are 'generally not intelligent enough',[32] comparing their appreciation to the shallow words, joy and pleasure that are the background noise of any art fair or collectors' dinner even today. To soften his standpoint, Duchamp allowed for a differentiation between 'the commercial collectors who have made modern art a field comparable to a Wall Street affair – the real collector, in my opinion, is an artist *au carré*, he selects paintings and puts them on his wall, in other words, "he paints a collection".'

COMB

See **edition of 1964–65, rendez-vous**.

COMMERCIALISM

One of the reasons Duchamp cherished **chess** was that, unlike art, it could not be exploited for commercial gain or its players corrupted by money. After the success of *Nude Descending a Staircase No. 2* (1912) at New York's **Armory Show** in 1913, Duchamp was offered a monthly salary by a contemporary gallery to continue painting in the same style, but he refused. Although he himself was a dealer for **Constantin Brâncuși** (1876–1957) and **Francis Picabia** (1879–1953) as well as many other artists, his lifelong aversion to commercialism did not necessarily contradict his sale of works by friends to other friends as a go-between for the European avant-garde and the American art market. 'One must live', he told Pierre Cabanne (1921–2007), 'it was simply because I did not have enough money.'[34]

Duchamp repeatedly made it clear that he did not need much to live on and many friends were astonished how modest and almost ascetic he was. 'My capital is time, not money'[35] is how he defined his lifestyle, long before spare time came to be considered the ultimate luxury. Critical of the **art market**, he advised young artists to avoid money. Also, as one of the reasons he gave for stopping painting altogether at an early age he stated that it was 'because there was too much commercialism. I did not like the mixture of money and art. I like the pure thing. I don't like water in wine.'[36] When an artist contacted him in 1964 to sign a bottle dryer he had found, an object similar to the one Duchamp had elevated to the status of a **readymade** half a century before, Duchamp refused, not wanting to compromise his own **edition of 1964–65** that he had authorized **Arturo Schwarz** (b. 1924) to manufacture. Yet, as he assured the artist in a letter, 'your find has the same "metaphysical" value as any other readymade, it even has the advantage to have <u>no</u> commercial value.'[37]

CONTRADICTIONS

Duchamp is not a riddle to be solved. He and his work simply cannot be grasped or pinned down by any one explanation, formula or key. Maybe this is another of his contributions to our understanding of art: to comprehend that our quest for clarity is futile and complex thoughts are just as true as their opposite may be. 'There is no solution because there is no problem'[38] he once famously quipped, and when it comes to Duchamp constantly contradicting himself, the artist Jasper Johns (b. 1930) had his own take on it: 'Shortly after his death, there were two **interviews** published in two art magazines. Toward the end of one Duchamp said, "I'm nothing else but an artist, I'm sure, and delighted to be." The other ended, "Oh yes, I act like an artist although I'm not one." There may be some malice in these contradictory self-descriptions or, perhaps, an unwillingness to consider any definition as

being final.'[39] Duchamp once stated, 'To live is to believe, that's my belief',[40] as well as 'I like the word "belief"'.[41] While in 1964 he told Otto Hahn (1879–1968) 'I believe in nothing because to believe gives rise to a mirage',[42] a few years later he said to Pierre Cabanne (1921–2007) that 'the word "belief" is another error' and called it a 'horrible idea'.[43] As Walt Whitman (1819–92) wrote in *Song of Myself*, 'Do I contradict myself. Very well, then I contradict myself. I am large, I contain multitudes.'[44]

As early as 1914, in his mid-twenties, Duchamp jotted down a note about wanting to research the 'principle of contradiction' and how this very principle 'by nature ... can contradict its own self'.[45] Half a century later he argued that 'contradiction is the whole point'.[46] When it came to the creation of his own art, there was a conscious effort on Duchamp's part not to choose sides: 'I have forced myself to contradict myself in order to avoid conforming to my own **taste**.'[47]

WILLIAM COPLEY

'Cops pullulate, Copley Copulates'[48] is how Duchamp rather obviously punned on the name of his friend William Copley (1919–96), the American art dealer, publisher and painter of humorous and erotic works, in an invitation for one of his New York shows in 1960. Not obvious enough, apparently, as three years later an even more sexually laden limerick followed:

'There once was a painter named Copley / Who never would miss a good lay / And to make his paintings erotic / Instead of brushes, he simply used his prick.'[49] Copley was both independently wealthy and tremendously generous. Duchamp helped him to jump-start his gallery after they first met in the late 1940s. It was the Copley Foundation that secured the purchase of *Étant donnés* (1946–66) and its donation to the **Philadelphia** Museum of Art, a work created by Duchamp over two decades in such secrecy that Copley was one of only a handful of people who knew about it before its posthumous inauguration in 1969.

A great supporter of many of Duchamp's projects, including the financial backing for his first retrospective in Pasadena in 1963 curated by Walter Hopps (1932–2005) and for **Richard Hamilton**'s (1922–2011) version of the *Large Glass* (1915–23), Copley described his relationship with Duchamp as 'personal and amicable'.[50] In fact, 'Duchamp's influence on me as a painter was enormous but strictly poetic, having to do with what I assumed to be my understanding of his **humor** and **philosophy** as expressed through his personality.'[51]

CRAFT

'I don't believe in the creative function of the artist. He's a man like any other. It's his job to do certain things, but the business man does certain things also ...

Now everyone makes something, and those who make things on a canvas, with a frame, they're called artists. Formerly, they were called craftsmen, a term I prefer. We're all craftsmen, in civilian, or military, or artistic life.'[52]

THE CREATIVE ACT'

Of Duchamp's few lectures and talks, most of which he delivered when in his late sixties and seventies, 'The Creative Act' is considered his most important. Within this brief speech given at the Convention of the American Federation of Arts in Houston, Texas in April 1957, Duchamp proposed that the viewer of an artwork is as important as the artist himself. While 'the artist may shout from all the rooftops that he is a **genius**, he will have to wait for the verdict of the spectator', who may also 'rehabilitate forgotten artists'.[53] The artist's creative struggle can never be fully aware of the difference between the intention and its realization' and it is this gap that allows the spectator to determine the weight of the work on the esthetic scale.'

In the same vein, and surely influenced by Duchamp's ideas, an essay on the *Large Glass* (1915–23) written by Roberto Matta Echaurren (1911–2002) and **Katherine S. Dreier** (1877–1952) states that 'the image is not a thing. It is an act which must be completed by the spectator. In order to be fully conscious of the phenomenon which the image describes, we ourselves must first of all fulfill the act of dynamic perception.'[54] What Duchamp offers then is a 'dialogue',[55] an 'esthetic osmosis', a 'transmutation' or 'transubstantiation' between the artist and the onlooker that goes way beyond **taste**, approval or rejection, or the infamous 'I could do that myself' remarks so often overheard in galleries exhibiting modern and contemporary art.

Duchamp's approach was not about **judging**: 'What I have in mind is that art may be bad, good or **indifferent**, but, whatever adjective is used, we must call it art.' Moreover, it has nothing to do with the all too often unnerving attempts to objectify our subjective opinions, which is at the root of so much purportedly neutral **art history**. Duchamp was primarily interested in engaging what he called **grey matter**, both of the artist and of the spectator. After all, while 'millions of artists create, only a few thousand are discussed or accepted by the spectator and many less again are consecrated by posterity.'

CRITICISM

'As much as possible I never try to judge or criticize anything' (**judging**),[56] Duchamp declared, and considered himself to be a 'great enemy of critical writing'.[57] He once advised that 'the more hostile the criticism, the more encouraged the artist should be.'[58] Duchamp noticed early on that the more secular the 20th

century grew, the more art became its ersatz religion: 'The public is a victim of a really staggering plot. The critics speak of "the truth of art" as one says "the truth of religion".'[59]

CUBISM

Of all artistic styles, Duchamp owes his coming of age as an artist to Cubism, in particular in his refusal to identify his work with any specific school, movement or aesthetic. By 1911 he had abandoned Fauvism in favour of Cubism. However, by the end of 1912, in part due to the opposition facing his *Nude Descending a Staircase No. 2* (1912), he had abandoned Cubism to avoid any indoctrination or systemization. Despite this, he was one of only ten painters included in **Guillaume Apollinaire**'s (1880–1918) influential *Les peintres cubists* (1913). Looking back, Duchamp thought of Cubism as a school of painting whereas both **Dada** and **Surrealism**, the two movements with which he would later become most associated, were more inclusive when it came to other artistic genres. Most importantly, he came to consider Cubism as mere **retinal** art, unlike Dada and Surrealism. Although the objects depicted appeared fragmented or as seen from many viewpoints, the style remained steeped in a wholly visual approach, even in its abstracted forms. Duchamp's brief writings on Georges Braques (1882–1963), Juan Gris (1887–1927) and

Pablo Picasso (1881–1973) for the **Société Anonyme**'s collection in 194? are careful not to pass any judgment on the movement the painters helped found (**judging**), and he often praised the Cubists' bible, *Du cubisme* (1912), by Albert Gleizes (1881–1953) and Jean Metzinger (1883–1956). However, he was quick to disassociate himself from Cubism as he did with every school that intruded too much upon his own thinking or was eager to win him over. 'Cubists were still old-fashioned painters who spent their days painting and had no idea what was going on around them', he later remarked, 'just plain toiling every day'. Whereas the **Futurists** were men of the world, they knew what was going on.'[60]

CURATING

Following on from Pontus Hultén (1924–2006), Harald Szeemann (1933–2005) and Ulf Linde (b. 1929), some of the most established international curators and museum directors today – among them Daniel Birnbaum (b. 1963), Chris Dercon (b. 1958), Elena Filipovic (b. 1972), Massimiliano Gioni (b. 1973) Udo Kittelmann (b. 1958), Hans Ulrich Obrist (b. 1968) and Ali Subotnick (b. 1972) – also draw inspiration from Duchamp with regard to their curatorial practice. For the 1938 *Exposition Internationale du Surréalisme* held at the Galerie Beaux-Arts in Paris, one of the many interventions staged by Duchamp

involved him suspending 1,200 empty coal sacks from the ceiling, thus creating a key Surrealist display and redefining the role of the curator. At the entrance, visitors were given torches to point at artworks as they walked through the darkened rooms, while German army parade marches could be heard through loudspeakers.

Whenever he had the chance, Duchamp experimented with display features and involved a variety of senses to subtly undermine the perceived self-importance of the works exhibited. To achieve this, he took inspiration from areas far removed from art, like trade show fairs, fairgrounds or scientific modes of presentation. In 1942 in New York, for the *First Papers of Surrealism* exhibition, Duchamp used about a mile of string to create a huge cobweb through which visitors had to find their way. At the opening, he brought together a group of children who played all evening without paying any attention to their surroundings. Many decades earlier, for the *First Exhibition of the Society of Independent Artists* at New York's Grand Central Palace in 1917, he proposed the hanging and placement of over 2,100 paintings and sculptures in alphabetical order. 'No jury – no prizes – no commercial tricks'[61] was the show's motto and Duchamp had found a radical way to translate the organizer's creed into the task of the curator.

Whether as co-founder of the **Société Anonyme** or by suggesting themes and shows like *Exhibition by 31 Women* to **Peggy Guggenheim**'s (1898–1979) Art of This Century space in 1942, Duchamp played an authoritative role in dozens of international gallery, museum and independent art exhibitions, especially during the phase of late **Surrealism**. Moreover, he devised shop window displays advertising his own books or those of friends and site-specific ephemeral artworks for temporary displays. From making a **door** for **André Breton**'s (1896–1966) Gradiva gallery to designing posters, flyers and catalogues, Duchamp's ceaseless and wide-ranging activities in the field of curating are astonishing for an artist who declared that he had stopped creating altogether. As for his own works, he more often than not declined to exhibit them in group shows, while his *Box-in-a-Valise* (1941) containing intricate miniature replicas of much of his oeuvre may be considered a small museum curated by the artist alone.

D

DADA [above]

Dada was founded in Zurich in 1916 during the First World War and spread quickly to cities such as Berlin, Hanover, Cologne, New York and eventually Paris. Radically pacifist, Dada's numerous manifestos embrace the illogical, the nihilistic and the nonsensical, 'the extraordinary and the absurd'.[1] Dada's playfulness transcended boundaries between artistic genres and defied any attempts at categorization. To Duchamp, who curated a seminal show on the movement in 1953, Dada 'was an integral part of the postwar European expression of disgust and revolt.'[2] He adopted the uncompromising, nonconformist elements of Dada, adding his own sense of **irony** and **humour** to what he thought of as a spirit that had already gained ground in previous centuries rather than a movement of a certain time and place. In New York, Duchamp, Alfred Stieglitz (1864–1946), **Francis Picabia** (1879–1953) and **Man Ray** (1890–1976) championed Dada in magazines such as *291*, *391* and *The Blind Man*, with Duchamp and Man Ray publishing the only number of *New York Dada* in 1921. Duchamp even proposed producing the four letters of DADA 'separately and then linked together by a little chain',[3] in metal, silver, gold and platinum editions, as good-**luck** charms to be 'worn around the neck, as cufflinks or a tie-pin'.[4] The playing field of Dada eventually provided the breeding ground for **Surrealism**, Dada's grown-up, intellectual next of kin.

SALVADOR DALÍ

Surprisingly, Salvador Dalí (1904–89) and Duchamp got along splendidly, although their wives – **Teeny** (1906–95) and Gala (1894–1982) – did not. Who would have thought that the Catalonian painter, a self-declared **genius**, would hit it off with a calm, comparatively quiet, intellectual Norman artist almost two decades his senior? Although like many **Surrealists** Duchamp reprimanded the Spaniard for being too interested in money, the two maintained a decades-long friendship, with Dalí toning down his ego and Duchamp on the verge of being reverent. Just like 'two minds on a single wavelength',[5] they had many mutual interests besides the arts, including **science**, **mathematics**, **Leonardo da Vinci** (1452–1519), metaphysics, **chess** and **eroticism**. Both artists employed peepholes in their work: Duchamp in *Étant donnés* (1946–66) to allow the viewer to glance through a massive wooden **door** giving way to a landscape and a spread-eagled naked female torso; and Dalí in his painting *Illuminated Pleasures* (1929), as well as in his own museum in Figueres, where a small opening reveals a lit-up green landscape complete with flamingos and a woman lying in bed. In his few writings on Duchamp, Dalí likens the artist to an 'aristocrat',[6] even a 'king',[7] while a monumental painting of his from 1965 depicts *Nude Descending a Staircase No. 2* (1912) as well as Duchamp disguised

as the Sun King Louis XIV. At that time, Dalí may have felt somewhat indebted to Duchamp. In 1960, despite strong opposition from **André Breton** (1896–66) and many others, Duchamp had included a major painting by Dalí, *Madonna* (1958), in a New York Surrealist show – a movement from which Dalí had been expelled some twenty years earlier for embracing fascism, Catholicism and riches.

DEALER

The Romanian artist Radu Varia (b. 1940) gently criticized Duchamp for his statement that 'art had no more meaning', while 'he was to earn a living by selling [Constantin] Brâncuşi's [1876–1957] works!'.[8] It is true that Duchamp, together with his friend **Henri-Pierre Roché** (1879–1959), bought and sold about thirty works by the 20th century's most important sculptor. The purchasers made a good investment in the long term as sculptures sold for much less than a thousand dollars in the 1930s, but seventy years later one of them hit a record high of almost forty million dollars. The eighty works Duchamp bought from **Francis Picabia** (1879–1953) also increased in value. 'This commercial aspect of my life made me a living',[9] the artist admitted. While Duchamp sold many of his own as well as friends' works through numerous dealers, he did not hide his aversion to the business itself. 'I have no respect for

the profession of dealer',[10] he once said. 'There are good dealers and there are bad dealers, like everything else. It's a very curious form of parasitism; instead of being a bother it's an enhancer.'[11] Duchamp detested anything that reeked of 'the good old mighty dollar'[12] and advised all artists to steer clear of money, at least those who did not wish to be seen as businessmen (**art market, commercialism, galleries**).

DEATH

Two years before he passed away, when asked about whether he thought about death, he answered 'As little as possible.'[13] As a non-believer, he was 'simply impressed by the fact that you're going to completely disappear.'[14] On the evening of 1 October 1968, at his studio apartment in Neuilly-sur-Seine, an affluent suburb west of Paris, Duchamp and his wife **Teeny** (1906–95) enjoyed dinner with Juliet (1912–91) and **Man Ray** (1890–1976) as well as Nina (1903–98) and **Robert Lebel** (1901–86). His guests left around 11.30 p.m. Of good humour and appetite – according to Juliet, 'pheasant and lots of red wine' were served[15] – and after reading a few pages by one of his favourite poets, Alphonse Allais (1854–1905), Teeny found her husband, fully dressed, on the floor of the bathroom that he had entered shortly before to get ready for bed. His death certificate states a 'massive embolism' as the cause

of his passing, with which earlier operations on his prostate and appendix in the 1950s apparently had no connection.[16] To his friend **Hans Richter** (1888–1976) Duchamp had once remarked: 'Death does not exist. You live with and through your consciousness. When you have no consciousness, you are just not there. That's all.'[17] For the acceptance of an artist's work, he believed that being alive could even be a hindrance: 'Death is an indispensable attribute of a great artist. His voice, his appearance, his personality – in short, his whole aura – intrudes such that his pictures are overshadowed. Not until all these factors have been silenced, can his work be known for its own greatness.'[18] Somehow, it worked out differently for Duchamp, whose aura and work still loom large, as the former never overshadowed the latter.

Among Duchamp's posthumously published **notes** we twice find the half sentence 'and besides it is always the others who die',[19] jotted down in French between other **puns** and thoughts on yellow sheets of legal paper under the heading 'epitaph'. At Rouen's Cimitière Monumentale, 'D'ailleurs c'est toujours les autres qui meurent' is what his family plot's gravestone reads above his name. The humorous presumptuousness of the epitaph, the hyperbole of believing that instead of yourself it is everything else that ceases to be at the very moment that you pass away, may well be read as a final tribute to **Max Stirner**'s

(1806–56) individualistic philosophy, which Duchamp held in high esteem.

DELAY

With Duchamp, delay was not due to procrastination but rather a concept in itself. Looking at his life, delay seems to have played a major role. Only from his late sixties onwards did long-term recognition for his achievements and admiration among younger artists begin, and at this time too he embarked on his lasting marriage and had his first retrospective. Also, the artist often expressed the insignificance of the contemporary audience as he felt that **posterity** would decide on an artist's true status and importance. There is a **note** in Duchamp's *Green Box* (1934) (**boxes**) in which he suggests 'Delay in Glass' as a 'Kind of Subtitle' for his *Large Glass* (1915–23): 'Use "delay" instead of picture or painting; picture on glass becomes delay in glass – but delay in glass does not mean picture on glass. It's merely a way of succeeding in no longer thinking that the thing in question is a picture … a delay in glass as you would say a poem in prose or a spittoon in silver.'[20] To Duchamp the word itself had a 'non-physical sense, it is a poetic association'.[21] The French word for delay, 'retard', is close to the musical term 'ritardando' (**music**), meaning a gradual slowing down of the tempo. Speaking out against **quick art**, the conscious act of delay may have manifested

itself in Duchamp letting go of certain things before they were considered finished. 'This is not a time in which to complete anything', Anaïs Nin (1903–77) remembers him telling her in 1934, 'this is a time for fragments'.[22] After all, he signed his *Large Glass* 'inachevé', or incomplete. There is a Romantic aspect to the fragmentary. Duchamp might have also had in mind what Friedrich Nietzsche (1844–1900), whose work he read (**philosophy**), meant when he said that in order to set off lightning one has first to be a cloud for a long time.[23]

DOORS [opposite]

Long before Aldous Huxley (1894–1963) published his book *The Doors of Perception* (1954) and a 1960s rock band based their name on its title (**drugs**) Duchamp was interested in the subject. In 1927, he devised *Door: 11, rue Larrey* for his tiny Paris apartment, a door hinged between the studio and the bedroom, which, to his pleasure, solved the old paradox of a door that could not be open and closed at the same time. He also designed the entrance for **André Breton**'s (1896–1966) short-lived Paris gallery Gradiva and once affixed a metal spoon to a door lock in the New York apartment in which **Max Ernst** (1881–1976) had previously lived. In 1968, about six months before he died, he produced a promotional leaflet for a contemporary art show on the theme of doors for a

gallery in Manhattan. Duchamp created many doors and passageways during his career, yet the most famous one, through whose peepholes we glimpse the interior of *Étant donnés* (1946–66), may not constitute a door at all. The wooden planks put together from a massive Spanish gate contain no hinges, keyhole, handle, knob or door lock, and there is no way to open the construction. Nothing with Duchamp is ever as simple as it first appears.

DOUBT

While Duchamp came to oppose the limitations of the overwhelmingly rational and logical **philosophy** of René Descartes (1596–1650), the artist nevertheless referred to his own 'Cartesian mind' that 'refused to accept anything, doubted everything'.[24] His perpetual questioning of himself and his work laid the foundation for Duchamp as a game-changer, iconoclast and inventor. 'It may be a great work of his to have brought doubt into the air that surrounds art',[25] the artist Jasper Johns (b. 1930) remarked about Duchamp. In fact, what Johns observed about artistic practice also holds true for the larger picture, as Duchamp himself made clear: 'If one is logical, one doubts the history of art'[26] (**art history**).

KATHERINE S. DREIER

Following their introduction in 1916, Katherine Sophie Dreier (1877–1952) and Marcel Duchamp remained close, lifelong friends. An artist, collector, early feminist, art critic and most of all a patron of the avant-garde, Dreier, the daughter of prosperous German immigrants, enjoyed an independently wealthy lifestyle. Together with **Man Ray** (1890–1976) and Duchamp she founded the **Société Anonyme** in New York in 1920, and purchased dozens of works by her protégé, among them *Three Standard Stoppages* (1913–14), the **Large Glass** (1915–23), *Tu m'* (1918) and *Rotary Glass Plates* (1920) (**optics**). While it is not mentioned in Duchamp's catalogue raisonné, sometime between the mid-1930s and the late 1940s the artist painted the left side of the lift installed next to the staircase in the entrance foyer of her Connecticut home to match the wallpaper. Dreier remained 'earnest, didactic, unyieldingly proper'[27] amidst the wild modern artists who gathered in New York during the First World War, and continued to cultivate her conservative and traditional demeanour, views and clothing. However, she followed Duchamp's lead in his views on art, making many of his opinions her own ('**The Creative Act**'). In Duchamp scholarship, Dreier is often referred to in a derogatory manner, but the artist held her in high regard, the tone of their written exchanges is cordial and they collaborated on many catalogues, books,

purchases and exhibitions. Within the catalogue for the collection of the Société Anonyme, he praised her paintings' 'delicate balancing of abstract forms and mellow colors' and herself as a member of 'the fortunate generations of painters who, in their prime, witnessed the blossoming of complete freedom in art.'[28]

DRUGS

While Duchamp might have referred to art as 'an outlet toward regions which are not ruled by time and space',[29] he did not take drugs. His friends maintained that **chess** was his only drug. To Duchamp, the danger of art lay in its capacity to become a 'habit-forming' or 'sedative drug'.[30] He was clean otherwise and even made a point of never having smoked opium with **Francis Picabia** (1879–1953) during their Paris heyday in the 1910s.[31] The one occasion on which he took LSD was very late in his life and it was slipped to him without his knowledge. According to his wife **Alexina Sattler** (**Teeny**; 1906–95), it was the only time she had to remove his shoes before he went to bed.[32]

DUST BREEDING

Duchamp, being the painstakingly tinkering do-it-yourselfer that he was, went out of his way to incorporate ephemeral **materials** in his work. *Dust Breeding*

(1920), a photograph by **Man Ray** (1890–1976), shows the back of parts of the lower half of the *Large Glass* (1915–23) while it was still under construction at Duchamp's perpetually messy studio. Looking like a lunar landscape or those giant Peruvian tribal motifs that can only be seen clearly from the air, the tiny picture depicts the dust Duchamp had allowed to accumulate on a glass plate before affixing it to its surface with glue to provide the colour and varnish for the 'seven sieves', a part of the *Large Glass*'s Bachelors' Apparatus. 'To raise dust on Dust-Glasses for 4 months. Six months. Which you close up afterwards hermetically = Transparency',[33] reads one of his many **notes**. Somehow, the photograph's popularity is as strong as it is ongoing. *Dust Breeding* is the name of a 1980s tune by Christian Marclay (b. 1955) and in 2001 the philosopher Jean Baudrillard (1929–2007) used the title for an essay on the emptiness of modern man's sexuality. In the same year, a British production company created an audiotape episode called 'Dust Breeding'. Part of a popular science fiction series, the story revolves around an artists' colony on planet Duchamp 331.

EARLY WORK

Just as a new garage band starts out by experimenting with different styles, paying tribute to and covering their favourite songs before perhaps hitting the big time, so did the young and highly gifted Duchamp try out many schools and isms' when applying oil on canvas (**painting**). He was not accepted at the Académie des Beaux-Arts and thus attended the private Académie Julian in Paris. Before finding his own incomparable style and palette in his early twenties, an endeavour that would culminate in paintings like *Nude Descending a Staircase No. 2* (1912) and the *Bride* (1912), Duchamp's artistic content mostly revolved around his immediate family and environs, the nude in all shapes and forms, living it up in Paris, and the game of **chess**. He also made some money providing cartoons for popular magazines such as *Le Courrier Français, Le Rire* and *Le Témoin.* Duchamp scholars never cease to be amazed by how many important themes and subjects of major later works originated in his early paintings and sketches. There is a charcoal on paper study from 1903–4 depicting a Bec Auer gas lamp that over sixty years later would be held up in the air by the nude in *Étant donnés* (1946–66). There are androgynous men, deliberate distortions (**anatomy**), nudes on a ladder, and humorous cartoons featuring men and women that pre-date the intricate interplay between the sexes as epitomized in the *Large Glass* (1915–23).

EDITION OF 1964–65

In 1964, on the fiftieth anniversary of the creation of the *Bottle Dryer* (1914), Duchamp authorized the Italian art dealer, philosopher and writer **Arturo Schwarz** (b. 1924) to make an edition of eight of a total of fourteen of his readymades. The asking price for an entire set was $25,000. To his friend **John Cage** (1912–92), Duchamp's approval for the edition appeared like 'a rather feeble attempt of a small businessman who tries to act in a businesslike way in a capitalist society.'[1]

Duchamp was not worried by interpretations like these. To him, a **replica** or a copy had the same status as the original, whose uniqueness he aimed to question. In any case, most of the original readymades had been lost by 1964. Moreover, Duchamp knew that in the time of Neo Dada and **Pop Art** his readymades had long forfeited their revolutionary, liberating and iconoclastic status. Their place now was centre stage in the discourse about modern art. **Max Ernst**'s (1881–1976) take on the influx of replicas of the readymades came close to what his friend had in mind: 'I asked myself if it wasn't a new attempt to throw public opinion, to deceive his admirers, to encourage his imitators by his bad example, etc. When I asked him, he answered laughingly: "Yes, it was all of that".'[2] When Duchamp was asked in 1966 whether he had forsaken his 'heroic standpoint, the disdain of commerce' and

'destroyed his myth'[3] by authorizing the reproductions of his works, he answered: 'Ah. Complaining and whining, are they? They ought to be saying "It's atrocious, it's an outrage, a disgrace." It would have suited them nicely to have me shut up in some category or formula. But that's not my style. If they are dissatisfied, *je m'en fous*. One mustn't give a F—. *Et merde*, ha ha.'[4] In his decision to agree to the edition of 1964–65, Duchamp was guided by his twin principles of **indifference** and **contradiction**. However, this does not mean that he did not differentiate. 'If you make an edition of eight ready-mades, like a sculpture … that is not overdoing it. There is something called "multiples", that go up to one hundred and fifty, two hundred copies. Now, there I do object because it is really getting too vulgar in a useless way.'[5]

Many Duchamp scholars, most of all Schwarz, have pointed out the strict visual adherence of the 1964–65 edition of his readymades to the lost originals. All of them were crafted from old photographs of the originals and were approved by Duchamp with his signature on the working drawings as the blueprint for their production. Yet the dissimilarities are striking and not just because the originals were mass-produced objects and the edition was created by craftsmen. For example, when comparing the 1916 version to the 1964–65 edition of the readymade *Comb* (**rendez-vous**) – the only original readymade that had not been lost

– it becomes apparent that the latter is missing two teeth. Is it possible that Duchamp was aware of this, and that he enjoyed the fact? 'Classify combs by the number of their teeth' reads an early **note**, in which 'the space between two teeth as a unit' could be made use of as a 'proportional control'.[6] The replicas and editions of Duchamp's readymades relate to the artist's concept of **infrathin**, as outlined in his posthumously published notes, in the way that they probe the infinitesimal difference between objects that look alike.

LOUIS MICHEL EILSHEMIUS

In a survey of artists from 1919, Duchamp named Louis Eilshemius (1864–1941) as the painter he most admired.[7] Two years earlier, Duchamp had declared the artist's work *Rose-Marie Calling (Supplication)* (1916) to be one of his two favourites among the over 2,100 artworks on display at New York's *First Exhibition of the Society of Independent Artists* (**Fountain**).

Duchamp's patronage and support of the self-taught American painter Eilshemius, with his landscapes and tableaux of mostly nude young women, was not just another prank with which the artist meant to upset those around him. He made possible Eilshemius's first one-person show at the **Société Anonyme** in New York and was eager to exhibit his work in Europe. Duchamp wrote enthusiastically about him two years after his

death, thinking it a 'tragedy' that he 'never was able to convince his fellow citizens that his paintings were the expression of a subtle America ... devoid of the teachings of any of the art schools of the moment. He was a true individualist, as artists of our time should be, who never joined any group.'[8] Duchamp may have had his own motivation for offering such kind words to a painter who was almost a quarter of a century his senior. Indeed, it has not gone unnoticed that the nude in Eilshemius's *Rose-Marie Calling (Supplication)*, with her raised arm and bent knee, bears more than a passing resemblance to the figure in Duchamp's major final work *Étant donnés* (1946–66).

Thanks to Duchamp, Eilshemius was saved from obscurity, with pre-eminent American art critics of the time such as Henry McBride (1867–1962) and Clement Greenberg (1909–94) beginning to recognize the painter, the latter hailing 'the phantasmagorical character' as 'one of the best artists we have ever produced'.[9] Later, artists such as Louise Bourgeois (1911–2010) and Jeff Koons (b. 1955) began to collect his work.

EJACULATE

While art historical reports on the use of sperm for mixing egg tempera colours between the 1st and 15th centuries are considered anecdotal, Duchamp was the first artist on record to unofficially employ this erotically charged material.

He kept quiet about its use in his small work *Paysage Fautif* (1946), or *Faulty Landscape*, which he presented to his lover **Maria Martins** (1894–1973), the sculptor and wife of the Brazilian ambassador to New York. Part of her *Box-in-a-Valise*, *Paysage Fautif* consists of ejaculate on Astralon mounted onto dark velvet (**onanism**). It was identified as such only in 1987, by the FBI laboratories in Houston, Texas, where the work was presented to the public for the first time as part of an exhibition at the nearby Menil Collection. Duchamp's collage pre-dates by more than a quarter of a century Vito Acconci's (b. 1940) masturbating beneath the floorboards of the Sonnabend Gallery, New York, in 1971, and by roughly half a century Takashi Murakami's (b. 1962) *Lonesome Cowboy* (2001) and Dash Snow's (1981–2009) *Fuck the Police* (2007), both of which feature sperm rather prominently.

ELECTRICITY

See **automobiles**, ***Bride***, ***Large Glass***, **love, trains, transformer.**

EPITAPH

See **death.**

MAX ERNST

In his 1945 vignette for the catalogue of the **Société Anonyme**, Duchamp called Max Ernst (1881–1976) 'extremely prolific' and highlighted his major role in **Dada** and **Surrealism**. He also gave him credit for his 'technical discoveries',[10] among them *frottage*, but not without pointing out that this method of rubbing with a drawing tool over paper placed above a textured surface was based on an old Chinese tradition. Duchamp was close to Ernst's first wife, **Peggy Guggenheim** (1898–1979), and it was Ernst's second, the artist Dorothea Tanning (1910–2012), who played the matchmaker between Duchamp and his future wife **Alexina Sattler** (**Teeny**; 1906–95).

Duchamp and Ernst were both exiled in New York during the Second World War and Duchamp once presented his **chess** partner with a tea towel featuring **Leonardo**'s *Mona Lisa* (c. 1503–19) to which he had added a moustache and goatee (***L.H.O.O.Q.***). As a member of the jury (**judging**), Duchamp saw to it that Ernst's painting *The Temptation of St. Anthony* (1946) won first prize in a competition to be featured in a Hollywood movie. When **André Breton** (1896–1966) and Ernst argued about their 'professional indebtedness toward each other', only Duchamp, as Robert Motherwell (1915–91) remembered, could manage to calm them down 'with his detachment, his fairness' and 'his innate sensitivity'.[11]

More recently, art historians have focused on the themes common to Duchamp's and Ernst's work – from Catholicism to questions of identity[12] – yet the two artists' indebtedness to one another, if any, remains as elusive as Ernst's abstract *Hommage à Marcel Duchamp* (1970), a whimsical colour etching and aquatint edition that does not reveal anything, even to the learned eye.

EROTICISM [illustration p. 67]

Duchamp believed that sexuality and eroticism were at 'the basis of everything and no one talks about it'.[13] Eroticism was the subject most dear to his heart and something he took very seriously. When a scholar approached him about why that was the case within a work otherwise defined by **humour**, Duchamp returned the question by asking him whether he 'had ever tried to laugh while making love?'[14] (**fourth dimension**). The ancient Greek playwright Aristophanes (*c.* 446–*c.* 386 BC), with whose writings Duchamp was familiar, emphasized the soul's earnestness within erotic passion, far exceeding mere carnal lust or sex drive.

As someone who named his alter ego **Rrose Sélavy** (*Eros, c'est la vie*, or *Eros is Life*), the place of eroticism within Duchamp's work was, of course, 'enormous. Visible or conspicuous, or, at any rate, underlying'.[15] From his early nudes to his major works, eroticism and desire – most often unfulfilled or solitary

– were fundamental guiding principles for Duchamp's creative production. In addition are the many **puns** and works that border on the pornographic. Although Duchamp did not treat eroticism lightly, it does not mean that a certain sense of amusement was banned from the subject entirely.

EROTIC OBJECTS

'Some bizarre artifacts'[16] is how the media welcomed the peculiar objects Duchamp started exhibiting in the early 1950s. Their erotic content was not lost on the press, which called them 'bronze phallic, male' or 'plaster, triangular, très femelle'.[17] The first description refers to *Objet-Dard* (1951), the second to *Female Fig Leaf* (1950). Together with *Not a Shoe* (1950) and *Wedge of Chastity* (1954), these small sculptures started to appear as bronzes or copper-electroplated plaster casts – with a base made of dental plastic in the case of *Wedge of Chastity*, which was a wedding gift to **Alexina Sattler** (**Teeny**; 1906–95) – as singular items or editions throughout the 1950s and early 1960s.

While it may be argued that every work created by Duchamp is in fact an erotic object, these sculptures, although it was not realized at the time, all turned out to be connected to the artist's posthumously revealed *Étant donnés* (1946–66). Like the half a dozen additional small sculptures first presented in an exhibition

about *Étant donnés* at the **Philadelphia** Museum of Art in 2009, they share the same origin in that they are all moulds, casts or tools that were used in the process of creating the most intimate body parts of the naked female torso in Duchamp's final assemblage.

ERRATUM MUSICAL

During a New Year's visit to Rouen in 1913, the twenty-five-year-old Duchamp cut up seventy-five musical notes, put them into a hat and took turns with his sisters Magdeleine (1898–1979) and Yvonne (b. 1895) to pick them out at random. He thus arrived at a composition whose score was also comprised of the twenty-five syllables of a French dictionary's definition of the word 'imprimer', or 'imprint'. As a visual artist, Duchamp, within a few hours on a single day, introduced chance to music and in the process changed the genre forever.

Another *Erratum Musical* of the same year bears the full title of his **Large Glass** (1915–23). Left incomplete, the randomly determined score involves a piano player, eighty-five numbered balls indicating notes (one ball per piano key), and an elaborate system of small wagons and a funnel. Decades later, when **John Cage** (1912–92) was working on similarly innovative themes and learned of *Erratum Musical*, Duchamp told him that, as with so many other things, he had simply been 'fifty years ahead of my time'.[18]

ESOTERIC

'All that was once esoteric, has become exoteric.'[19] For this, Duchamp blamed the overpowering forces of **commercialism** in the art world, which, within only a hundred years, had turned art into a commodity like 'beans' or 'spaghetti'.[20] The term manages to retain its mystery, however, defying definition: 'Esotericism should not be mental. It should have ritual.'[21]

ÉTANT DONNÉS

Duchamp's major work, *Étant donnés: 1. la chute d'eau / 2. le gaz d'eclairage (Given: 1. The Waterfall / 2. The Illuminating Gas)*, was first revealed to the public at the **Philadelphia** Museum of Art in 1969, about nine months after the artist's death. According to an accompanying installation manual, he had worked on the assemblage in New York between 1946 and 1966. Through two peepholes in a massive wooden **door**, the onlooker views a brick wall with a large opening, behind which the torso of a naked woman lies spreadeagled on autumn branches and leaves. Her shaved genitalia are exposed and she is holding up a shining gas lamp. In the background, there is a forest landscape with clouds made from cotton and a glistening waterfall consisting of layers of transparent glue, lit by a bulb from behind and seemingly set in motion through the trickery of a rotating

motor. According to singer-songwriter Björk (b. 1965), 'this artwork completely changed the 20th century'.[22] It inspired Jeff Koons's (b. 1955) series of *Landscape* paintings of 2007–9 and the work of dozens of internationally renowned artists – from **Andy Warhol** (1928–87) and Hannah Wilke (1940–93) to Robert Gober (b. 1954) and Marcel Dzama (b. 1974) – as well as an abundance of books, academic articles and PhD theses. Many Duchamp scholars regard *Étant donnés* as a shocking and controversial artwork, but not everyone reacted in such a way at the time it was first shown in public. Critic John Canaday (1907–85), writing for the *New York Times*, thought that 'for the first time, this cleverest of 20th century masters looks a bit retardaire' or, in short, 'Very interesting, but nothing new.'[23]

Duchamp used casts of body parts of **Maria Martins** (1894–1973), **Mary Reynolds** (1891–1950) and **Alexina Sattler** (**Teeny**; 1906–95) for the consciously distorted **anatomy** of the torso at the centre of the work. When a treasure trove of photographs taken by Duchamp of *Étant donnés* and kept hidden in a Dom Pérignon champagne box came to public attention in 2009, the revelation was not so much about his monastic existence (Dom Pérignon being the monk credited with inventing champagne) but about the word on the box preceding Dom Pérignon – Cuvée, or 'blend' – a hint that the torso is a composite of parts from different bodies. But are we

looking at a defiled woman, a crime scene, or are at least some onlookers meant to be aroused by this elaborate peep show revolving around the 'lady of desire',[24] as Duchamp once called her? After all, in the late 1920s, he had related to his friend **Julien Levy** (1906–81) his wish to create a 'machine onaniste' and to make 'a life-size articulated dummy, a mechanical woman whose vagina, contrived of meshed springs and ball bearings, would be contractile.'[25]

Is the nude in *Étant donnés* supposed to be dead or alive and, if she is dead, how can she hold up a gas lamp? Or could the *trompe-l'oeil* be meant as an allegory, with the torso of the nude being the 'fallen' bride of the **Large Glass** (1915–23)? The dried up leaves on which the torso rests suggest the 'fall', or autumn, as Duchamp's American artist friend, **William Copley** (1919–96), first pointed out.[26] Although Duchamp left no direct clues about this, he does describe the season in one of his letters: 'Autumn is quite beautiful here but all the same has a funereal air, like all beautiful autumns – something like a funereal relaxation of things.'[27] In his **notes** on the concept of **infrathin**, next to a drawing of a flattened capital M that suggests the initial of his surname as well as a pair of legs spread wide open, Duchamp jotted down 'carcass (pseudo-scientific)'.[28]

Throughout Duchamp's notes and visual works, there are many allusions to **water and gas**, **eroticism** and the **fourth dimension** that may be pertinent when

contemplating *Étant donnés.* In retrospect, even the puzzling **erotic objects** of the early 1950s can be viewed within the context of the work's process of production. As we know from writers as diverse as Ovid (43 BC–AD 17/18) and Charles Baudelaire (1821–67), porn and poetry need not be mutually exclusive, an idea that is clearly demonstrated by *Étant donnés.* The work is surprising in that it breaks with many, if not all, of our preconceived notions of Duchamp. It just might be that this is precisely what he had in mind.

FAMILY

See **children**, **marriage**.

FEAR

As far as we know, Duchamp was afraid of only two things: flying in an aeroplane, according to his artist friend Gianfranco Baruchello (b. 1924), and **hair** – an 'almost morbid horror of hair', as his first wife, **Lydie Fischer Sarazin-Levassor** (1903–88), remembered in her memoirs of their short-lived **marriage**.[1]

FILMS

In 1918, Duchamp made his film debut as an extra, playing a blinded soldier in Léonce Perret's (1880–1935) movie adaptation of *Lafayette! We Come!* Billed as 'a story of mystery and intrigue, flavoured with a throbbing romance of love and war', the movie is set in the First World War and stars Dolores Cassinelli (1888–1984) as the heroine. From the 1920s to the 1950s Duchamp appeared in about half a dozen avant-garde films by **Hans Richter** (1888–1976), René Clair (1898–1981) and Maya Deren (1917–61). In 1966, Duchamp sat for one of **Andy Warhol**'s (1928–87) silent *Screen Tests*. The almost eighty-year-old Duchamp smiles and looks at the camera, puffing away on a cigar, while out of the camera's range Italian supermodel Benedetta Barzini (b. 1943) rubs herself against his knees. At one point, Duchamp, who went to the cinema frequently, thought of becoming a professional cameraman

and together with **Man Ray** (1890–1976) realized an experimental six-minute film, *Anémic Cinéma* (1926). This consists of ten optical disks and nine others inscribed with **puns**, all of which slowly rotate (**optics**). The puns are laden with sexual references, from a spiral-shaped penis to incest and intercourse between the 'marrow of the sword' (*moëlle de l'épée*) and the 'oven of the beloved' (*poêle de l'aimée*) – wordplays that make more sense in the French original, taking into account their intonation and internal rhymes.

Many of the projects that Duchamp contemplated but never realized were ideas for films that appear throughout his posthumously published **notes**, for example: 'continuous mixture of 2 or several films by mixing the photos of one with those of the other'[2]; 'attach the camera to the stomach, and walk in the street (?) turning the handle'[3]; 'electric wires seen / from a moving / train – Make / a film'[4]; 'make a movie of the tuner tuning and synchronize the tunings on a piano.'[5]

FLUTTERING HEARTS

One of the most visually appealing pieces Duchamp ever created was his colour lithograph *Coeurs Volants* (1936), or *Fluttering Hearts*, as part of his optical investigations (**optics**). Three hearts in red and blue, one set within the other, give the illusion of fluttering, or jumping, at their edges due to the contrasting colours. The effect had been known as *coeurs dansants*, or 'dancing hearts', ever since Sir Charles Wheatstone (1801–75) and Sir David Brewster (1781–1868), the inventors of stereoscopy, introduced their findings based on heart-shaped patterns in carpets during a congress in York, UK, in 1844.

Duchamp's hearts first appeared in 1936 on the cover of the magazine *Cahiers d'Art*. Within the journal, Duchamp's former sweetheart, **Gabrielle Buffet-Picabia** (1881–1985), titled her essay about him 'Fluttering Hearts', describing him as a 'benevolent technician', while calling 'any work' of his 'always, even for the best-informed of his friends, a source of surprise and speculation.'[6] *Fluttering Hearts* is also the title of a 1927 Hollywood silent movie, a short comedy about a young woman in distress, featuring Oliver Hardy (1892–1957) and Charley Chase (1893–1940). All ends well, of course, just as Duchamp's own heart never literally fluttered. We know this because, in 1966, the artist Brian O'Doherty (b. 1928) conducted an electrocardiographic study on Duchamp's heart at the New York University Medical Center. O'Doherty's multi-part *Portrait of Marcel Duchamp* includes a celluloid sleeve moving around a central fluorescent light bulb and showing Duchamp's previously recorded heartbeat.

FOOD

Duchamp's penchant for **chocolate** is well known, a substance that, like marzipan, he once incorporated into a work of art, as he did with a photograph of **cheese**. In general, he was a frugal eater, consuming half of what everybody else did, according to **Man Ray** (1890–1976), who once witnessed his friend ordering 'scrambled eggs and apple sauce'.[7] 'Marcel took very little alcohol or food; he would simply eat what was given to him',[8] is how **John Cage** (1912–92) remembered him. While he indulged in all-night drinking binges as a young man, later in life he enjoyed just a little wine and an occasional cold beer or, when on holiday in **Cadaqués**, a glass of Pernod or Manzanilla.

His favourite foods were pastrami and crisp French fries. 'Marcel liked spaghetti and peas', remembers his stepdaughter Jacqueline Matisse Monnier.[9] He was a great lover of milk and enjoyed sweetcorn on the cob, although not the 'gymnastics involved in eating it'.[10] Duchamp raved about Argentinean butter while in **Buenos Aires**, and about **Constantin Brâncuşi**'s 'delicious rabbit sauce', which he prepared for his friends in his Paris studio.[11] For the *Artist's and Writer's Cookbook* (1961), 'dedicated to the art of imperfection in the kitchen', Duchamp contributed the recipe for an elaborate steak tartare, originating with the Siberian Cossacks, which 'can be prepared on horseback, at a swift gallop, if conditions make this a necessity'.[12] Apart from Jean Tinguely (1925–91) and Serge Stauffer (1929–89) separately witnessing the artist enjoying a pickled knuckle of pork, no other idiosyncrasies regarding his eating habits are known.

FOUNTAIN

According to a BBC report in 2004, Duchamp's urinal *Fountain* (1917) was voted by 500 art experts as the most influential artwork of the 20th century, surpassing the accomplishments of Henri Matisse (1869–1954), **Pablo Picasso** (1881–1973) and **Andy Warhol** (1928–87). Unfortunately, the original version of his most iconic **readymade** was lost without ever having been publicly displayed.

To make the work, Duchamp turned a *pissotière* 90 degrees onto its flat back and signed it **R. Mutt** on its outer rim (**graffiti**). He used this pseudonym so as to conceal his authorship when he sent the work to an exhibition of the newly founded Society of Independent Artists in New York in 1917. Despite their motto of 'no jury – no prizes – no commercial tricks',[13] the show's organizers, among them Duchamp himself, rejected the entry, an unsurprising decision but one that nevertheless led to the resignation of Duchamp and other members of the committee. Two years previously, three porcelain urinals had been displayed in the Newark Museum not far from New York. In 1915, its founding director, John

Cotton Dana (1856–1929), had declared that 'the genius and skill which have gone into the adornment and perfecting of familiar household objects should receive the same recognition as do now the genius and skill of painting in oils.'[14] As for *Fountain*, it was referred to as a 'Buddha of the Bathroom'[15] by **Louise Varèse** (née Norton; 1890–1989) shortly after its failed display. Duchamp's close friend **Beatrice Wood** (1893–1998) also defended the choice of object by R. Mutt in the Dada journal *The Blind Man*. She proclaimed that 'the only works of art America has given are her plumbing and her bridges.'[16] With several signed urinals, miniature versions, etchings and an authorized **edition of 1964–65** based on the only surviving photographs, taken by Alfred Stieglitz (1864–1946) in 1917, Duchamp made up for the lost original and paved the way for a shiny white porcelain bathroom fixture to be revered worldwide. Re-cast or re-photographed by Elaine Sturtevant (b. 1930) and Sherrie Levine (b. 1947), painted and drawn by Richard Pettibone (b. 1938) and Mike Bidlo (b. 1953), appropriated by artists from Claes Oldenburg (b. 1929) and Bruce Nauman (b. 1941) to Robert Gober (b. 1954) and Shi Xinning (b. 1969), Duchamp's *Fountain* has held onto its place at the centre of the contemporary art world.

FOURTH DIMENSION [opposite]

Early on in his career, Duchamp made it clear that he was not interested in mere **retinal art**. Instead he wanted to engage the **grey matter** of the onlooker, putting the brain before the eyes and thought processes before the pleasures of the purely visual. In this context, eroticism plays a crucial part. 'I want to grasp things with the mind the way the penis is grasped by the vagina',[17] Duchamp once remarked. In letters to Serge Stauffer (1929–89) dating from the late 1950s and early 1960s, the artist compares the act of love to a 'four dimensional situation par excellence'.[18] Of all the senses, only the sense of touch as a crucial part of lovemaking could possibly provide a rare glimpse, or at the most a physical interpretation, of the fourth dimension. This from an artist who maintained that a three-dimensional object related to the fourth dimension in the same way that the **shadows** of his **readymades** related to the objects themselves: 'Any three-dimensional object, which we see dispassionately, is a projection of something four-dimensional, something we're not familiar with.'[19]

Duchamp was often occupied by thoughts about the fourth dimension because he was interested in things that were not obvious at first glance. The concept appears frequently in his **notes**, especially in those dealing with **perspective** and incorporating ideas on groundbreaking achievements in **mathematics** and **science**. Both of his

major pieces, the *Large Glass* (1915–23) and *Étant donnés* (1946–66), are attempts at presenting four-dimensional regions 'not ruled by time and space'.[20] The works of philosophers such as Henri Bergson (1859–1941) and mathematicians like **Henri Poincaré** (1854–1912) were widely read in Duchamp's circle and were essential to the nascent **Cubism** eager to move away from objective representations of the outside world and to focus instead on rendering subjective multi-sensual experiences simultaneously.

BARONESS ELSA VON FREYTAG-LORINGHOVEN

Over sixty years before Louise Bourgeois (1911–2010) mischievously smiled at Robert Mapplethorpe (1946–89) for his famous 1982 photograph of her holding *La Fillette* (1968), her sculpture of an enormous, erect phallus, it was the self-styled baroness and penniless Dada artist Elsa von Freytag-Loringhoven (1874–1927) who wiggled a plaster cast of a penis at many of those who ventured into her Greenwich Village apartment. Eccentric in both her appearance and her art, she fell madly in love with Duchamp: 'Marcel, Marcel, I love you like hell, Marcel',[21] and 'Marcel is the man I want.'[22] Duchamp collaborated with her (**hair**) and published her poetry and portrait in the only issue of *New York Dada* in 1921. He may have been drawn to her free spirit as well as to her androgynous

appearance (**Rrose Sélavy**) and must have felt at home in her run-down living quarters cluttered with assemblages of found objects (**readymades**) – yet, to her great dismay and frustration, he never returned her feelings for him.

FUTURISM [opposite]

'I was never a Futurist',[23] Duchamp exclaimed in 1961, and while this is certainly true, early on in his career he may have been indebted to the Futurists' writings as well as to the originality of their paintings. Later on, it became important for Duchamp to differentiate between his idea of movement expressed in the painting **Nude Descending a Staircase No. 2** (1912), which was inspired by cinematography and chronophotography, and the Futurists' fascination with speed and simultaneity.

Yet the Futurist Manifesto of 1909, published by Filippo Tommaso Marinetti (1876–1944) in the pages of the French daily *Le Figaro*, encouraged or at least shared Duchamp's attraction to machines, technology, industrial products and **automobiles**. Duchamp claimed he had had no knowledge of the Futurists this early on and in any case would have disapproved of the fascist tendencies (**politics**) within the movement. Futurism was of Italian origin and **Cubism** ruled supreme in France, which may be another reason why Duchamp once called his paintings of the early 1910s 'a Cubist interpretation

of a Futurist formula'.[24] While he praised leading Futurist painter and sculptor Umberto Boccioni (1882–1916), Duchamp also expressed his apprehension towards any artistic school: 'But since movements in art remain only as vague as labels representing a period, the artist continues to live through his work. Thus Boccioni will be remembered, not so much as a Futurist but as an important artist.'[25]

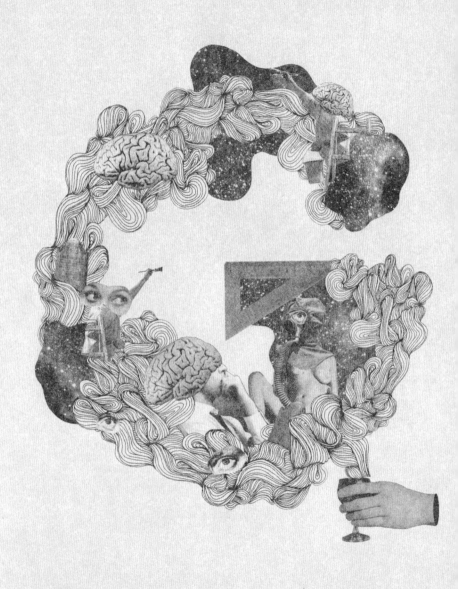

GALLERIES

Biographer Alice Goldfarb Marquis (1930–2009) relates the story of an interviewer who asked the famous New York art **dealer** Leo Castelli (1907–99) what 'his criterion for selecting artists to show in his gallery was', to which he answered 'quite simply, "Marcel Duchamp".'[1] Duchamp, however, unusually *non*-nonchalant, lashed out against the profession: 'So many artists, so many dealers and collectors and critics who are just lice on the back of the artists.'[2] The peculiar profession of the art advisor was not included here, probably for the sole reason of having achieved its present level of notoriety only after Duchamp had passed away.

GENIUS

Although close to those such as **Salvador Dalí** (1904–89), Duchamp did not believe in self-declared geniuses ('**The Creative Act**'). In Duchamp's opinion, one first needed to be dead to be hailed a genius, so young artists would have to 'decide whether you want to make a living or be a genius'.[3] In two **interviews** with Otto Hahn, he expanded on this idea. 'If genius succeeds too quickly, it is finished. There are fifty geniuses today, but almost all of them are going to throw their genius in the dustbin. In order for a fellow to go through life without letting himself be devoured, he must pass plenty of traps. Geniuses are two a penny, but they are swallowed up, commit suicide or are transformed into show-offs on the boards. But all that is but an illusion, a reflection.

Let's be content with the beauty of the mirage, since that's all there is.'[4] Two years later he added: 'Painters think everything's fine, because they've got a "one-man-show." They can't see the trap that's been laid for them. As I told you once before, there are heaps of geniuses. There are 50 or 100 around at the moment. The difficulty lies in hanging on to it. Refusing to become a "fashion". The public ruins everything. It kids the artist that he's made it, then gets bored and drops him.'[5] When speaking to Calvin Tomkins (b. 1925) at around the same time, the number of geniuses grew a hundredfold but the warning stayed the same: if an artist 'is spoiled or contaminated by the sea of money around him, his genius will completely melt and become zero. There may be ten thousand geniuses today but they will never become geniuses, unless they have **luck** and very great determination.'[6]

GOD

While many scholars discuss the allusions to Catholicism in Duchamp's work, which are not necessarily unusual for an artist coming of age at the turn of the 20th century in rural France, others see his blasphemous imagery, **notes** and **puns** as a revolt against the constraints of his upbringing. Duchamp's statements on the subject are ambiguous. He did not always say that he did not believe in God but, as with religion, he thought of

Him as 'man made'[7] and 'a human invention',[8] based on rational norms as well as a belief in cause and effect. 'All these religious concepts that come out of **causality** – the idea of God being the first one to do everything is another illusion of causality',[9] Duchamp said in 1964. Despite this, he often rejected the description 'atheist': 'In terms of "popular metaphysics," I refuse to get involved in arguments on the existence of God – which means that the term "atheist" (as opposed to the word "believer") is of no interest to me at all, no more than the word believer or the opposition of their very clear meanings.'[10] Even so, in a 1959 **interview** he likened the condition of being 'stripped bare',[11] a phrase taken from the title of the *Large Glass* (1915–23), to that of Christ on the Cross. To Duchamp, though, there was no truth; it simply did not exist, either in religion or in art. 'All this twaddle, existence of God, atheism, determinism, free will, societies, **death**, etc. are the pieces of a game of **chess** called language and are only entertaining if one is not concerned about "winning or losing this chess match".'[12] As early as 1960, he recognized that art had replaced religion when it came to the search for 'spiritual values', something that made it all the more important 'to oppose this materialistic state of affairs'[13] around him.

GRAFFITI

There is a convincing case for suggesting that Duchamp introduced graffiti to the fine arts. In January 1916, he reminded himself to find an 'inscription for the Woolworth Building',[14] the highest skyscraper in the world at the time, thereby identifying the structure as a **readymade**. With two other readymades, *Fountain* (1917) and *L.H.O.O.Q.* (1919), Duchamp employed a graffiti-like technique by scribbling the pseudonym **R. Mutt** on the urinal and drawing a goatee and moustache on a reproduction of the *Mona Lisa* (*c.* 1503–19). While at a New York restaurant with **Walter Arensberg** (1878–1954) and some friends around 1916, he signed a monumental old painting at the Café des Artistes on the Upper West Side. This was over half a century before United Graffiti Artists was founded in the same city and three generations before street and graffiti artists such as Banksy (b. 1974) became of interest to the art world. While graffiti is known from Egyptian times and the first bathroom scribbles date back to ancient Greece, a small and little-known photographic collage by Duchamp, now in the collection of the Guggenheim Museum, New York, presents pornographic toilet graffiti as part of an artwork for the first time. Its title, *Nous Nous Cajolions* (*c.* 1925), is a French **pun** that refers both to a woman with a baby standing in front of a lion's cage and to the act of intimately caressing one another.

If graffiti is defined as illicit text or drawing on any public surface, an unrealized and mischievous project described in Duchamp's posthumous notes also qualifies: 'Make an instrument which, placed under the floor, lets appear, when one spits on the ground, in illuminated letters: "Spitting prohibited," or "I love you" – naturally this apparatus would only be sensitive to spit.'[15]

GRAPHIC DESIGN [illustration p. 84]

The renowned New York graphic designer Milton Glaser (b. 1929) based his famous Bob Dylan (b. 1941) poster of 1966 on Duchamp's *Self-Portrait in Profile* (1958). He also regarded the artist's 1953 typographical poster for **Sidney Janis's** (1896–1989) *New York Dada* exhibition as a source of inspiration to graphic designers generally. It is not surprising to see Duchamp's influence in this area of creative activity. He paid meticulous attention to designing his own editions of **boxes**, posters and books as well as dozens of catalogues, announcements, invitations, flyers and publications for his friends or for the **Surrealist** and **Dada** movements. As the American art director and graphic design critic Steven Heller (b. 1950) noted, Duchamp is credited not only for what he has done but also for what he chose not to do: 'Marcel Duchamp's magazines, *Rongwrong*, *The Blind Man* and *New York Dada*, prefigured the underground press

punk and fanzine cultures that emerged in the US. Since these publications were "un-designed," they gave credence to the idea of anti-design. What Duchamp hath wrought, many in my generation continued.'[16]

GREY MATTER

A vague but important concept in Duchamp's thinking, grey matter is most often referred to in opposition to the **retinal**, or mere visual art. He likened it to 'our urge for understanding'[17] outside the picture plane, engaging the mind instead of solely dabbling in questions of aesthetics. Therefore, the **readymade** is 'completely grey matter',[18] as its true significance can be grasped only beyond its visible manifestation. As for 20th-century art movements, 'only the Surrealists have reintroduced the "grey matter" quality in painting.'[19] Moreover, and as always with Duchamp, there was **chess**, with its 'extremely beautiful things in the domain of the movement or of the gesture that makes the beauty, in this case. It's completely in one's grey matter.'[20]

PEGGY GUGGENHEIM

Although he was 'a handsome Norman and looked like a crusader', and 'every woman in Paris wanted to sleep with him',[21] sometime one evening in the late 1920s Peggy Guggenheim (1898–1979)

and Marcel Duchamp ended up *not* hooking up in the French capital as they 'wandered around all night longing to go to bed together'.[22] According to the art collector, they did not 'consider it an appropriate moment to add to the general confusion'.[23] In her memoirs, Duchamp gets full credit for many things, including introducing the wealthy socialite to modern art and artists, and helping to jump-start her collection as well as her New York gallery space Art of This Century in 1942, for which he proposed shows such as a 1943 exhibition of the work of thirty-one women painters. There was a longstanding rumour that Duchamp once suggested cutting about 20 cm (8 in.) off a mural by Jackson Pollock (1912–56) so that it would fit into Guggenheim's East Side townhouse.[24] 'Delightful to see Peggy without premeditation',[25] he wrote in the guest book of her Venetian Canal Grande palazzo on 6 May 1966, the building that fourteen years later became a museum for her amazing collection of artworks, among them Duchamp's *Sad Young Man on a Train* (1911).

HAIR [illustration p. 88]

Hair – its presence and absence – features throughout Duchamp's oeuvre and life. In 1920, **Man Ray** (1890–1976) and his friend Duchamp shot a movie – destroyed in the developing process – of Man Ray shaving the pubic hair of a nude model. Around the same time, the eccentric and impoverished Dada artist **Elsa von Freytag-Loringhoven** (1874–1927) starred in a **film** by Man Ray and Duchamp, descriptively titled *The Baroness Shaves Her Pubic Hair*, now lost as well. Seven years later, Duchamp asked his first wife, **Lydie Fischer Sarazin-Levassor** (1903–88), to remove all of her body hair. Duchamp donned a wig as **Rrose Sélavy**; posed with his hair shampooed for *Monte Carlo Bond* (1924); shaved his pubic hair as part of a ballet by **Francis Picabia** (1879–1953) and Eric Satie (1866–1925); and shaved his head entirely or with a tonsure of a five-pointed star on the back of his head (1919 or 1921). For a collage presented to the painter Roberto Matta Echaurren (1911–2002), he taped head, armpit and pubic hair onto paper mounted on cardboard. Famously, for *L.H.O.O.Q.* (1919) he added a moustache and goatee to a reproduction of the *Mona Lisa* (*c.* 1503–19). When, in 1965, he attached unaltered postcards of **Leonardo**'s (1452–1519) renowned sitter to signed dinner invitations for a New York exhibition of his, the caption underneath simply read 'rasée L.H.O.O.Q.'. For the exposed torso in *Étant donnés* (1946–66), Duchamp opted for a hairless pudendum. Incidentally, Duchamp changed the colour of the hair undulating from the mannequin's hidden

head onto her left shoulder from dark brown to blond, in homage to his light-haired wife **Alexina Sattler** (**Teeny**; 1906–95) who had replaced his brunette lover **Maria Martins** (1894–1973) as a model for the assemblage.

RICHARD HAMILTON

In the mid-1950s, the British **Pop Art** pioneer Richard Hamilton (1922–2011) began to correspond with Marcel Duchamp, whom he later befriended. It is thanks to him that, beginning in 1960, Duchamp's **notes**, particularly those of the *Green Box* (**boxes**), became widely available in English, in a typographic version that it took Hamilton over three years to complete. Duchamp let him know that his 'labour of love' had created a book that he and his wife **Teeny** (1906–95) were 'crazy about'.[1] We also owe a great **interview** with the artist to Hamilton, who completed a full-scale **replica** of the *Large Glass* (1915–23) in 1965, after Ulf Linde's (b. 1929) famous version of 1963, both of them signed by Duchamp. Hamilton and the artist collaborated frequently, and the former organized the first major European retrospective of 242 of Duchamp's works at London's Tate Gallery in 1966. His introduction for the accompanying catalogue begins with the statement: 'No living artist commands a higher regard among the younger generation than Marcel Duchamp.'[2] In another text, on the *Large Glass*, Hamilton

comments that with his 'incomparable mind', Duchamp 'saw through every sham, subjecting his own talent to no less fierce a distrust. This aggressive humility (it might be mistaken for arrogance) nourished the little inventor.'[3] Duchamp, 'remote and alone', thought of 'detachment as the greatest human virtue'.[4]

HATE

'What's the use of hating? You're just using up your energy and die sooner.'[5]

HERNE BAY

In August 1913, Duchamp accompanied his sister Yvonne (b. 1895) to Herne Bay in Kent, south-east England, then a small seaside town of about ten thousand residents. It appears that a few of the most important **notes** and sketches referring to the *Large Glass* (1915–23) were executed there, especially those about the sexual operations of the bride in the upper half of this work. In postcards and letters to his friends and family, Duchamp raves about the beautiful weather and countryside, and seems in very good spirits, one reason being the sale of his *Nude Descending a Staircase No. 2* (1912) and three more of his paintings at New York's **Armory Show** for almost $1,000 earlier that year. However, what held Duchamp's attention most was the newly installed Grand Pavilion, which

was lit up at night and was situated on Herne Bay's long pier, stretching out into the North Sea for about 1,200 m (almost 4,000 ft). A scrap of paper illustrating the illuminated pavilion was found attached to one of Duchamp's notes, within which he poetically imagines for his *Large Glass* 'as background, perhaps: An electric fête recalling the decorative lighting of Magic city or Luna Park or the Pier Pavilion at Herne Bay – garlands of lights against a black background or a background of the sea.' The note also stipulates that the 'final picture' is to be 'executed on two large sheets of glass about 1 m. 30 x 1,40, one above the other'. Therefore, Herne Bay can take the credit for inspiring Duchamp's decision to realize one of the most enigmatic artworks of the 20th century on glass rather than on canvas.

HUMOUR [opposite]

Humour is essential to understanding the work and life of Duchamp. The worlds of fairs and amusement parks are just as important for the machinery of his 'hilarious picture',[7] the *Large Glass* (1915–23), as they are for the **ready-mades** or his many **notes**, which would otherwise come across as rather dry and learned. 'Humor and laughter – not necessarily derogatory derision – are my pet tools', Duchamp said to Katherine Kuh (1904–94) in 1961. 'This may come from my general **philosophy** of never taking the world too seriously – for fear of dying

of **boredom**.'[8] Most writing on Duchamp introduces humour as an afterthought, at best paying lip service to what was for him a 'great power' and 'liberation'.[9] Even **Robert Lebel** (1901–86), in his brilliant first biography on the artist of 1958, rushes in a small chapter on it at the very end. Humour, by definition, escapes the seriousness of scholarly scrutiny, yet it is through humour that Duchamp questions its very *raison d'être*. 'Nothing is serious enough to take seriously',[10] Duchamp once quipped, besides perhaps **eroticism**. Humour was indispensable 'because the serious is something very dangerous'.[11] His humour, then, is not a joke, it is not of the laughing aloud or knee-slapping varieties, but subtle, *With My Tongue in My Cheek*, as he called a 1959 self-portrait. Duchamp said that humour was to be considered an 'absolute condition'[12] within his work and life. It is both sophisticated and subversive in that the artist consciously implements it to protect his works from the traps of self-importance and prestige. To **Gabrielle Buffet-Picabia** (1881–1985), 'Duchamp's humor is one of merry blasphemy.'[13] To his first wife, **Lydie Sarazin-Levassor** (1903–88), it was 'crude, vulgar and not worthy of his intelligence'.[14] It is also charming, elaborate and fresh – accessible and good-natured rather than indebted to the **Surrealist** variety of *l'humor noir*. As with his **puns**, Duchamp's humour does not translate visually and is therefore another means by which he frees himself from the dogma of the purely **retinal**.

ICONOCLASM

'A painting which doesn't shock isn't worth painting'[1] stated Duchamp, although he later felt this was 'a little rash'.[2] However, he accepted being referred to as an iconoclast and often reminisced about the fun that went with it, the nonconformity of **Dada** and how one had to revolt against the norm before becoming complacent with age. For Duchamp, however, iconoclasm was never just an anarchistic end in itself, just as shock for shock's sake would have been too shallow an undertaking. He did not set out to shock, but certainly came to appreciate such a reaction as an inevitable by-product of his artistic output. When asked in 1966 about whether he was tired of being labelled an iconoclast, his attitude of **indifference** manifested itself yet again: 'Oh no! Because I couldn't care less. The way I live doesn't depend on what others say about me. I don't owe anybody anything and nobody owes me anything.'[3]

INDIFFERENCE

Duchamp's take on indifference was anything but indifferent. One might even say that he was indifferent towards almost anything except his idea of indifference. His **iconoclasm** did not turn him into an anti-artist, nor did his disbelief in God turn him into an atheist. His distrust of family and **marriage** did not necessarily make him an anti-feminist just as his sense of **irony** did not translate into his being ironical. Although he naturally never provided his own definition of

the word, with Duchamp, indifference is an essential term to reckon with and it is not as easy as claiming that he simply did not care. 'Visual indifference'[4] was at the heart of his choice of **readymades**. For Duchamp, in 'the simplest sense of the word', indifference is what 'desire' or 'need' is not, it is about not 'taking sides'.[5] As a strategy, 'the only refutation is indifference';[6] it helps in escaping from **taste** and aesthetics, and from **judging** or categorizing into positive and negative. Yet, in his **notes**, he speaks of 'the beauty of indifference',[7] and also writes that, 'For me there is something other than *yes, no* and *indifferent* – the absence of investigations of this sort, for instance.'[8] Further, as Duchamp explained in his 1957 lecture **'The Creative Act'**, 'what I have in mind is that art may be bad, good or indifferent, but whatever adjective is used, we must call it art'.[9]

INDIVIDUALISM

Duchamp placed great importance on the individual, in which he was ultimately more interested than in any of the art movements with which he was associated but never fully joined. It would be wrong to think, though, that his own aloofness and detachment, his frequent desire to be left alone and his often proclaimed modus operandi of **indifference** meant that he held no beliefs whatsoever. On the contrary, Duchamp embraced the self-centred philosophy of **Max Stirner**

(1806–56) and thus cared deeply about acting on his own beliefs and about the well-being of those close to him. He lived frugally and saw materialism as dangerous to the formation of the individual, in the same way that the art industry posed a threat to the undisturbed search of the artist for himself. To Duchamp, artistic creativity was one of the purest ways for an individual to express him- or herself. As he almost never quoted others, it is noteworthy that T.S. Eliot's (1888–1965) essay 'Tradition and the Individual Talent' (1921) was one exception. Duchamp cites the poet at length in his seminal lecture **'The Creative Act'**, including the following well-known lines: 'The more perfect the artist, the more completely separate in him will be the man who suffers and the mind which creates.'[10]

INFLUENCE

Duchamp's influence can be seen in conceptual, minimal and kinetic art, Op and **Pop Art**, Fluxus and Neo-Dada Happenings, installations and the art of assemblage as well as in the work of the Young British Artists (YBAs), from Damien Hirst (b. 1965) to Tracey Emin (b. 1963) and Sarah Lucas (b. 1962) and the generation that followed. He contributed significantly to **Cubism** and **Dada**, while the **Surrealists** were in awe of him. Duchamp inspired works of **literature**, **philosophy**, **graphic design** performance, theatre, dance, **film** and

music. The two artists, collaborators and close friends who gave him the greatest support by channelling his work through theirs were **Man Ray** (1890–1976) and **Francis Picabia** (1879–1953). From the 1950s onwards, Jasper Johns (b. 1930), **Robert Rauschenberg** (1925–2008) and **Richard Hamilton** (1922–2011) were as hugely inspired by Duchamp as they were instrumental for his revival. Gerhard Richter (b. 1932) painted *Ema (Nude Descending a Staircase No. 2)* in 1966, while two years previously Joseph Beuys's (1921–86) performance, *The Silence of Marcel Duchamp is Overrated,* had been broadcast live on West German television. Nowadays, many artists who make use of the **readymade** do so as if it still retains some of its revolutionary **iconoclasm** from a hundred years ago. The perception of Duchamp as a liberating figure is as welcome as it is strong in contemporary Middle Eastern, Asian, South American, Indian and African art. For better or for worse, the Japanese artist Takeshi Murakami (b. 1962) said that 'our generation of artists is constantly comparing itself to Duchamp',[11] while the British painter Bridget Riley (b. 1931) concedes that Duchamp has had an enormous influence on the art world, but not necessarily the most beneficial. His influence affects collectors, dealers, museum personnel and the culturati in general'.[12] Here are just some of the artists influenced by Duchamp: Vito Acconci (b. 1940), Bill Anastasi (b. 1933), Arman (1928–2005), John Armleder (b. 1948),

Eduardo Arroyo (b. 1937), Richard Artschwager (1923–2013), Michael Asher (1943–2012), John Baldessari (b. 1931), Richard Baquié (1952–96), Matthew Barney (b. 1967), Robert Barry (b. 1936), Gianfranco Baruchello (b. 1924), Mike Bidlo (b. 1953), Sanford Biggers (b. 1970), Guillaume Bijl (b. 1946), Peter Blake (b. 1932), Ecke Bonk (b. 1953), George Brecht (1926–2008), Marcel Broodthaers (1924–76), Chris Burden (b. 1946), Maurizio Cattelan (b. 1960), Vija Celmins (b. 1938), César (1921–98), Christo (b. 1935), Bruce Connor (1933–2008), William Copley (1919–96), Joseph Cornell (1903–72), Martin Creed (b. 1968), Gregory Crewdson (b. 1952), Jim Dine (b. 1935), Mark Dion (b. 1961), Atul Dodiya (b. 1959), Marcel Dzama (b. 1974), Olafur Eliasson (b. 1967), Robert Gober (b. 1954), Hans Haacke (b. 1936), Raymond Hains (1926–2005), Al Hansen (1927–95), David Hammons (b. 1943), Rudolf Herz (b. 1954), Eva Hesse (1936–70), Dick Higgins (1938–98), Thomas Hirschhorn (b. 1957), Damien Hirst (b. 1965), Roni Horn (b. 1955), Richard Jackson (b. 1939), Ray Johnson (1927–95), Donald Judd (1928–94), Ilya Kabakov (b. 1933), Allan Kaprow (1927–2006), Shreyas Karle (b. 1981), Mike Kelley (1954–2012), Edward Kienholz (1927–94), Martin Kippenberger (1953–97), Alison Knowles, (b. 1933) Willem de Kooning (1904–97), Jeff Koons (b. 1955), Joseph Kosuth (b. 1945), Barbara Kruger (b. 1945), Shigeko Kubota (b. 1937), Bertrand Lavier (b. 1949),

Louise Lawler (b. 1947), Les Levine (b. 1935), Sherrie Levine (b. 1947), Roy Lichtenstein (1923–97), Glenn Ligon (b. 1960), Sarah Lucas (b. 1962), Paul McCarthy (b. 1945), George Macunias (1931–78), Sarat Maharaj (b. 1951), Piero Manzoni (1933–63), Christian Marclay (b. 1955), Sophie Matisse (b. 1965), Roberto Matta Echaurren (1911–2002), Mathieu Mercier (b. 1970) Jonathan Monk (b. 1969), Yasumasa Morimura (b. 1951), Robert Morris (b. 1931), Robert Motherwell (1915–91), Bruce Nauman (b. 1941), Olaf Nicolai (b. 1962), Brian O'Doherty (b. 1928), Claes Oldenburg (b. 1929), Yoko Ono (b. 1923), Tony Oursler (b. 1957), Nam June Paik (1932–2006), Grayson Perry (b. 1960), Richard Pettibone (b. 1938), Paul Pfeiffer (b. 1966), Huang Yong Ping (b. 1954), Michelangelo Pistoletto (b. 1933), Sigmar Polke (1941–2010), Richard Prince (b. 1949), André Raffray (1925–2010), Charles Ray (b. 1930), Jean-Pierre Raynaud (b. 1939), Jason Rhoades (1965–2006), Elena del Rivero (b. 1952), James Rosenquist (b. 1933), Edward Ruscha (b. 1937), Carolee Schneemann (b. 1939), George Segal (1924–2000), Andres Serrano (b. 1950), David Shrigley (b. 1968), Kiki Smith (b. 1954), Robert Smithson (1938–73), Daniel Spoerri (b. 1930), Haim Steinbach (b. 1954), Elaine Sturtevant (b. 1930), Mark Tansey (b. 1949), Paul Thek (1933–88), Wayne Thiebaud (b. 1920), André Thomkins (1930–85), Lin Tianmiao (b. 1961), Jean Tinguely (1925–91), Rirkrit Tiravanija (b. 1961), Ben Vautier (b. 1935), T. Venkanna (b. 1980), Francesco Vezzoli (b. 1971), Robert Watts (1923–88), Peter Weibel (b. 1944), Lawrence Weiner (b. 1942), Ai Weiwei (b. 1957), Ji Wenju (b. 1959), Tom Wesselmann (1931–2004), William T. Wiley (b. 1937), Hannah Wilke (1940–93), Fred Wilson (b. 1954), Christopher Wool (b. 1955), Wang Xingwei (b. 1969), Shi Xinning (b. 1969), Zhao Zhao (b. 1982).

INFRATHIN [opposite]

Of all Duchamp's neologisms, inframince, or 'infrathin', is probably the most significant. During his lifetime, the artist mentioned the term only twice (**smoking**, *View*) and all that we know about the concept behind the word, from the comical to the cryptic, is taken from his forty-six posthumously published **notes**. For someone who signed mass-produced objects as **readymades** with the 'infrathin separation', he established a category of infinitesimal variants between '2 forms cast in the same mould', in that they would 'differ from each other by an infrathin separative amount': 'All "identical" as identical as they may be … move toward this infrathin separative difference.'[13] Duchamp's thoughts on the infrathin are as important for his **erotic objects** and the torso of *Étant donnés* (1946–66) as they are for his observations on **shadows**, moulds (**replica**) and

the *Large Glass* (1915–23): 'Painting on glass seen from the unpainted side gives an infrathin.'[14] He also gave many concrete examples, such as the 'infrathin separation between the detonation noise of a gun (very close) and the apparition of the bullet hole in the target (maximum distance 3 to 4 meters).'[15] In the only conversation in which he mentioned infrathin, Duchamp described it as a category that escaped any existing scientific definition, deliberately choosing the word 'mince', or 'thin', as it was more of a human, emotional expression than the precise term for a measurement or scale used in a laboratory. 'I believe that through the inframince one can pass from the second to the third dimension', he stated.[16] The 'whistling sound' of 'velvet trousers' signals an 'infrathin separation',[17] just as the space between the front and back of a sheet of paper does. However serious the concept, infrathin also exists in the spheres of poetry and **humour**: there are 'infrathin caresses'[18] and an idea for a pastel drawing resulting from dandruff falling out of one's hair onto paper covered with glue.[19] He also mentions an infrathin situation that many people have experienced: when the passengers of an underground train enter through the closing doors at the last moment – that moment, Duchamp assures us, is an infrathin moment.[20]

INTELLIGENCE

The interviewer Pierre Cabanne (1921–2007) once asked Duchamp: '**André Breton** [1896–1966] said that you were the most intelligent man of the twentieth century. To you, what is intelligence?', to which he replied: 'There is something like an explosion in the meaning of certain words: they have a greater value than their meaning in the dictionary. Breton and I are men of the same order – we share a community of vision, which is why I think I understand his idea of intelligence: enlarged, drawn out, extended inflated if you wish'.[21] Duchamp was fond of his friends' 'auto-intelligence', which could not be explained by 'why' and 'because' but was based on their efforts to grasp what they themselves were about.[22]

According to Duchamp, it is essential for young artists to have intelligence so that they are not corrupted and are equipped to avoid the traps of **commercialism** by making too much money.[23] In the 21st century, artist Thomas Hirschhorn (b. 1957) has expressed afresh what Breton previously stated and on which many fellow artists and art historians seem to be able to agree 'He was the most intelligent artist of his century.'[24]

INTERVIEWS

Of all the public interviews and state-
ments by Duchamp, about ninety per cent
are from the time between his mid-sixties
and his **death** in 1968 at the age of eighty-
one. Therefore, for us to understand the
artist, it is important to remember that
almost everything we know of or about
him in his own words – apart from his
works, **notes**, rare writings, **puns** and
letters – is brought to us through the
eyes of an elderly man reflecting back
upon his **life** with **intelligence**, sophisti-
cation and **humour**.

IRONY

My irony is that of **indifference**:
meta-irony.'[25]

SIDNEY JANIS

The well-to-do art collector Sidney Janis (1896–1989) and his wife Harriet (1898–1963) first opened their New York gallery in 1948 on 57th Street, and later specialised in **Abstract Expressionism**. Like the Rose Fried Gallery and the Cordier & Ekstrom Gallery during the 1960s, and the **Julien Levy** Gallery in the 1930s and 1940s, this showroom became an important hub for Duchamp as artist, dealer, curator and authoritative figure when it came to generating understanding and visibility for art movements such as **Dada** and **Surrealism**. The Janises admired Duchamp as the 'arch rebel of the 20th century'.[1] It is thanks to them that we owe the earliest reincarnations of two **readymades** whose originals had been lost: *Fountain* (1917) of 1950

and the *Bicycle Wheel* (1913) of 1951, now both at the Museum of Modern Art in New York. At their gallery in 1953, Duchamp organized, installed and curated *Dada 1916–1923*, one of the first major retrospective shows on Dada with over 200 works by some thirty-six artists. Duchamp's exhibition poster with his landmark typographical design also functioned as the catalogue and guide through the gallery. In true Dada spirit, crumpled balls of paper in a waste bin at the entrance, when unfolded by the visitor who chanced upon them, turned out to be those exhibition posters.

JOBS [illustration p. 103]

At some point in his life, Duchamp was one, or a combination, of the following:

professional **chess** player, curator, (self-) publisher, painter, volunteer for military service, artist, graphic designer, art **dealer**, French teacher, lecturer, critic, gambler, printer, photographer, inventor, translator, librarian, executor of several wills, writer, the secretary to a French war mission during the Second World War, and, from 1961, an honorary doctor of humanities at Wayne State University in Detroit. He was a self-declared window maker, bricoleur or simply a breather. In addition, he dabbled in the cleaning and fabric-dying businesses, thought of becoming a professional cameraman and was eager to market self-designed chess sets, optical machines and scientific toys, as well as the letters DADA cast in silver, gold and platinum.

JUDGING

'Jurors are always apt to be wrong ... even the conviction of having been fair does not change any doubts on the right to judge at all.'[2] It may be that the cautiousness expressed in Duchamp's statement of 1946 – the year he acted as a juror, helping to select **Max Ernst**'s (1881–1976) painting *The Temptation of St. Anthony* (1946) as the winning entry to be featured in a Hollywood movie – had something to do with the initial rejection of both his **Nude Descending a Staircase No. 2** (1912) and **Fountain** (1917) by his friends, fellow artists and, in the case of the former, even his own brothers. He

was adamant that 'the very idea of judgment should disappear'[3]. Any audience should not have the privilege to decide 'what is good and what is bad'.[4] The artist thought judgment to be a 'horrible idea'[5] and was even concerned about possible future jury service when applying for American citizenship. 'Who am I and who is any man that he can bring judgment on another man? I just don't want to do it.'[6] Judgment was a 'mistake', a 'superficial expression of the subconscious',[7] to be avoided at all costs. A few years before his death, when Pierre Cabanne (1921–2007) questioned whether his role as art collector for the **Société Anonyme** was 'rather anti-Duchamp', even putting himself in danger of 'repudiating his own opinions', Duchamp made it clear that he 'did it for friendship. It wasn't my idea. The fact that I agreed to be a member of a jury which determined what works were chosen didn't involve my opinions at all on that question.'[8] The artist, it seems, could have it both ways once again, being a juror while dismissing the idea of a jury. After all, 'it was a good thing to help artists be seen somewhere. It was more camaraderie than anything else.'[9] In any case, Duchamp was much more interested in the onlooker as an essential part of '**The Creative Act**' than in his or her arrival at a final judgment.

WASSILY KANDINSKY

When Duchamp spent a few months in **Munich** in 1912, he saw the recently published book, *Concerning the Spiritual in Art*, by Wassily Kandinsky (1866–1944), in shop windows all over the city. A copy of the German edition was later found among the books belonging to Duchamp's brother, Jacques Villon (1875–1963), and scholars have argued that the annotations in the margins were in fact made by Duchamp himself. Duchamp made no effort to meet the artist during his stay in Munich, although the almanac of Der Blaue Reiter, an avant-garde art movement co-founded by Kandinsky in 1912, mentioned Duchamp as an up-and-coming talent. From 1923, Kandinsky served as vice-president of **Katherine S. Dreier**'s

Société Anonyme, just as Duchamp had before him. Together with Dreier, Duchamp visited Kandinsky in Dessau in May 1929, where the latter artist was director of the Bauhaus. Duchamp presented the abstract artist with a postcard of his ***Bride***, painted in 1912 while in Munich, which Kandinsky went on to use when teaching his students. Although Duchamp gave up painting soon after he first learned of Kandinsky, he later hailed him as 'someone who wanted to make clear that painting could be born again' creating his 'first abstract paintings when the word "abstract" was not yet invented'.[1] To Duchamp, who could have been writing about himself, Kandinsky's real contribution to art was a 'deliberate condemnation of the emotional' as well as a 'conception of esthetics not related to the preceding or following "isms"'.[2]

LANGUAGE

'But the most powerful language is the one in which all is said without a word being uttered.'[1] Jean-Jacques Rousseau (1712–78) doubted the ability of language just as Gustave Flaubert (1821–80) was later pained by its imperfections: 'Human speech is like a cracked kettle on which we tap crude rhythms for bears to dance to, while we long to make music that will melt the stars.'[2] Although Duchamp did not have much to do with either writer, his massive mistrust of language was built upon a centuries-old trajectory of French thought.

Outside poetry and puns, the artist was keenly aware of the limitations of the spoken or written word, which was at best 'useful to simplify'.[3] The artist once called language 'an error of humanity'[4]

and 'a great enemy'.[5] Besides, 'between two beings in love, language is not what is the most profound'.[6] Human relations aside, Duchamp did not like the imprecision of language and was convinced that art already had one of its own, so did not need to be translated. This attitude was also the basis for Duchamp's profound dislike of **art history**, or any writing about art in general.

THE *LARGE GLASS*

Sometime in the distant future, on Freeside, a space resort created for the entertainment of the rich and owned by the Tessier-Ashpool Corporation, deep within the countless rooms of the Villa Straylight, Duchamp's *La mariée mise à nu par ses célibataires, même* (1915–23)

(*The Bride Stripped Bare by Her Bachelors, Even*), or the *Large Glass*, is installed somewhere in an orbital configuration far, far away – at least according to William Gibson's (b. 1948) sci-fi cyberpunk novel *Neuromancer* (1984). Back on Earth, Duchamp's *Large Glass* has been permanently installed at the **Philadelphia** Museum of Art since 1954, being too fragile to travel after it was shattered following its first display in 1926–27 – and repaired by the artist himself in 1936. It consists of abstract figures, motifs and patterns of strange brownish red and silver-grey colours. The slightly deteriorating, ageing construction is made of oil, varnish, lead, dust, aluminium foil and wire, its cracked glass mounted between two large glass panels, positioned vertically on top of each other in a steel frame, almost 3 m high and 2 m wide (approximately 9 ft by 5 ft 9 in.). When Duchamp was asked if his magnum opus should be regarded as a preliminary study for a mobile construction, he replied, 'Absolutely not … it's like the hood of an **automobile**. What covers the engine.'[7] Although the *Large Glass* and the **notes** about its intricate operations and complex movements seem to lend themselves to computer-generated 3D animations, Duchamp's response to the question suggests that, even if such technologies had been available to him, he would not have pursued this way of working.

Rather than explaining the work, its title, *The Bride Stripped Bare by Her Bachelors, Even*, provokes a whole set of questions. Why many bachelors and not one? Why would the bride let herself be stripped instead of stripping herself? What does the 'even' (même) at the end mean? 'An adverb which makes no sense, since it relates to nothing in the picture or title. Thus it was an adverb in the most beautiful demonstration of adverbness. It has no meaning',[8] Duchamp said in the 1960s. However, we do have Duchamp's universe of notes, sketches and drawings for the work, about 300 in total. Those contained in the *Green Box* of 1934 (**boxes**) are kept close to the *Large Glass* for visitors to consult, and without these documents it is difficult to understand the work at all. 'The Glass and the book are very much connected. Not only connected, they are made for one another',[9] as Duchamp described. It is here that we learn about the lower panel depicting the nine bachelors, funnelling their desire for the bride through seven sieves balancing on top of scissors placed above a rotating chocolate grinder. The latter is one of many devices set in motion and assigned specific tasks as the bachelors' longing undergoes different stages of material conditions – from solidified illuminating gas into spangles culminating in a splash and a sculpture of drops. The entire Bachelors' Apparatus is restricted by three-dimensional space and central **perspective**, but it provides the architectonic base for the Bride's Domain above, located in the **fourth dimension**. Both panels are separated from one another by

three horizontal plates of glass signify-
ing the horizon, the bride's clothes and
a gilled cooler.

The bride herself is located to the
upper left, where her motor, which 'must
appear as an apotheosis of virginity, i.e.
ignorant desire, blank desire (with a
touch of malice)',[10] draws its energy from
a reservoir of secreted love gasoline. Her
other parts include a *pendu femelle*, a skel-
eton and a steam engine, while a vibrating
sex cylinder, as well as the sparks of a
desire magneto, assist in generating the
'voluntary' and 'electrical stripping'.[11] In
turn, her commands to the bachelors are
communicated through a cloud-like con-
figuration referred to as a halo, or Milky
Way, which takes up most of the upper
third of the Bride's Domain. Duchamp
left the *Large Glass*, his 'pile of ideas'[12]
as he once called it, unfinished and many
parts are mentioned only within the
notes. While on the upper right side
of the Bride's Domain he drilled nine
holes through the glass panel – their loca-
tion determined by **chance** by the artist
firing nine matches at the glass from
a toy cannon, their tips dipped in fresh
paint – we will never know whether the
longing of the nine bachelors is ever con-
summated or forever remains unfulfilled,
or unrequited.

The *Large Glass*, in playful, light and
humorous ways that belie its scientific
aspects, lets us know that nothing can
be explained completely. Even logos
succumbs to eros in the end, leaving us
with **doubts** about what we see as well as

about ourselves. The work is an almost
otherworldly, beautiful reminder that our
existence on this planet is not entirely
in vain. **Intelligence**, intellect and an
inspiring vision transmitted through
art may reinforce our fleeting trust in
the true achievements of our species.
The *Large Glass* ranks among the great
expressions of pure creative freedom and
individualism of 20th-century art and
literature – and of **eroticism** for that
matter. As much as pop psychology keeps
telling us that men are from Mars and
women are from Venus, let us stick with
what at one point may be installed on that
Freeside space station instead (see also
automobiles, **boxes**, *Box-in-a-Valise*,
André Breton, *Bride*, **Gabrielle Buffet-
Picabia**, **causality**, **chance**, **chocolate**,
delay, *Dust Breeding*, *Étant donnés*,
fourth dimension, **Richard Hamilton**,
Herne Bay, **humour**, **love**, **mathemat-
ics**, **Munich**, **notes**, **onanism**, **optics**,
perspective, **Philadelphia**, **puns**, **replica**,
Raymond Roussel, **science**, **taste**, **three**,
Three Standard Stoppages, **titles**, **water
and gas**, *Yara*).

LAZINESS

See **work**.

ROBERT LEBEL

In 1959, Michel Sanouillet's (b. 1924)
Marchand du sel: Ecrits de Marcel Duchamp

(Paris: Terrain vague), Duchamp's collected writings, was published. In the same year, Duchamp's first biography and catalogue raisonné, *Sur Marcel Duchamp* by Robert Lebel (1901–86), appeared in French and English, helping to save Duchamp from oblivion and steering a new generation of artists towards his achievements. A French scholar and writer, Lebel got to know Duchamp in New York at Alfred Stieglitz's (1864–1946) gallery in the summer of 1936 and befriended him during their years of forced exile in the city during the Second World War. On 1 October 1968, it was the Lebels, together with **Man Ray** and his wife, who had dinner at the Duchamps' the night the artist passed away (**death**). The idea of a biography occurred to Lebel in the late 1940s and he worked on it for most of the next decade. Unusually for Duchamp, he expressed his fondness for the new insights Lebel's writings provided.

Lebel went on to write about twenty more essays on Duchamp, covering a variety of subjects, from the artist's assemblage ***Étant donnés*** (1946–66) to his close relationships with **André Breton** (1896–1966), **Francis Picabia** (1879–1953) and **Man Ray** (1890–1976), and his admiration for the Italian painter of *pittura metafisica*, Giorgio de Chirico (1888–1978). On the occasion of a retrospective at the Museum of Modern Art in New York in 1973–74, Lebel summed up their friendship of over thirty years, contrasting Duchamp's personal endeavours with his public persona: 'He had created his private world in which he moved, worked, played, and loved in ultimate seriousness, even when in the outside world he seemed to joke, to deny, and to destroy. Through the disturbance of all senses once recommended by Rimbaud, he reached a state of super-awareness, which raised him to the level of the great visionaries of all time.'[13]

LEONARDO DA VINCI

As an artist-scientist, Leonardo da Vinci (1452–1519) held great appeal for Duchamp, who had a lifelong interest in **mathematics** and **science**. Both were sons of notaries, and both left behind only a comparatively small number of works and a major work unfinished, as well as many **notes** interspersed with sketches.

For his examination to become a printer and engraver in Rouen, the young Duchamp was quizzed about the Renaissance artist. Leonardo's *Treatise on Painting* was widely read by the **Cubists**, especially within Duchamp's own circle in Puteaux. From 1911 onwards, this loose collective of mostly French artists fervently discussed culture, science and mathematics. They named their salon 'La Section d'Or', or 'Golden Section', after the ideal ratio of two quantities as described by Leonardo for painting and the picture plane. 'My landscapes begin where da Vinci's end',[14] Duchamp said in 1963 and throughout

his life and work it is clear that he was much inspired by the quintessential Renaissance man and all-time **genius**. Comparisons have been made between Leonardo's take on painting as a *cosa mentale* and Duchamp's preoccupation with **grey matter**. Moreover, parallels can be found between Leonardo's drawing of a woman's internal organs and the visceral forms of Duchamp's *Bride* (1912), or the cracks in his *Large Glass* (1915–23) and the theoretical writings of Leonardo in which he likens crevices in walls to features of the landscape. The notes of both artists continue to be scrutinized by scholars. Early on in his career, Duchamp would have studied Leonardo's mechanical investigations and scientific scribbles just as closely. As for Duchamp's signature, the artist was able to jot it down in a perfect mirror image, the method of writing that a similarly cerebral Leonardo used to fill his notebooks (see also *L.H.O.O.Q.*).

Levy wrote extensively about Duchamp's life and work, pointing out the 'accidental background' of the *Large Glass* (1915–23), formed by 'the spectators who passed through the museum behind the glass',[15] when it was exhibited in 1926–27. In Levy's memoirs of 1977, we find a curious description of an encounter with Duchamp on board a transatlantic steamer taking them from New York to Paris in 1927. Their dialogue revolved around a 'mechanical female apparatus', a 'machine onaniste'[16] (**onanism**) that pre-dated Duchamp's **erotic objects** and *Étant donnés* (1946–66) by many decades.

Levy admiringly thought of Duchamp as 'always in advance of his time',[17] yet often found him 'quite invisible', 'silent', and 'ambiguously negative'.[18] The dealer once invited him for drinks in Paris, but when the artist rang Levy's doorbell it was only 'to say that he could not come, and then he left'.[19]

JULIEN LEVY

The New York art dealer Julien Levy (1906–81) ran his Manhattan gallery between 1931 and 1949 on Madison Avenue, and later from 57th Street. He championed the avant-garde, photography and, upon Duchamp's introduction, **Surrealism**, about which he published a book in 1936, having staged the movement's first major New York exhibition four years previously.

L.H.O.O.Q.

One of Duchamp's most iconic images, perhaps second only to his *Nude Descending a Staircase No. 2* (1912) or his **readymade** *Fountain* (1917), is his bearded *Mona Lisa*. In 1919, Duchamp pencilled a moustache and goatee onto a reproduction of **Leonardo**'s (1452–1519) famous painting. Its **title**, *L.H.O.O.Q.*, translates into a vulgar pun if the letters are pronounced in French: 'Elle a chaud

au cul', or 'She has a hot ass'. In the 400th anniversary year of Leonardo's death, Duchamp's gesture may also have been aimed at the increasing **commercialism** surrounding the artist. The iconoclastic **Dada graffiti** turns La Gioconda into a man, hinting at Leonardo's possible homosexuality, as examined by Sigmund Freud (1856–1939), and at Duchamp's own forays into the opposite sex by taking on a female alter ego, **Rrose Sélavy**. Moreover, *L.H.O.O.Q.* invites the viewer to LOOK carefully, as its very title seems to suggest. Just like Leonardo's paintings, Duchamp's artworks are often about much more than is obvious at first glance. Among the numerous speculations about both the *Mona Lisa* (*c.* 1503–19) and *L.H.O.O.Q.* is that they may be meticulously crafted self-portraits.

LIFE

See **luck**.

LITERATURE

Duchamp was not an avid reader. While there is an entire sub-genre of Duchamp scholarship devoted to drawing parallels between the lives and work of Duchamp and James Joyce (1882–1941), there is no evidence that the artist had read any of his writings. Duchamp also took great pride in never having read a word of any of Marcel Proust's (1871–1922) work.

So much for the greatest writers of the 20th century.

If Duchamp had any special area of interest at all, it was French poetry, as well as some early 20th-century French prose. He considered it a strength to be influenced by writers rather than fellow artists and said that 'my ideal library would have contained all of **Roussel**'s [1877–1933] writings – Brisset [1837–1919], perhaps Lautréamont [1846–1870] and Mallarmé [1842–98]'.[20] He referred to Alfred Jarry (1873–1907) ('**pataphysics**) and François Rabelais (*c.* 1494–1553) as 'my gods, evidently' (**God**).[21] Although Duchamp spoke favourably of Arthur Rimbaud (1854–91), he preferred Jules Laforgue (1860–87), whose poetry inspired a number of his works, including a preliminary sketch that provided the idea for his *Nude Descending a Staircase No. 2* (1912). He owned the collected writings of Lewis Carroll (1832–98), read the works of Jules Verne (1828–1905), cherished the poetry of Léon-Paul Fargue (1876–1947) and introduced an artist friend to the writings of Samuel Beckett (1906–89), Albert Camus (1913–60) and Louis-Ferdinand Céline (1894–1961). However, he did not read Franz Kafka's (1883–1924) *Metamorphosis* (1915) until the late 1940s. Duchamp cherished Paul Laforgue's (1842–1911) late 19th-century treatise on *The Right to be Lazy* and enjoyed the verbal witticisms of Alphonse Allais (1854–1905), whose poetic **puns** Duchamp read the night he passed away (**death**).

LOVE

In his work and life, Duchamp's love was one of longing and desire, frequently impossible to detach from the sexual act and always erotically charged – complicated, and often unfulfilled or unrequited. When in 1919 he was asked what he thought of love, he replied that he made it as little as possible.[22]

The bride of Duchamp's *Large Glass* (1915–23) has at its base a 'reservoir of love gasoline (or timid power)',[23] which sets into motion the mechanisms of her 'electrical stripping'[24] by the bachelors, yet we will never know whether their craving for her, or hers for them, is ever truly consummated or satisfied. In his letters to his married lover **Maria Martins** (1894–1973), it is painful to observe how much her absence hurts him: 'our formula for love on the wing is too sorrowful at heart, and not what we deserve',[25] he wrote in 1951. The artist charmed everyone and, to his friends, the comings and goings of the young women surrounding him may have seemed 'like a great flower of fragrant dresses that constantly renewed itself'.[26] But to Duchamp himself, with the possible exception of **Alexina Sattler** (**Teeny**; 1906–95), no real love between man and woman could be free of pain.

LOVERS [illustration p. 113]

Duchamp had innumerable lovers French, American, Brazilian, Germa – from one-night stands to decade-lon affairs. The verdict is still out regardin his conduct, though. To some, he seeme emphatic, passionate, warm and giving; t others, cold, remote, detached, even crue

While the biographer of **Mar Reynolds** (1891–1950) thought the artis 'incapable of loving',[27] **Beatrice Woo** (1893–1998) remembered that 'Marc was as gentle in bed as he was ou of it'.[28] Both assessments are pro ably true. Duchamp sometimes desire married women that he could not hav (**Gabrielle Buffet-Picabia**, 1881–198 and **Maria Martins**, 1894–1973) an there is an onanistic strain of unfulfille longing running through his entir work (**onanism**).

In addition to his real-life lovers, h depicted a number of couples and recli ing nudes in *The Lovers*, a series o etchings from 1967, the subjects in pa borrowed from Lucas Cranach (147; 1553), Gustave Courbet (1819–77) an Jean-Auguste-Dominique Ingres (178 1876). One work, inspired by August Rodin's (1840–1917) famous white marb sculpture *The Kiss* (1889), shows a nuc young man and woman in an intima embrace. Duchamp's etching differs fro the sculpture only in that the man's rig hand instead of carefully resting on th woman's upper left thigh now disappea between her legs. 'After all, that mu

have been Rodin's original idea. It is such a natural place for the hand to be',[29] Duchamp mused.

LUCK

Duchamp not only thought of luck as the essential component for any **art- ist**'s career but also considered himself a very lucky man: 'I have had an absolutely wonderful life, an intensive lust for life I had luck, fantastic luck! Not a day without eating, and I have never been rich either. Everything turned out well.'[30] When asked what it was that had satis- fied him most in his life, he replied: 'First, having been lucky.'[31]

Fig 73

MANIFESTO

Although closely linked to art movements such as **Dada** and **Surrealism**, Duchamp never signed a manifesto, always placing radical individualism first. It is no surprise that Duchamp's bible was the 19th-century work *The Ego and its Own* by German philosopher **Max Stirner** (1806–56).

MANTRA

According to his lifelong friend **Beatrice Wood** (1893–1998), Duchamp was always smiling and murmuring *Cela n'a pas d'importance* ('this doesn't really matter').[1] However, his warm and light-hearted tongue-in-cheek **indifference** should not be confused with a lack of care or empathy.

MARRIAGE

Duchamp was married twice: from 8 June 1927 to 25 January 1928, to **Lydie Fischer Sarazin-Levassor** (1903–88); and from 16 January 1954, at the age of sixty-seven, until his death in 1968, to Alexina Matisse (Teeny; 1906–95; née **Alexina Sattler**). His first marriage soon seemed to the self-declared and proud bachelor 'as boring as anything'.[2] As he never wanted any children, 'simply to keep expenses down',[3] Duchamp did not marry again until old age. As for women, 'one can have all the women one wants. One isn't obliged to marry them.'[4] Even in his very happy second marriage, he

gave the main reason for keeping a studio as simply not wanting to spend twenty-four hours a day with his wife.[5]

MARIA MARTINS

Catalogue number 173 of *The Almost Complete Works of Marcel Duchamp*, the major 1966 retrospective at London's Tate Gallery, is an item whose inclusion the artist was angry about, according to the show's curator, **Richard Hamilton** (1922–2011). The small work entitled *The Illuminating Gas and the Waterfall* (1948–49), made of painted leather over a plaster relief mounted on velvet, was on loan from Maria Martins (1894–1973), to whom it was also dedicated. Not only did the depicted female torso and title give away too much information about *Étant donnés* (1946–66), which Duchamp had been working on in secret from the mid-1940s, but also around that time Martins had been his lover. She was a successful as well as excellent Surrealist sculptor and the wife of the Brazilian ambassador to New York. Their affair lasted into the early 1950s and inspired numerous works, including *Étant donnés*, for which her involvement with the casting process proved essential to the assemblage's creation (**anatomy, breasts, ejaculate, eroticism, hair, Yara**). Duchamp was smitten and his letters written during their decade-long relationship provide a rare glimpse into Duchamp as a lover: 'Kisses everywhere at the same time',

'I often think about your hand ... which has given me more joy than any lover could wish for', 'I am within you and you only have to knead me to make us happy', 'How I would like to breathe with you.'[6] While he and Maria 'both need physical love ... these long interruptions of chastity only serve to sharpen a new razor blade', ultimately 'work is a sexual stimulant' and making the plaster casts of her body made him feel as if she were with him.[7] The letters also reveal his sadness in being unable to convince Martins to live with him. He is often in 'a state of great **laziness** and disgust'.[8] He feels as if 'life is empty, the city is empty' and that 'isolation hurts', experiencing 'a feeling of great emptiness'.[9] Unfortunately, it seems that the feelings may not have been entirely mutual. Martins was always unlikely to leave her husband and at the height of their affair wrote a prose poem that suggests how she really might have felt: 'Even long after my death / Long after your death / I want to torture you. / I want the thought of me / to coil around your body like a serpent of fire / without burning you. / I want to see you lost, asphyxiated, wander / in the murky haze / woven by my desires.'[10]

MATERIAL

Duchamp used many curious materials and items for his works, including: a bicycle wheel and fork mounted on a wooden kitchen stool (1913); three

-metre-long (approximately 39 in.) threads (1913–14); oil and lead wire on glass (1913–15); a galvanized iron bottle dryer (1914); a wood and galvanized iron snow shovel (1915); a steel comb, a ball of twine and a faux leather typewriter cover (1916); a porcelain urinal, a painted tin advertising sign, a hat rack and a coat rack (1917); a magnifying lens, a bottle brush, safety pins and bathing caps (1918); a stereopticon slide (1918–19); a cardboard and paper geometry textbook and a glass ampoule (1919); black leather and dust (1920); a glass perfume bottle, marble cubes, cuttlebone, a glass thermometer and a metal birdcage (1921); a Plexiglas dome (1925); phonograph records (1926); cigarette tobacco (1936); jute coal bags, a metal stove, a wax mannequin and a red electric lamp (1938); chicken wire, gauze, iodine and string (1943); a rubber glove (1944); ejaculate and head, armpit and pubic hair (1946); false breasts (1947); painted leather over plaster relief (1948–49); galvanized plaster and transparent perforated Plexiglas (1950); chocolate and talcum powder (1953); dental plastic (1954); a woollen waistcoat and a metal spoon (1957); pine needles (1958); black flies, marzipan and cotton potholders (1959); cigar ashes (1965); a metal licence plate (1962–63); calfskin, bricks and twigs (1966).

MATHEMATICS [illustration p. 120]

'I am not a mathematician, and I would never dream of understanding mathematics or think mathematically, because I have not the natural tools for it.'[11] Nevertheless, as a young man, Duchamp made serious forays into the field of mathematics, and not only through popular **science**. As a librarian at the **Bibliothèque Sainte-Geneviève** and in the intense discussions among the **Cubist** artists at Puteaux, Duchamp became interested in non-Euclidean geometry, distortions of **perspective**, and the **fourth dimension**. In his **interviews**, conversations, writings and **notes**, we find references to Nikolay Ivanovich Lobachevsky (1792–1856), Georg Friedrich Bernhard Riemann (1826–66), Justus Wilhelm Richard Dedekind (1831–1916), Esprit Pascal Jouffret (1837–1904), **Henri Poincaré** (1854–1912), Gaston de Pawlowski (1874–1933), Maurice Princet (1875–1971), the Viennese logicians and the Banach-Tarski paradox. The artist acknowledged that he 'always wanted to be a mathematician, but I never had enough stuff in me'.[12] Accordingly, just before his early notes on mathematics were published in 1967 within *À l'infinitif* (**boxes**), about half a century after most of them were written, Duchamp asked their translator, the abstract artist Cleve Gray (1918–2004): 'Do you think this is all right, all of this? I mean does it make sense? You know I don't want to appear foolish.'[13] Duchamp enjoyed the playful

mathematics of **chess**, but frequently said that he had never studied mathematics in any depth. However, some art historians believe that he consciously understated his knowledge of both mathematics and science to divert attention away from those principles that many agree provide essential keys to his ideas and most important works. Others have argued that his related thoughts on **tautology** are indispensable here as well. 'If I used the little mathematics I knew', Duchamp once stated, 'it was just because it was amusing to introduce that into a domain like art, which has very little of it generally.'[14] In 1954, Duchamp told Alain Jouffroy (b. 1928) that 'while nobody dares to butt into a conversation between two mathematicians for fear of being ridiculous, it is perfectly normal to hear long conversations at dinner on the value of such and such a painter in relation to another'.[15]

MERDE

Duchamp once thought of a '**transformer** designed to utilize wasted energies', among them 'the fall of urine and excrement'.[16] His eroticized occupation with **chocolate** in many of his works has been linked to faeces by some writers. 'Merde' is the word he scrawled across the painting of a seated nude in 1911, apparently unhappy with his achievement. More famous still is Duchamp's well-known analogy, in one of his **notes** from the

Box of 1914 (**boxes**), 'arrhe is to art as shitte is to shite', or '"arrhe" divided by "art" = "shitte" divided by "shit"'.[17] While the 'arrhe of painting is feminine in gender',[18] it is also the French term for a non-refundable deposit, whereas 'shitte', or 'merde', was first used by Alfred Jarry (1873–1907) in his opening line of *Ubu Roi* (1896), to get his play past the censors (**literature**, **'pataphysics**). In 1924, Rrose Sélavy wholeheartedly declared 'Oh! Do shit again! Oh! Douche it again!'.[19] Six months before his death and seven years after Piero Manzoni's (1933–63) canned *Merda d'artista* (1961), Duchamp finally conceded by creating the cover for **William Copley**'s (1919–96) de luxe periodical *S.M.S.*, or *Shit Must Stop.*

MONA LISA

See *L.H.O.O.Q.*, **Leonardo da Vinci**.

MONTE CARLO BOND

While Duchamp was striving to become a professional chess player, he set out on a quest to eliminate chance in gambling by devising a pseudo-scientific system that would give him a shot at making money at roulette – and breaking the bank at Monte Carlo. The artist was no stranger to the idea of creating art at the service of money. In 1919 he paid his dentist's bill with a fake enlarged cheque

made out for Fr115, which its recipient, Dr Daniel Tzanck (1874–1964), fully accepted as payment. In 1924, to raise money on a large scale for his *Monte Carlo Bond* adventure, Duchamp formed a stock company, issuing limited edition shares at Fr500 each. The faux bond features a picture of a roulette wheel with a photograph of Duchamp's head by **Man Ray** (1890–1976) in front, all foamed up with soapsuds and his hair parted in the middle to create devilish protruding horns. Signed by the artist and **Rrose Sélavy**, stockholders were to receive a dividend of twenty per cent. Determined to pay the dividends, Duchamp set out for Monte Carlo's casino in early 1925. As he told a friend: 'The winning formula is of no importance. All of them are right and all of them are wrong. But with the right combination, even the wrong winning formula can hold up.'[20] Unfortunately, his system based on 'a mechanical mind against a machine'[21] was not very successful and fewer than eight of the original shares were actually sold. When Duchamp returned from a fortnight in Monte Carlo many decades later, he assured a friend that there had been 'no gambling'.[22] What has escaped scholarship so far is that the upper third of the roulette table layout incorporated in Duchamp's design for the bond is cut by one quarter, exactly where the numbers one, two and three are located. It looks as if, once again, Duchamp knew precisely what he was doing, remaining in complete control of his endeavours,

especially when we bear in mind the importance that he placed on the number **three**.

MUNICH

At the age of twenty-four, Duchamp left **Paris** for Munich and stayed there from late June to September 1912. His brothers and artist friends had just refused to exhibit his painting **Nude Descending a Staircase No. 2** (1912) at the Salon des Indépendants; he was madly in love with **Gabrielle Buffet-Picabia** (1881–1985), the wife of his friend **Francis Picabia** (1879–1953); and – without knowing it at the time – he had fathered a daughter with his model, Jeanne Serre. It was the German painter Max Bergmann (1884–1954), with whom he had enjoyed the Paris nightlife in 1910, who invited Duchamp to stay in Munich – the city just outside of which the Behrendt colours were manufactured, a brand that Duchamp had been using exclusively for a couple of years on Bergmann's recommendation. The importance of his three-month stay in Munich cannot be underestimated.[23] He described the city as the 'scene of my complete liberation',[24] and it was here that Duchamp created his most accomplished painting (**Bride**, 1912) and that the title, the first **notes** and the initial drawing for the **Large Glass** (1915–23) came into being. At this early stage, the work was still conceived of as oil on canvas. **Wassily Kandinsky** (1866–1944),

whose German Expressionist Der Blaue Reiter movement had just been founded in Munich, published his *The Spiritual in Art* in 1912, and Duchamp owned a copy. The Deutsche Museum and the Bavarian Trade Fair received over four million guests that same summer and both presented industrial, mass-produced objects in a museum-like setting. Duchamp's first **readymade**, the *Bicycle Wheel* (1913), appeared about a year later, and perhaps it was Munich that provided the ideal creative atmosphere in which he could develop his conceptual ideas for using commonplace artefacts in his work.

MUSIC [illustration p. 124]

Duchamp's invention of the **readymade**, taking something and signing it and saying, "It's mine" – that's what the DJ does today, takes someone's music and remixes it.'[25] The American artist Christian Marclay (b. 1955) should know about mixing Duchamp with DJ culture. In 1980, he started a two-man band, *The Bachelors, Even*, named after the *Large Glass* (1915–23). It is no surprise that Duchamp's name pops up frequently in the realm of music. He grew up in a musical family, as illustrated in several of his early drawings and paintings, such as his **Cubist**-style *Sonata* (1911), in which his mother and three sisters are playing the piano and the violin. The artist appreciated Richard Wagner (1813–83) and Richard Strauss (1864–1949), as well

as Johann Sebastian Bach (1685–1750), Ludwig van Beethoven (1770–1827) and Igor Stravinsky (1882–1971), whose themes of *Le sacre du printemps* (1913) he played on the piano to the writer Alfred Kreymborg (1883–1966) in September 1915 with a single finger. Two years earlier, with **Erratum Musical** (1913), he introduced **chance** to music. Duchamp was a lifelong friend of the composer **Edgard Varèse** (1883–1965) and in 1924, together with **Francis Picabia** (1879–1953), collaborated with Erik Satie (1866–1925) on a ballet (*Relâche*) and an avant-garde film (*Entr'acte*).

Throughout his work and **notes**, some of which he jotted down on music paper, we find him preoccupied with sound and music. His readymade *With a Hidden Noise* (1916) contains a secret object placed within a ball of twine fastened between two brass plates. Dozens of early references in his **boxes**, such as 'One can look at seeing; one cannot hear hearing', 'make a painting of frequency', and 'Musical Sculpture. Sounds lasting and leaving from different places and forming a sounding sculpture that lasts',[26] place him on a par with, if not far ahead of, the avant-garde composers of his time. Notes about **unrealized projects** mention a 'piano tuned on the stage',[27] a 'Venus de Milo made of sounds around the listener'[28] and 'Gap music: from a (chord) group of 32 notes for ex. on the piano / not emotion either but enumeration through the cold thought of the other 53 missing notes'.[29] In **interviews**,

he often did not appear as open towards music as his private scribbles suggest. 'I'm not anti-music. But I don't get on with the "catgut" side of it. You see, music is gut against gut: the intestines respond to the catgut of the violin. There's a sort of intense sensory lament, of sadness and joy, which corresponds to retinal painting, which I can't stand. For me music isn't a superior expression of the individual. I prefer poetry. And even **painting**, although that's not very interesting either.'[30] Nevertheless, Duchamp inspired many individuals working in music, from **John Cage** (1912–1992) and Merce Cunningham (1919–2009) to, more recently, Bryan Ferry (b. 1945), David Bowie (b. 1947), Michael Stipe (b. 1960) of R.E.M., Björk (b. 1965) and Beck (b. 1970).

R. MUTT

Besides his most prominent alias, **Rrose Sélavy**, Duchamp made use of many more noms de plume. With a penchant for **puns**, he employed the pseudonym R. Mutt as the creator of his urinal **readymade** *Fountain* (1917). Duchamp claimed that the word 'Mutt' was inspired by the popular cartoon series 'Jeff and Mutt' – which featured at least one episode based in a bathroom – as well as by the company J. L. Mott Iron Works of Trenton, New Jersey, from whose Manhattan showroom Duchamp claimed to have bought the urinal. When the two words are reversed, however, to 'Mutt R.', besides secretive muttering, the German 'Mutter' (English: 'mother') comes to mind, turning the all-male appliance boldly signed R. Mutt into a womb, or the ultimate female receptacle. In his *Box of 1914* (**boxes**), Duchamp mentions a urinal in a rather unflattering manner: 'one only has: for *female* the public urinal and one *lives* by it',[31] perhaps an allusion to the centuries-old practice of urinating into the female sex after intercourse to prevent unwanted pregnancy. 'Mutt' also sounds very similar to the German 'Matt', a term used in **chess** for 'checkmate', an allusion that is logical bearing in mind Duchamp's passion for the game. From the original delivery tag attached to *Fountain*, we learn that the 'R.' stands for the name 'Richard'. Possible interpretations could then include the pun 'Rich Art = Mud', which would make sense when considering Duchamp's adamant rejection of the **art market**. Although the name itself has a rather common sound, no link to an actual person has been made and no Richard Mutt was listed in the phone or residence directories of New York and neighbouring states in 1917. The only name that came close was Richard Mott, a professional golfer and former Connecticut state champion.

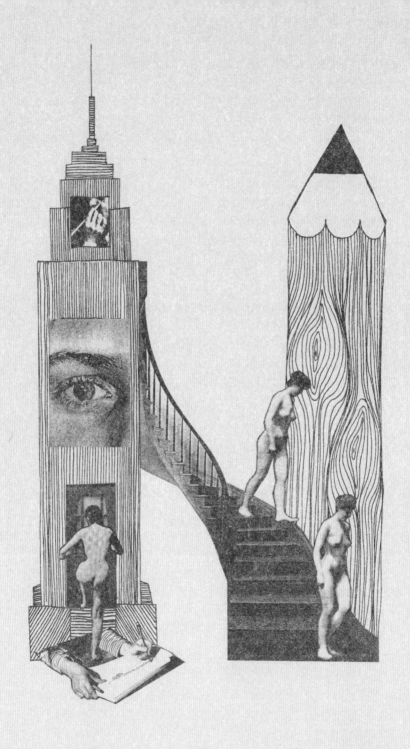

NEW YORK

Duchamp first arrived in New York in mid-1915 and stayed there until moving to **Buenos Aires** about three years later. He visited the United States for brief periods in the 1920s and 1930s and eventually settled in Manhattan in 1942, exiled by the Second World War. Aside from frequent trips to **Paris** and summers spent in **Cadaqués** from the late 1950s onwards, Duchamp remained in New York, returning to Europe six months before his **death** in 1968. In the mid-1950s he became a US citizen (**citizenship**). 'I adore New York',[1] Duchamp declared in 1915. On his first visit to the city, which he eventually came to call his home, he considered it to be 'a complete work of art'.[2] He was drawn to the city's inventiveness and novelty while enjoying its distance from the old world. Unlike Paris, where artists 'as a group' were 'more demanding', Duchamp cherished 'the respect for your privacy'[3] in New York. Or as **Henri-Pierre Roché** (1879–1959) remarked about his artist friend: 'It is easier to isolate oneself in New York than in Paris, and it may be more agreeable and more exciting for some people to participate in a budding culture than in one that is ripe and oversure of itself.'[4]

Without his permanent presence in New York, his legacy as we know it today, his role as a mediator between the avant-gardes of Europe and the American art world and his significance for the artists of the 1950s and 1960s would be entirely unthinkable.

NIHILISM

There are nonsensical traits of nihilism within **Dada** that Duchamp clearly appreciated. He may also have been interested in the term's negative connotations as expressed by Friedrich Nietzsche (1844–1900), with whose philosophy Duchamp was familiar. Despite being 'personally delightful with his gay ironies',[5] **Gabrielle Buffet-Picabia** (1881–1985) also mentioned the 'pitiless pessimism of his mind',[6] the 'strict discipline necessary to this self-control, to this self-denial',[7] which 'suppressed every impulse, every desire to create'.[8] Despite this, Duchamp's light-hearted frivolity as well as his bright and intelligent sense of **humour** usually took precedence; as he claimed in 1956, 'Complete nihilism is clearly impossible: Nothing is Something.'[9]

NOMINALISM

As someone who based many of his **philosophical** beliefs on the writings of **Max Stirner** (1806–56) and thus never tired of defending the individual as opposed to the masses, it follows that the concept of nominalism appealed to Duchamp. Nominalism does not believe in generalities or overarching themes and universals. 'A kind of Pictorial Nominalism (check)'[10] is what he jotted down in 1914 while other **notes** introduce us to his thoughts on 'literal nominalism'.[11] In both cases,

Duchamp wanted the onlooker or reader to focus on a painting, a sculpture or words without automatically grouping or comparing them. What we are left with are **tautologies**: 'As a good "nominalist", I propose the word "Patatautologies".'[12] Freed of the traps of contextualizing and 'independent of the interpretation', a word or a work may be looked at as a 'plastic being', which eventually 'no longer expresses a work of art (poem, painting, or music)'.[13]

For Duchamp, these thoughts underpinned his artistic creations as well as being an essential element of his worldview: 'I refuse to think of the philosophical clichés rehashed by each generation since Adam and Eve in every corner of the planet. I refuse to think about it or talk about it because I don't believe in **language**. Language, instead of expressing subconscious phenomena, in reality creates thoughts through and after words. (I willingly declare myself a "nominalist", at least in this simplified form.)'[14]

The Duchamp scholar Thierry de Duve (b. 1944) has argued that it was Duchamp's idea of pictorial nominalism that made him abandon painting and that paved the way for the introduction of his **readymades**.[15]

NOTES

Fewer than 500 notes were left behind by Duchamp, a number that includes sixteen in the *Box of 1914*, ninety-nine

in the *Green Box* (1934), seventy-nine in the *White Box* (1967) (**boxes**), and 289 published posthumously in 1980. His writings cover a time span of around fifty-five years, from the early 1910s to the mid-1960s, which translates into one note about every month and a half, or rather one every three and a half months if we count only those Duchamp considered worth publishing during his lifetime. His friend **Julien Levy** (1906–81) suggested that 'Duchamp's fame derives from what he *has not* said and what he *does not* do It is such apparent juggling with time and space that adds significance even to Duchamp's slightest gestures.'[16] Or, as **Man Ray** (1890–1976) said of him in the same year: 'The most insignificant thing you do is a thousand times more interesting and fruitful than the best that can be said or done by your detractors.'[17]

Beyond the 'considerable documentary value'[18] **André Breton** (1896–1966) ascribed to them early on, it is the notes in their typographical rendering, complete with crossings out and changes, and their ephemeral character (often on torn pieces of paper) – more so than his interviews and even his other writings – which are Duchamp's quintessential legacy outside of his visual works. Of course, the latter cannot be separated from the former and vice versa. His notes for the *Large Glass* (1915–23) were to 'complement the visual experience like a guide book'.[19] Some knowledge of the notes is needed to be able to understand

the concepts behind his **readymades** and his major work ***Étant donnés*** (1946–66) as well as his thoughts on merely **retinal** art versus the complexities of **grey matter**, and his notion of the **infrathin** It is by studying them that the reader may catch a rare glimpse of the beautiful, often frustratingly contradictory and hilarious universe that is the mind of Duchamp (**contradictions, humour**).

NUDE DESCENDING A
STAIRCASE NO. 2 [illustration p. 129]

Duchamp's *Nude Descending a Staircase No. 2* (1912) is one of the most iconic images of 20th-century art. Indeed, today entire exhibitions revolve around the works of artists that have paid tribute to the painting.[20] More than a century after its creation it is hard to fathom what all the fuss was about when his own brothers asked Duchamp to take down his *Nude* from the walls of a Cubist show in **Paris** just two months after he had finished painting it. In 1913, at New York's **Armory Show**, the work created such a bemused outcry among the viewers and critics that it was described with mockery as resembling an 'explosion in a shingle factory' or 'a collection of saddlebags',[21] and depicted as 'The Rude Descending the Staircase (Rush Hour in the Subway)'[22] by a contemporary illustrator. Former US president Theodore Roosevelt (1858–1919) compared the painting unfavourably to a Navajo rug

The daughter of its first owner, Frederic C. Torrey (1864–1935) – who bought the painting for $324 – 'often suggested that my dates meet me at a nearby sorority house rather than subject my father to unkind remarks about his treasure'.[23]

The *Nude* is now estimated to be worth in excess of $100 million and is part of the permanent collection of the **Philadelphia** Museum of Art. Duchamp's offence was that his painting subscribed neither to the **Cubist** nor **Futurist** dogmas and that it broke away from hundreds of years of art historical tradition by not presenting the usual passive nude. While Duchamp was inspired by chronophotography, and about twenty different positions of the nude can be made out on the picture plane, what he portrays is not so much motion but rather the idea of movement, also suggested by the three circular dotted lines slightly above the work's centre. 'I wanted to create a static image of movement …. Fundamentally, movement is in the eye of the spectator, who incorporates it into the painting.'[24] Unlike Futurist compositions at the time, the quiet and unassuming brownish palette of his painting indicates that the actual movement is not so much presented to as created by the onlooker. As for painting, Duchamp was at the height of his game, but only a handful of canvases would follow before he abandoned the craft he had perfected.

It was the hurtful rejection of the *Nude* that made Duchamp leave Paris for **Munich**, and it was the work's public success at the Armory Show that encouraged him to travel to **New York**. No work shaped the artist more than *Nude Descending a Staircase No. 2*. His mind was ready to engage in the ideas informing the **Large Glass** (1915–23), his ultimate masterpiece.

ONANISM [above]

Auto-eroticism finds its way into many of Duchamp's **puns**, which is perhaps unsurprising for an artist who introduced his own semen to art (**ejaculate**). In the **Large Glass** (1915–23), the bachelors and the bride indulge in what could be considered masturbatory exercises. While the 'bride-desiring' en route to her orgasm involves a 'stripping voluntarily imagined',[1] her nine bachelors set their complex process of longing into action through the help of a 'chariot', whose repetitive 'litanies' also involve 'onanism'.[2] The turning wheels of the **chocolate** grinder work their magic of solitary pleasures, something Duchamp recognized as a sort of motto when he stated that 'always, there has been a necessity for circles in my life, for, how do you say,

rotation. It is a kind of onanism.'[3] This life was often spent craving for women he could not fully have, like **Maria Martins** (1894–1973), the wife of the Brazilian ambassador to New York. It was in one of his many intimate letters to her, written in 1951, while she yet again had to spend an extended time away from him, that he finally admitted defeat – in the long run, there could never be a substitute for his 'need' for 'physical love': 'There is no ersatz love. It does not exist.'[4]

OPTICS [illustration p. 135]

Why would an artist who had ceased **painting** partly because of his resentment of **retinal** art – which aimed to please the eye instead of engaging the onlooker's **grey matter** – embark on

optical investigations during which he would explore and experiment with the most advanced visual phenomena of his era? Through **film**, **photography** and his **notes**, Duchamp delved into everything from the study of perspective and illusions of spatial depth (*Rotoreliefs*) to stereoscopy, and from anaglyphic techniques to colour contrasts (*Fluttering Hearts*). *Rotary Glass Plates* (1920) and *Rotary Demisphere* (1924) – two elaborate motorized rotating devices, created four decades before the Op Art movement – bear an identical subtitle: *Optique de precision*, or *Precision Optics*. When asked by Serge Stauffer (1929–89) what the term meant, Duchamp answered briefly that it 'mostly meant to paraphrase the advertising signs of opticians'.[5] In an earlier **interview**, he had already suggested that the term could have been employed as 'a compensation for my poor retina condemned to inactivity',[6] perhaps an allusion to his official abandonment of anything merely visual. Yet the 'mostly' of the first quote suggests another layer.

At the same time that Duchamp was preoccupied with his optical experiments, he was also working on the *Large Glass* (1915–23). 'Exactitude' and 'precision'[7] were what he was after, at least in appearance. It is within the Bachelors' Apparatus, the lower region of the *Large Glass*, for example, that the 'oculist witnesses' appear – three circular shapes appropriated from optical charts. They are the eyewitnesses to the bachelors' longing for the bride in the upper half of the work. It is through them, according to Duchamp's notes, that their desire must pass. He said that it had taken 'at least six months'[8] to transfer the drawing of the oculist witnesses onto a silvered section of the glass from which all excess silvering had to be meticulously scratched away afterwards. The process 'demanded high precision. It was precision optics, in short.'[9] The way in which Duchamp employs the **science** of optics in his oeuvre is more cerebral than solely visual, as are his optical devices.

PAINTING

We know from **Robert Lebel** (1901–86) that Duchamp's 'career as a painter was interrupted almost exactly on his twenty-fifth birthday.'[1] The artist collaborated closely with his first biographer, which is why assertions like this may be traced back safely to Duchamp himself, who celebrated this birthday while in **Munich** in 1912. Although *Tu m'* (1918) is generally regarded as his last painting, after *Bride* (1912) he executed only three painted canvases in the next six years – all of which were studies for the *Large Glass* (1915–23). Duchamp was a gifted painter, with a penchant for the nude. From his first painting, *Landscape at Blainville* (1902), he experimented with many styles and schools. Starting out with Impressionism, he swiftly moved on to Fauvism and post-Impressionism before settling on **Cubism** and **Futurism**, until he found and perfected his own style determined 'to put painting once again at the service of the mind'.[2] Soon, however, his ideas and intellect outgrew easel painting, and he simply stopped. As he became more occupied with fields of thought outside art, he denounced the 'olfactory masturbation'[3] (**onanism**) of his colleagues, the emotional rush brought about by the smell of paints and tubes. Despite this, Duchamp repeatedly spoke out against the French saying 'bête comme un peintre', or 'stupid as a painter', wondering why the artist should 'be considered less intelligent than the average man'[4] (**stupidity**).

PARIS

In 1904, after graduating from high school in Rouen, Duchamp left for Paris at the age of seventeen to join his brothers and to study painting at the Académie Julian. Between 1908 and 1913 Duchamp established his studio in Neuilly (**death**), a wealthy suburb just outside the French capital, until leaving for **New York** in 1915. He returned to Paris after the end of the First World War and settled there from late 1923 to early 1941, when he had to flee the German occupation. Throughout his life, Duchamp travelled widely, but Paris and New York, both mentioned on the label designed for his **readymade** perfume bottle *Belle Haleine* of 1921 – incidentally the same year Chanel No. 5 was launched – were the cities most important to him. It was in Paris that many of his enduring friendships were forged and some of his greatest works were created. His readymade *Paris Air* (1919), an emptied and resealed glass ampoule containing Parisian air, pays poetic tribute to the city, no matter how much he might have dismissed it as finished and old-fashioned during his first visit to New York. 'I am not going to New York, I am leaving Paris',[5] he underlined in a letter to Walter Pach (1883–1958) in 1915.

'PATAPHYSICS

This whole 'new **science** that deals with the laws that govern exceptions and will explain the universe supplementary to this one'[6] must have appealed strongly to Duchamp and his thoughts on 'Playful Physics'.[7] Invented by the French 19th-century writer and punning satirist Alfred Jarry (1873–1907) (**literature**), the science of imaginary solutions, as Jarry described it, also involved non-Euclidean geometry (*Three Standard Stoppages*). Duchamp had always been interested in 'a reality which would be possible by slightly distending the laws of physics and chemistry'.[8] Although he admitted that there was 'no direct influence' of the proto-Surrealist on his own work, he did refer to François Rabelais (1494–1553) and Jarry as 'my gods, evidently' (**God**).[9] In 1935, Duchamp designed an opulent leather book binding for Jarry's 1896 play, *Ubu Roi*. The artist joined the Collège de 'Pataphysique in 1952 and was announced a Transcendent Satrap the following year, a title he shared with the Marx brothers.

PAYSAGE FAUTIF

See **ejaculate**.

OCTAVIO PAZ

Any artist would appreciate the lavish attention of a Nobel Prize winner. Although Octavio Paz (1914–98) did not win his for literature until 1990, having written about Duchamp back in 1966, his essay must nevertheless have greatly pleased the artist, who was very fond of poetry. At the time of writing, Paz, a poet and critic with a penchant for **Surrealism**, was the Mexican ambassador to India, and Duchamp encouraged the French translation of this unpublished work. The publication of the small volume entitled *Marcel Duchamp or the Castle of Purity* coincided with a gallery show in Paris and appeared as a limited edition in 1967. The first 100 copies included sixteen serigraphs by the artist, which, when put together, depicted white blurry shadows of the *Bicycle Wheel* (1913) and *Bottle Dryer* (1914).

When discussing Duchamp's *Large Glass* (1915–23), Paz evokes Hindu rituals, the Tantric tradition and **alchemy** and, in another essay written in 1972, the goddess Diana. In the preface of his biography on Duchamp, Calvin Tomkins (b. 1925) dismisses Paz's conclusion that the *Large Glass* is 'a comic and infernal portrait of modern love'.[10] However, when it comes to creating a beautiful narrative and describing Duchamp in literary instead of art historical terms, no one else has come close to the poetry of Paz's sentences: 'The relation of Duchamp to his creations is contradictory and cannot be pinned down: they are his own and they belong to those who contemplate them' (**contradictions**); 'Duchamp was a painter of ideas right from the start and he never yielded to the fallacy of thinking of painting as a purely manual and visual art'; 'The Ready-made is a two-edged weapon: if it is transformed into a work of art, it spoils the gesture of desecrating it; if it preserves its neutrality, it converts the gesture into a work.'[11]

PENIS

'I want to grasp things with the mind the way the penis is grasped by the vagina.'[12] (**vagina**)

PERSPECTIVE [illustration p. 140]

One of the most frequently cited images when discussing Duchamp's use of perspective is Albrecht Dürer's (1471–1528) woodcut of 1525. It features an artist observing a barely covered woman through a tabletop grid and drawing her onto a corresponding geometrical pattern laid out before him. The implied voyeurism in the Dürer woodcut gains ground if we liken the woman to the female figure in Duchamp's *Étant donnés* (1946–66), where the viewer's perspective is strictly limited to the two peepholes through which she can be seen. It is believed that Duchamp, while working at the **Bibliothèque Sainte-Geneviève** in

Paris in 1913, studied the library's rich collection of works on the science of perspective, among them *Thaumaturgus Opticus* (1646) by Jean François Niceron 1613–46). Here, the young Duchamp delved into the world of anamorphosis, *trompe-l'oeil*, vanishing points, the illusion of optics and distortion, all of which would inform his later work.

Of the fifteen **notes** loosely gathered in the black envelope titled 'Perspective' within his *White Box* (1967) (**boxes**), many deal with the **fourth dimension**. According to Duchamp, the Bride's Domain of his *Large Glass* (1915–23) is presented' in the fourth dimension, while the Bachelors' Apparatus of the lower glass panel remains steeped in three-dimensional central perspective. From his optical devices (**optics**) to his small glass work titled *To be Looked at (from the Other Side of the Glass) with One Eye, Close to, for Almost an Hour* (1918) and *Clock in Profile* (1964), the artist constantly toyed with the perspective of the viewer as well as that of the object viewed.

Art historian Craig Adcock (1945) writes that Duchamp 'believed that, just as how we use a particular geometry to interpret the shape of the world is largely a matter of discretion, as **Henri Poincaré** [1854–1912] argued, so too is our choice of the interpretive frameworks that we use in making our aesthetic judgments. As an artist, Duchamp was engaged in self-referential, contemplative activities. He tried to look at himself seeing, and by so doing, to dislocate himself from

the center of his own perspective.'[13] More cryptically, Duchamp included a similar thought in one of his notes in the *Box of 1914*: 'linear perspective is a good means of representing equalities in diverse ways, i.e. the equivalent, the similar (homothetic) and the equal blend together in perspective symmetry.'[14] The discipline of linear perspective relinquished Duchamp from the tyrannies of personal taste, freehand and avant-garde artistic practice. At the very least, the representational function of perspective – to display worlds, whether they be real or imaginary – allows it to present any subject on equal terms. This prevents Duchamp from being the focal point of his work – or the centre of attention.

PHILADELPHIA

In the movie *Rambo* (1982), Sylvester Stallone (b. 1946) plays a Vietnam War veteran of the same name, the pronunciation of which is identical to the last name of the late 19th-century French poet Arthur Rimbaud (1854–91). The latter is well known for having stopped writing as suddenly as Duchamp ceased to paint. One of the most iconic movie scenes of all time shows the actor running up the seventy-two stone steps leading to the main entrance of the Philadelphia Museum of Art, which was completed in 1919. In the boxing drama *Rocky* (1976), as well as in four of its sequels, these steps, with Stallone standing at the top of them,

arms raised, also feature prominently and have become known as the 'Rocky Steps'.

The unique and internationally renowned collection of the Philadelphia Museum of Art contains most of Duchamp's major works, including *Nude Descending a Staircase No. 2* (1912), the *Large Glass* (1915–23), *Étant donnés* (1946–66) and all of his **readymades**, either in the original versions or later editions. For *Rocky III*, a bronze statue, later donated to the city by Stallone, was placed at the top of the steps. Its location triggered a decades-long debate between the museum, Philadelphia's art commission and die-hard fans of *Rocky* about what is considered art and what is not – all this within the immediate vicinity of the readymades, which, one could argue, had started it all. In 2006, the statue of Rocky Balboa, arms extended above his head, was finally installed at the bottom of the steps. In 1876, the monumental Statue of Liberty, with its raised arm, was displayed in Philadelphia on the occasion of the Centennial Exhibition – it was not assembled on New York City's Liberty Island until 1886. In *Étant donnés*, the woman's arm holding up a gas lamp closely resembles Lady Liberty's right arm clasping a torch.

PHILOSOPHY

One of Duchamp's close friends claimed that he would be 'known as a greater philosopher than an artist'.[15] However, if any philosophy was a guiding principle for Duchamp, it was that of **eroticism**. References to philosophers throughout his **notes** and oeuvre are scarce. As he had studied the ancient Greeks in school, comparisons have been made between the non-judgmental skeptic philosophy of Pyrrho (*c.* 360–*c.* 270 BC) and Duchamp's embracing of **indifference**. However, the artist did not invite such associations. He wholeheartedly dismissed the 'horribly boring philosophers of the 19th century'[16] as well as René Descartes (1596–1650), although he admitted that he had never even read his work. Despite this, he sometimes referred to himself as a Cartesian, drawn to the philosopher's capacity for **doubt**. He did read the work of Henri Bergson (1859–1941), taking inspiration from his joint interests in **science** and **art**.

Duchamp also acknowledged the influence of Friedrich Nietzsche (1844–1900). In one of his notes, the artist appropriates the philosopher's concept of 'eternal return' as 'a neurasthenic form of a repetition in succession to infinity'.[17] As a young man, Duchamp read *The Ego and its Own* (1845) by **Max Stirner** (1806–56), the one philosopher he truly came to cherish and whose uncompromising belief in **individualism** lies at the core of the artist's own worldview. As for philosophers of the second half of the 20th century, Duchamp himself has influenced the writings of Jean Baudrillard (1929–2007), Arthur C. Danto (b. 1924), Gilles Deleuze (1925–95), Félix Guattari

(1930–92) and Jean-François Lyotard (1924–98), who published *Les transformateurs Duchamp* in 1977, which focuses on *Étant donnés* (1946–66).[18]

PHOTOGRAPHY

Duchamp's answer to camera pioneer Alfred Stieglitz's (1864–1946) 1922 survey 'Can Photography have the Significance of Art?' is rather straightforward: 'You know exactly how I feel about photography. I would like to see it make people despise painting until something else will make it unbearable.'[19] As to what might follow, Duchamp – always interested in the latest scientific and technological developments – suggested in the 1960s that 'you may be able to see an art show in Tokyo simply by pushing a button',[20] while advanced techniques and 'the phenomenon of light' could 'become the new tool for the new artist'.[21]

Duchamp had a great interest in photography. His fascination with chronophotography and the pioneering works of Eadweard Muybridge (1830–1904) and Étienne-Jules Marey (1830–1904) in part inspired the fragmented, moving body of *Nude Descending a Staircase No. 2* (1912). He explored virtually all of photography's facets in hinged-mirror multiple portraits, film stills, stereoscopy, close-ups and enlargements, *trompe-l'oeil* and illusionary imagery, questions of **perspective** and **optics**, 3D, photocollages, overexposure, time-lapse pictures as well as alterations and retouching of all kinds. His portrait was taken by some of the most successful photographers of the 20th century, including **Man Ray** (1890–1976), with whom he often collaborated, Richard Avedon (1923–2004), Irving Penn (1917–2009), Edward Steichen (1879–1973) and Stieglitz.

FRANCIS PICABIA

'I've never been a bond-ish man, because I don't believe in talking', Duchamp admitted to Calvin Tomkins (b. 1925) in 1964, providing a reason for why he 'never' had 'very close friendships'[22] with artists. There were exceptions, of course, and he hastened to name the poet and painter Francis Picabia (1879–1953) as an early and 'close friend'.[23] According to Duchamp, theirs 'was a man to man friendship. One could even see a homosexuality in it, if we were homosexuals. We are not, but it comes back to the same.'[24] Although there was little collaboration between Duchamp and Picabia, **Henri-Pierre Roché** (1879–1959) remarked that 'when those two were together, sparks were bound to fly'.[25] The artist himself spoke of 'exploding ideas'.[26] Many years after Picabia's death, Duchamp called their pairing 'a strange match. A sort of artistic pederasty. Between two people one arrives at a very stimulating exchange of ideas. Picabia was amusing. He was an iconoclast on principle.'[27] (**iconoclasm**). The two got

to know each other in Paris in 1910 and, from the outside, they could not have been more different. Picabia was eight years his senior, flamboyant, financially independent and in love with women, **automobiles**, alcohol and opium – not necessarily in that order. Duchamp, on the other hand, was a young, inexperienced notary's son from the countryside who soon fell in love with **Gabrielle Buffet-Picabia** (1881–1985), his new friend's wife. She found the two men 'of very different temperaments and conceptions', and as 'opposed in their reactions as in their methods'.[28] However, 'they emulated one another in their extraordinary adherence to paradoxical, destructive principles, in their blasphemies and inhumanities which were directed not only against the old myths of art, but also against all the foundations of life in general.'[29]

In New York, from 1915 onwards, the friendship between the two artists intensified and they both engaged in **Dada** activities and mechanist drawings, 'joining nothing and craving no notoriety'[30] as Duchamp phrased it. It was Picabia who had convinced his artist friend to meet him abroad and they remained close until his death in 1953. In 1926, with an inheritance from his father, Duchamp bought and successfully sold dozens of works by Picabia, whose pioneering abstract work and perpetual stylistic inventions Duchamp held in high esteem. 'He could be called the greatest exponent of freedom in art, not only

against academic slavery, but also against slavery to any given dogma',[31] he wrote in 1949. To Duchamp, Picabia was 'the type of artist who possesses the perfect tool: an indefatigable imagination'.[32]

PABLO PICASSO

Pablo Picasso (1881–1973) and Marcel Duchamp first met in **Paris** around 1912 and the young French artist's cubistic experiments were certainly indebted to the paintings of the already well-established Spaniard. However, there was no love lost between them and often they are seen as the two great opposing forces of 20th-century art: painting versus anti-painting, sensuality versus sabotage, as Robert Motherwell (1915–91) remarked,[33] or, as **Octavio Paz** (1914–98) once wrote, they both 'succeeded in defining our age: the former by what he affirms, by his discoveries; the latter by what he negates, by his explorations.'[34]

Duchamp may have taken some cues from Picasso when it came to staying aloof or withholding statements about his own work, and not taking any one position or being lured into the great movements of the time. Yet he frequently referred to Picasso's stardom in a rather derogatory way[35] and told an interviewer in 1933 that 'the modern artist must hate Picasso in order to make something new',[36] as in his opinion there were still too many individuals dabbling in **Cubism**. Another rather cryptic remark to Jasper

Johns (b. 1930), 'I like Picasso, except when he repeats himself',[37] was left unexplained. In contrast, for the catalogue of the **Société Anonyme**, Duchamp praised Picasso as having 'never shown any sign of weakness or **repetition** in his uninterrupted flow of masterpieces'.[38] On the occasion of the major Duchamp retrospective at the Palazzo Grassi, Venice, in 1993, its curator Pontus Hultén (1924–2006) remarked in the catalogue's preface: 'If, in 1953, somebody had said that forty years later Duchamp's work would be considered more important than Picasso's, that person would have been looked on as a madman.'[39] It was because of this rising influence, especially among younger artists, that an ever-competitive Picasso came to despise him.[40] When he learned of Duchamp's death, he said, after a long pause, 'He was wrong!',[41] while proclaiming of contemporary artists, They loot Duchamp's store and change the wrapping.'[42]

HENRI POINCARÉ

The mathematician, physicist and philosopher Henri Poincaré (1854–1912) died of a heart attack in Paris on 17 July 1912. Duchamp was in **Munich** at the time and, considering his knowledge of the German language, must have learned of his death through the daily newspapers there, which mourned him as 'the greatest mathematician of our time' and as the 'king of **science**'.[43] Poincaré's popular

science writings were read widely among artists in France. Much has been made of his influence on the young Duchamp, who mentioned the scientist repeatedly in the context of his own studies on the **fourth dimension**.

It is to the credit of scholars Craig Adcock (b. 1945) and Linda Dalrymple Henderson (b. 1948) that they discuss Poincaré's revolutionary thoughts in relation to Duchamp's own, discovering parallels in their joint rejection of absolutes and their firm belief in the relativity of human knowledge.

POLITICS

As he was convinced that 'art never saved the world',[44] politics and social causes did not mean much to Duchamp. His friend Gianfranco Baruchello (b. 1924) called him 'entirely apolitical'.[45] We know that he voted for the Democratic candidate Lyndon B. Johnson (1908–73) in 1964, if only to please his wife **Alexina Sattler** (**Teeny**; 1906–95). Although he volunteered for a year of military service when he turned eighteen, Duchamp quickly came to oppose concepts such as militarism and patriotism. He avoided both world wars by living in exile and considered himself 'very pacifist'.[46] Politics were a myth to him, just as **science** was, a remark prompted by the nuclear bomb that was dropped on Hiroshima on 6 August 1945.[47]

Direct references to politics remain playful and ambiguous in Duchamp's work. Two names of American presidents are blended together in the 'Wilson-Lincoln system' of the *Large Glass* (1915–23), an unrealized part of the complex machinery of the Bachelors' Apparatus, which attempts to channel their desire towards the bride. For the 1945 cover design of *View* magazine, he incorporated a wine bottle whose label consisted of a page from his military papers. Two years earlier, in the midst of the Second World War, he was asked to create the cover for an issue of *Vogue* magazine. He overlaid the profile of George Washington (1732–99) on a map of the USA and filled in his silhouette with the American flag. The editors rejected the design in shock as the gauze partly soaked with iodine to resemble the red and white of the flag was too reminiscent of dripping blood, violence and death.

'I don't understand anything about politics, and I say it's a really stupid activity, which leads to nothing', Duchamp said in 1966. 'Whether it leads to communism, to monarchy, to a democratic republic, it's exactly the same thing as far as I'm concerned. You're going to tell me that men need politics in order to live in society, but that in no way justifies the idea of politics as a great art in itself. Nevertheless, this is what politicians believe; they imagine themselves doing something extraordinary!'[48]

POP ART

Duchamp seems to have been fonder of Pop Art than he was of **Abstract Expressionism**. He was curious about **Andy Warhol** (1928–87) and often voiced his admiration for Jasper Johns (b. 1930) and Robert Rauschenberg (1925–2008) both of whom were greatly inspired by Duchamp's writings. Comparing Pop Art to **Dada**, Duchamp claimed that 'Pop Art appeals to and is financially supported by members of the upper society – cultured bourgeoisie. Acceptance of Dada was impossible when it flourished.' Nevertheless, he praised the Pop Art movement's 'return to "conceptual painting, virtually abandoned, except by the **Surrealists**, since Courbet, in favor of **retinal** painting.' He believed it to be 'good that a group of young men do something different. The deadly part of art is when generation after generation copies one another.'[49]

POSTERITY

'Artists who, in their own lifetime, have managed to get people to value their junk are excellent traveling salesmen, but there is no guarantee as to the immortality of their work',[50] Duchamp wrote in a letter to his sister. 'And even posterity is just a slut that conjures some away and brings others back to life ... retaining the right to change her mind every 50 years or so.'[51]

PROGRESS

'There is no progress in art. There might be progress in civilization – which I don't believe at all – but in art, I am sure it does not exist.'[52]

PSEUDONYMS [illustration p. 147]

As befits the complex and often contradictory nature of Duchamp and his work, it should not come as a surprise that he was known by many names, effortlessly swapping nationalities as well as gender (**contradictions**). Besides his third Christian name, some friends called Henri Robert Marcel Duchamp simply Totor (**Henri-Pierre Roché**, 1879–1959) or Dee (**Katherine S. Dreier**, 1877–1952). In their correspondence, **Constantin Brâncuși** (1876–1957) and Duchamp used the mutual pet name Morice. Duchamp's letters to his young New York artist friend **Ettie Stettheimer** (1875–1955) were signed anything from Stone of Air to Duche. MarSélavy, Marcelavy, Marcel Rrose, Marcel à vie, Selatz, Duch and even Rrrose were also in frequent use. Instead of with a name, his love letters to **Maria Martins** (1894–1973) were signed Love, or Amour or just M.

The artist's most famous pseudonym was **Rrose Sélavy**, with which he signed many of his works. Besides using the nom de plume **R. Mutt** on his urinal *Fountain* (1917), his **readymade** poster *Wanted: $2,000 Reward* (1923), onto which

he pasted two photographs of himself, offers the money 'for information leading to the arrest of George W. Welch, alias Bull, alias Pickens, etcetry, etcetry' who also 'operated a bucket shop in New York under the name Hooke, Lyon, and Cinquer' (a **pun** on the phrase 'hook, line and sinker'). A posthumously published and unfinished novel by Roché is titled *Victor*, referring to the protagonist based on Duchamp. The phonetic rearrangement of Marcel Duchamp into the name Marchand du Sel (or Salt Seller), a pun created in the early 1920s by none other than Rrose Sélavy, was used for the title of his first collected writings in 1958.

PUNS [opposite]

Duchamp's distrust of **language** and words comes together with his sense of **humour** in his frequent use of puns. In **literature**, Duchamp cherished the elaborate system of wordplays in the works of **Raymond Roussel** (1877–1933) and Alphonse Allais (1854–1905). From the captions of his early cartoon drawings and *L.H.O.O.Q.* (1919) to his perfume bottle *Belle Haleine* (1921) and his inscribed discs of *Anémic Cinéma* (1926) (**films**), Duchamp's puns are found throughout his oeuvre, **notes** and correspondence as well as in the dozens of wordplays, allusions, anagrams and alliterations that he concocted for his artist friends. Many of his quips are

pornographic, or at least sexually explicit; others are outright bizarre.

What is important, though, is that puns go against the static logic of reality by decontextualizing and displacing words in subversive ways, not unlike the mass-produced objects that were chosen as **readymades**. 'I like words in a poetic sense. Puns for me are like rhymes', he told Katherine Kuh (1904–94), 'just the sound of the word alone begins a chain reaction. For me, words are not merely a means of communication. You know puns have always been considered a low form of wit, but I find them a source of stimulation both because of their actual sound and because of unexpected meanings attached to the interrelationships of disparate words. For me, this is an infinite field of joy – and it's always right at hand. Sometimes four or five different levels of meaning come through. If you introduce a familiar word into an alien atmosphere, you have something comparable to distortion in painting, something surprising and new.'[53] Any entry on Duchamp's puns within a book published in English must fall short of being able to fully present the beauty of his wordplays as most of them are in French and remain untranslatable, or at least lose their wit and zest. The following examples were all originally written in English: 'My niece is cold because my knees are cold';[54] 'A Guest + A Host = A Ghost';[55] 'gin and virgin';[56] 'asstricks';[57] 'daily lady';[58] 'scrambled legs';[59] 'Swiss side (suicide)';[60] and 'elevator boy – or the indoor aviator'.[61] In fact, the last one is not a pun, but it is a great image!

Q–E5 [above]

According to Francis M. Naumann (b. 1948), move number twenty-three with the white Queen from e6 to e5 constitutes Duchamp's best ever move as it caused his opponent, E. H. Smith, to resign during the second round of the team match Joueurs d'Échecs de Nice vs. L'Échiquier Hyérois, in the Hyères-les-Palmiers chess tournament of January/February 1928 (**chess**).

QUICK ART

'Quick art, that's been the characteristic of the whole century from the **Cubists** on. The speed that's being used in space, in communications, is also being used in art. But things of great importance in art have always to be slowly produced.'[1] Duchamp's stance against the increasing **commercialism** of the art world and its constant need for new works anticipated early on what would only become worse. However, when he 'boast[ed] of having introduced **laziness** in the arts',[2] it was not the full story. He simply took his time, sometimes as much as twenty years, to create a single artwork. **Gabrielle-Buffet Picabia** (1881–1985) commented: 'His dominant urge ceaselessly to control each element of his work, implacably to track down everything it might harbor of a traditional nature explains why it's proved sparse and slow.'[3] Duchamp's first catalogue raisonné listed only 209 original works, but, apparently due to art market forces, by 2000 this number had increased to 663 in the third edition of **Arturo Schwarz**'s (b. 1924) catalogue.

MAN RAY

The avant-garde photographer and painter Man Ray (born Emmanuel Radnitzky, 1890–1976) was one of Duchamp's closest artist friends. The two were involved in a life-long creative exchange, and their rich discussions revolved around topics such as exhibitions, publications, relationships with gallerists, collaborative business dealings in art, chess matches and projects in support of the chess foundation. They came to know each other in 1915, when Duchamp arrived in New York, and both joined the city's art scene, including long nights among the creatives at **Walter Arensberg**'s (1878–1954) apartment. Man Ray was lucky to survive an incident at Duchamp's studio in the late 1910s, when he turned on the motor of an early version of his friend's *Rotary Glass Plates (Precision Optics)* machine (**optics**). The glass panels, arranged symmetrically around a central axis, accelerated and started 'whirling like an airplane propeller' followed by a 'crash like an explosion with glass flying in all directions'.[1]

In 1920, Man Ray and Duchamp founded the **Société Anonyme** with **Katherine S. Dreier** (1877–1952), and in 1921 published their single issue of *New York Dada*. Man Ray, who documented Duchamp's work (***Dust Breeding***) and, among many other portraits, took the famous pictures of his friend in drag as **Rrose Sélavy**, was later entrusted by Duchamp to purchase another bottle dryer as a **readymade** for a 1936 Surrealist show in Paris and to create a limited edition of his *Female Fig Leaf* (1950) (**erotic objects**) in 1951. 'While

few understood his enigmatic personality and above all his abstinence from painting', Man Ray later wrote in his autobiography, 'his charm and simplicity made him very popular with everyone who came in contact with him, especially women.'[2] Looking back upon his artistic achievements, in 1949 Duchamp called his friend one of the 'old masters of Modern Art'.[3]

For an exhibition in London in 1959, Duchamp wrote a fake dictionary entry for the catalogue, 'Man Ray, n.m. synon. de joie jouer jouir',[4] identifying his friend with joy, play and orgasm. When asked to provide a eulogy after Duchamp's **death**, Man Ray, who had dined with Duchamp the night he passed away, submitted only a few enigmatic lines: 'With a little smile on his lips / His heart had obeyed him and had / ceased beating / (as formerly his work stopped) / Ah yes, it is tragic as an end game / in chess / I shall not tell you any more.'[5] As for keeping secrets, Man Ray may have been one of the very few friends who had prior knowledge of Duchamp's *Étant donnés* (1946–66). Executed with only a few brushstrokes, *Hommage à Marcel Duchamp*, Man Ray's cover for the Duchamp number of the magazine *Art and Artists* of July 1966, shows the body of a nude woman. Three years later, this study evolved into a painting entitled *Virgin* (1969). With her legs spread apart and her face hidden away, the depiction is not unlike the female torso at the centre of *Étant donnés*.

READYMADE

'I'm not at all sure that the concept of the readymade isn't the most important single idea to come out of my work',[6] Duchamp related to an interviewer about half a century after he had first signed and inscribed mass-produced objects in 1913–14. While his own contradictory statements regarding the readymades changed significantly over time, the artist never gave a single definition of what constituted a readymade, or what the readymade itself defined: 'The real point of the readymades was to deny the possibility of defining art'[7] and the 'curious thing about the readymade is that I've never been able to arrive at a definition or explanation that fully satisfies me. There's still magic in the idea, so I'd rather keep it that way.'[8]

The *Dictionnaire abrégé du surréalisme* (1938), however, provides a clear-cut definition of the term followed by Duchamp's initials, but closer inspection reveals that it was in fact written by **André Breton** (1896–1966), who had used the same words in his 'Lighthouse of the Bride' essay on the *Large Glass* (1915–23) three years earlier: 'manufactured objects promoted to the dignity of art through the choice of the artist'.[9] It is this definition that still holds true for many Duchamp scholars, art historians and artists – pick an object, change its context, call it art and there you go. Yet this diluted version of 'anything goes' does more harm than justice to the elaborate conceptual

thought process behind the idea of the readymade. Certainly, the readymades' original **iconoclasm** has long been lost, as Duchamp himself noticed early on when he agreed to the **edition of 1964–65**. Their belated recognition, despite their early shock value, now places them at the centre of one of the greatest achievements and significant sculptural interventions of 20th-century avant-garde art. While Duchamp did not entirely dispute Breton's definition, he did once describe a readymade as 'a work of art without an artist to make it',[10] while at the same time saying 'please note that I didn't want to make a work of art out of it.'[11] What then are we to make of a *Bicycle Wheel* (1913), a *Bottle Dryer* (1914), a snow shovel, a typewriter cover, a *Hat Rack* (1917), a coat rack, a urinal (*Fountain*, 1917), a *Comb* (1916), or a reproduction of the Mona Lisa with a goatee and moustache drawn upon it (*L.H.O.O.Q.*, 1919)? The term itself came to Duchamp two years after his first readymade was conceived, on his arrival in New York in 1915, possibly when looking up the French term *tout-fait* in a dictionary.

'Limit the no. of rdymades yearly (?)',[12] Duchamp wrote in one of his **notes**, as he wanted to keep the idea pure, and 'there's a danger of making too many', not least because 'anything, however ugly it may be, will become pretty after forty years'.[13] The readymades were an attempt to discredit the handmade and to escape from

taste as well as from an artistic sense of god-like creation and mere visual pleasure, employing strategies of **chance** and aesthetic **indifference** instead. Another 'important characteristic was the short sentence which I occasionally inscribed on the "readymade"', as was 'its lack of uniqueness'.[14] The question of choice was essential, either intentionally inviting randomness, as in a blind date or **rendez-vous**, or following complex instructions: 'Look for a Readymade / which weighs a weight / chosen in advance first decide on a / weight for each year / and force all Readymades / of the same year to be the same weight.'[15] Besides the works that are now regarded as readymades, there were others that were unrealized or were never turned into an edition, for example: 'buy a pair of ice-tongs as Rdymade'.[16] In 1918, he wrote to a friend that 'a very funny article in the Tribune is a "Ready made." I signed it, but didn't write it.'[17]

The originals of the readymades realized by Duchamp in the 1910s are virtually all lost and, except for a few occasions, he made no effort to exhibit them for four decades. However, he did hang some of them from the ceiling of his New York studio in 1917, and attached others to the floor or rotated them by 90 degrees, as with his urinal *Fountain* (1917). Primarily, the readymades were 'a very personal experiment that I had never intended to show the public'[18]. They are souvenirs of Duchamp's speculations revolving around his preoccupation with **grey matter**, the **fourth dimension**,

the casting of **shadows**, non-Euclidean geometry (**mathematics**), **perspective**, **science** and **nominalism**. He 'made them with no intention other than unloading ideas'.[19] It is with the readymades that Duchamp said he 'wanted to change the status of the artist or at least to change the norms used for defining an artist'.[20] After more than a hundred years and despite their original subversiveness having lost its sting, many of these iconic objects are still making us question **art**, **art history** and what it is that constitutes an **artist** (*Box-in-a-Valise*, **doubt**, **graffiti**, **humour**, **infrathin**, **irony**, **Munich**, **R. Mutt**, **Octavio Paz**, **repetition**, **replica**, **retinal**, **Arturo Schwarz**, **titles**, **unrealized projects**).

RENDEZ-VOUS [opposite]

Duchamp described the moment of randomly choosing an object for a **readymade** as 'a kind of rendez-vous'[21] between the person making the choice and the item. For the rendez-vous to take place, 'the moment to come (on such a day, such a date, such a minute)' has to be predetermined: 'The important thing then is just this matter of timing.'[22] What Duchamp refers to here is a blind date rather than a rendez-vous, in a similar vein to Comte de Lautréamont's (1846–70) quotation of 1868, much endorsed by the **Surrealists**, in which he describes beauty as a 'fortuitous encounter upon a dissecting-table of a sewing-machine

and an umbrella'.[23] As for the artist, he also specifies that the 'date, hour, minute' should 'naturally [be] inscribe[d] ... on the ready-made as information.'[24] His work entitled *Rendez-vous* (1916) consists of four postcards each bearing a typewritten text as well as the date and time: 'Dimanche 6 Février 1916 à 1h ¾ après midi' ('Sunday, 6 February 1916, 1.45 p.m.'). Eleven days later, he inscribed a comb with a short sentence and, again, the date and time: 'FEB 17 1916 11 A.M.' Duchamp's *Comb* (1916) is the only original readymade still in existence. The inscription on the *Comb* ('Three or four drops of height have nothing to do with savagery') appears as nonsensical as the text in *Rendez-vous*. However, rather than this being a found text of automatic writing, Duchamp had in fact toiled over the words for many weeks, to 'avoid' any 'meaning', so that they would 'finally read without any echo of the physical world'.[25]

REPETITION

With editions, **replicas**, miniatures and differing versions of many of his own works in existence, which Duchamp himself often recycled and incorporated back into much of his art, it may come as a surprise that he frequently stated how much he loathed repetition: 'The idea of repeating for me is a form of masturbation'.[26] He felt that doing the same thing over and over again hampered true invention, creativity and independence while

at the same time leading to **boredom**, habitual conformity and commercial success. He therefore could not bear those artists who 'think they can repeat, repeat, repeat, and repetition is good. Because you know why? So the collectors can collect.'[27] (**collecting**). In order to avoid the trap of **taste**, he forced himself not to repeat his works, as, just like taste, 'repetition has been the great enemy of art in general, I mean formulas and theories are based on repetition.'[28] Duchamp's friend **Salvador Dalí** (1904–89), in his preface to Pierre Cabanne's (1921–2007) *Dialogues with Marcel Duchamp* (1967), used even stronger words: 'The first man to compare the cheeks of a young woman to a rose was a poet; the first to repeat it was possibly an idiot.' [29] **Robert Lebel** (1901–86) wondered why Duchamp included so many **replicas**, editions and copies in his oeuvre if he found repetition 'not only unthinkable but, what is more, impossible'.[30] Besides the artist's infamous **indifference**, Lebel points towards his 'absolute ambivalence and **humour**'[31] as potential explanations. Yet there is another possibility, reinforced by Duchamp's posthumously published **notes** about the **infrathin**: 'nothing can ever be fully identical to the unique',[32] writes Lebel. It would have been easy for Duchamp to continue painting in the style of his *Nude Descending a Staircase No. 2* (1912) or to churn out more **readymades**. Instead he consciously kept his creative output small and, wherever superficial visual comparisons suggest

repetition, Duchamp's intricate game of infinitesimal differences in appearance size and colour comes into play.

REPLICA

In a brief talk that Duchamp gave at the Museum of Modern Art in New York in 1961, he embraced the **readymades** 'lack of uniqueness', maintaining that 'the replica of a readymade' was 'delivering the same message'.[33] Accordingly, he allowed, commissioned, authorized, certified and signed objects as readymades that acquaintances and others brought to him. He also occasionally asked close friends to pick up or buy mass-produced objects resembling his original readymades, almost all of which by the 1920s had been lost, thrown away or (accidentally) destroyed. In 1936, **Man Ray** (1890–1976) was called upon to pick up a bottle dryer at the same Paris department store where Duchamp had bought his in 1914. In 1962, the German curator Werner Hofmann (1928–2013) was asked to do the same. **Henri-Pierre Roché** (1879–1959), in 1949, closely following Duchamp's instructions about where to get hold of it, acquired another glass ampoule for *Air de Paris* (1919) as the original had been broken. Upon the request of the artist in 1950, **Sidney Janis** (1896–1989) selected a urinal resembling the lost readymade *Fountain* (1917) Duchamp often authenticated objects by signing them 'pour copie conforme'

or 'certified true copy' (also punning on 'poor copy confirm'), in the way that his notary father would have signed documents to assign a copy the same legal status as the original. However, after the art dealer **Arturo Schwarz** (b. 1924) had issued the **edition of 1964–65** of fourteen readymades, collaborated on dozens of numbered and signed etchings, and reissued many of his other works, Duchamp's nonchalant attitude towards replicas came to a halt.

Replicas of Duchamp's works did not stop with the readymades, though. The talented Swedish art scholar and curator Ulf Linde (b. 1929), who had been given early blanket permission by the artist to create replicas of his work, built the first copy of the *Large Glass* (1915–23) for Pontus Hultén's (1924–2006) groundbreaking *Rörelse i Konsten* exhibition at Stockholm's Moderna Museet in 1961. For a show at Tate Modern in 1966, Duchamp authorized yet another version of the *Large Glass*, as the cracked original was too fragile to leave the **Philadelphia** Museum. For his *Box-in-a-Valise* the artist painstakingly created miniature models of some of his most important works.

Duchamp intentionally blurred the lines between the original and the copy: just as the **shadows** of actual objects could themselves be readymades, so a replica's status could be equal to that of the original. As his idea regarding replicas involved the negation of the aura of the original, there was a more subtle game at play as well, which becomes apparent when consulting his **notes**: '2 "similar" objects i.e. of different dimensions but one being the replica of the other, could be used to establish a 4-dim'l perspective'[34] (**fourth dimension**). According to **Robert Lebel** (1901–86), Duchamp knew 'that the replicas of his objects, although mathematically true, have but an approximate relationship to the original.'[35] The artist, after all, was keen to avoid **repetition**, and upon close observation of the various replicas and editions of his readymades, there is none to be found. Moreover, his **notes** about the **infrathin** are full of references to casts and moulds, which, as another form of replica, were essential to the creative process behind the 'malic moulds' in the Bachelors' Apparatus of the *Large Glass* and also informed his **erotic objects** and *Étant donnés* (1946–66). What all of these jottings have in common are his thoughts about the minuscule differentiations one can make out between objects, be they mass-produced or cast from the same mould. Duchamp's *Large Glass* was meant to be 'the sketch (like a mold) for a reality which would be possible by slightly distending the laws of physics and chemistry'.[36]

RETINAL

Duchamp defined retinal as a 'completely nonconceptual'[37] approach, 'one of the characteristic qualities common

to all the works of "modern art",[38] in that 'the aesthetic pleasure depends almost entirely on the impression on the retina, without appealing to any auxiliary interpretation.'[39] The retinal was what he disapproved of in abstract art and almost every school of painting since Gustave Courbet (1819–77), from Impressionism to **Abstract Expressionism**, apart from perhaps **Dada**, **Surrealism** and, later on, **Pop Art**. His strong objection to merely enchanting the viewer on a visual level made him 'put **painting** once again at the service of the mind'[40] before abandoning it altogether. As always, Duchamp had an exit strategy to avoid the pitfalls of easy pleasure and painting, one which he named **grey matter**.

MARY REYNOLDS

The American bookbinder Mary Reynolds (1891–1950) was an amazing woman. She collaborated with artists and writers such as **Max Ernst** (1881–1976), James Joyce (1882–1941), Jean Cocteau (1889–1963), **Man Ray** (1890–1976) and **Salvador Dalí** (1904–89), fought in the French Resistance during the Second World War under the code name 'Gentle Mary' and, among many other things, assisted Charles Henri Ford (1913–2002) with his magazine *View*. In Paris in the 1920s, her home was a well-frequented salon for the avant-garde, yet as much as she enjoyed the company, she was a heavy drinker who, according

to **Henri-Pierre Roché** (1879–1959), also had 'something like a desire to die'.[41] The unmarried Duchamp and the widowed Reynolds were companions and lovers on and off for two decades from the mid-1920s. The artist was not keen on their liaison becoming public, but they still worked together on many projects, including the cover for his book on **chess** and the bookbinding for a de luxe edition of Alfred Jarry's (1873–1907) play *Ubu Roi* (1896) ('**pataphysics**). 'She worshipped Duchamp, but understood that he was determined to live alone',[42] Man Ray wrote about their relationship. Duchamp benefited from her knowledge when it came to the creation of his *Green Box* (1934) (**boxes**) and *Box-in-a-Valise*. Reynolds was also involved in the preliminary stages of what would become *Étant donnés* (1946–66). Shortly before she lost her battle with cancer, Duchamp rushed to Paris from New York to be with her. He was at her side when she passed away and stayed on to settle her estate and sort out her personal papers and belongings. Until his own death, Duchamp received payments amounting to $6,000 a year from a trust fund set up in his name by Reynolds's brother, Frank Brookes Hubachek (1894–1986). Hubachek bequeathed her collection to the Art Institute of Chicago and in the accompanying catalogue Duchamp concluded his introduction by calling Reynolds 'a great figure in her modest ways'.[43]

HANS RICHTER

For anyone interested in **Dada**, *Dada: Art and Anti-Art* by Hans Richter (1888–1976), first published in 1965, is considered one of the best books ever written on the subject. Richter was a German avant-garde experimental filmmaker, who became an American citizen during the Second World War to escape Nazi persecution. He got to know Duchamp in the 1940s and enlisted him to take part in his film *Dreams That Money Can Buy* (1947), in which a four-minute sequence features the artist's revolving *Rotoreliefs* (1935) and a fragmented nude descending a staircase, all set to the music of **John Cage** (1912–92) (**films**). This was not the last movie starring Duchamp (**chess**), who in his witticisms based on untranslatable **puns** praised Richter as a 'young Gargantua' who 'films dynamite'.[44]

Richter and Duchamp were born within six months of each other, and Duchamp saw it as a contest of who would outlive the other. Richter won by seven years, although he thought of Duchamp not as dead but as 'just temporarily absent – for an eternity or two.'[45] The filmmaker called him 'a myth even during his lifetime' whose 'total detachment made him a kind of moral arbiter, as a person as well as an artist.'[46] To Richter, Duchamp was 'a very handsome, extremely gifted, fantastically intelligent man' who 'lived in a cosmos all by himself, a cosmos of which he was the benevolent center.'[47] In *Dada: Art and Anti-Art* we can find Duchamp's furious comments about the younger generation of artists, allegedly quoted from a letter to Richter of 1962: 'I threw the bottle-rack and the urinal into their faces as a challenge and now they admire them for their aesthetic beauty.'[48] However, many years later, Richter admitted that he had sent this and other remarks as his own (Richter's) to Duchamp, whereupon the artist had simply scrawled 'Ok, ça va très bien' in the margins before returning them.

HENRI-PIERRE ROCHÉ

Would the writings of Henri-Pierre Roché (1879–1959) still be read as much and would he be remembered as fondly if it was not for François Truffaut (1932–84), who adapted his two novels for the big screen, most notably *Jules and Jim* (1962) based on the 1953 autobiographical book of the same name? Despite much speculation, the love triangle of Jules, Jim and Catherine was not inspired by the simultaneous romance of Roché and his close friend Duchamp with the artist **Beatrice Wood** (1893–1998) in New York in the late 1910s, during which time they published the Dada magazines *Rongwrong* and *The Blind Man* together.

Although eight years Duchamp's senior, Roché resembled the artist, whom he had called Victor or Totor ever since their first meeting in New York in late 1916. Duchamp thought of Roché as 'a charming man'.[50] Together they bought

and sold almost thirty sculptures by their mutual friend **Constantin Brâncuşi** (1876–1957) (**dealer**) and Roché himself became a collector of Duchamp's works. He also advised and supported Duchamp financially on many projects, from his *Green Box* (1934) (**boxes**) and the *Rotoreliefs* (1935) to the *Box-in-a-Valise*. 'I don't know of any other work of art more "unique"',[51] Roché remarked upon encountering the *Large Glass* (1915–23). In his contribution to Duchamp's first biography, he describes him as 'young, alert and inspired'.[52] The artist 'enjoyed **life** and knew how it should be lived'.[53] To the writer, his friend 'was creating his own legend' and wore a 'halo' made up of his 'outward calm, his easygoing nature, his keenness of intellect, his lack of self-ishness, his receptiveness to whatever was new, his spontaneity and audacity.'[54] Returning the favour, Duchamp praised his books and thought Roché's writings about him were 'perfect'.[55]

Roché kept a diary from his early twenties until two days before he died, about 300 notebooks in all, within which his sexual exploits are meticulously listed in astonishing detail. The two friends' insatiable adoration of women was mutual. Through Roché, we know of Duchamp's amorous adventure with three young ladies and his penchant for 'very vulgar women' as **lovers**.[56] In 1977, on the occasion of Duchamp's first retro-spective in France, at the newly opened Centre Georges Pompidou in Paris, the museum posthumously published Roché's

fragment of *Victor*. In this novel about Duchamp, we recognize the artist and his combination of ascetic self-sufficiency and outgoing charm, of **eroticism** acted upon and desires unfulfilled.

ROTORELIEFS

In 1935, Duchamp, as witnessed by **Henri-Pierre Roché** (1879–1959) 'decided to try what he called "direct contact" with the people. He had just completed twelve *Rotoreliefs*, optical discs which when placed on the turntable of a phonograph produced the illusion of motion in perspective. He rented a tiny stand among the inventions at the Concours Lépine, near the Porte de Versailles, and waited for the crowds to arrive. I had to go and see that. All the discs were turning around him at the same time, horizontally, others vertically, a regular carnival – but I must say that his little stand went strikingly unnoticed. None of the visitors, hot on the trail of the useful, could be diverted long enough to stop there. A glance was sufficient to see that between the garbage compress-ing machine and the incinerators on the left, and the instant vegetable chopper on the right, this gadget of his simply wasn't useful. When I went up to him, Duchamp smiled and said, "Error, one hundred percent. At least, it's clear."'[57]

In the end, the artist sold a single set at Fr15 and readily admitted commercial failure. Later on, in New York, Macy's

department store bought one of the *Rotoreliefs* on commission. Yet Duchamp, with his circular, spiralling and abstract imagery of a rocket taking off, a fish swimming in a bowl, a boiled egg, a light bulb and a cocktail glass from above, had achieved something else: building on his own experiments of the early 1920s, he had invented a scientific device by which visual depth, volume and relief could be experienced by those with sight in only one eye. Moreover, his experiments with **optics** 'amused'[58] Duchamp, and to **Gabrielle Buffet-Picabia**, 'the optical illusion created by their rotation' generated 'surprise and ambiguity' and thereby came close to 'a kind of **humor** which is frequently met in Duchamp's works'.[59] While Duchamp himself may have sold only a single set of *Rotoreliefs*, in the decades to come the rotating discs became the largest edition of any one work by the artist.

RAYMOND ROUSSEL

The writings of Raymond Roussel (1877–1933), the poet, playwright and **chess** expert, were introduced to Duchamp by **Guillaume Apollinaire** (1880–1918). Roussel was the most important writer to the artist, who considered him to be the 'French James Joyce'.[60] The novelty and uniqueness of Roussel's universe of strange inventions and his systematic approach to language made Duchamp repeatedly state that 'it was fundamentally Roussel who was responsible for my glass, *The Bride Stripped Bare by her Bachelors, Even*'[61] (***Large Glass***). He was just as fond of Roussel's use of homophonic **puns**, which guided the overall composition of his books, a strategy only posthumously revealed in his *How I Wrote Certain of my Books* (1935). The artist felt 'indebted' to the writer 'for having enabled me ... to think of something other than **retinal** painting.'[62]

Moreover, Duchamp regarded Roussel as 'all the more important for not having built up a following'.[63] Even Duchamp did not make his admiration known to him. By some accounts, in 1932 in Paris, the artist saw Roussel playing chess at a nearby table at the Café de la Régence. It might be because he valued his own privacy so highly that he chose not to intrude upon Roussel's.[64]

LYDIE FISCHER SARAZIN-LEVASSOR

Before the Centre Georges Pompidou in Paris opened with a Duchamp retrospective in 1977, Lydie Fischer Sarazin-Levassor (1903–88) was asked by the museum to write about her time as the artist's first wife. She was sixteen years his junior, and the two were married for only seven months, from June 1927 to January 1928. In a letter to **Katherine S. Dreier** (1877–1952) announcing his wedding, Duchamp described her as 'not especially beautiful nor attractive', yet 'he was tired of this vagabonding life' and whether he was 'making a mistake or not is of little importance as I don't think anything can stop me from changing altogether in a very short time if necessary'[1] – rather inauspicious words for the start of a marriage. **Peggy Guggenheim** (1898–1979)

referred to her as a 'hideous heiress'[2] and blamed their liaison on Duchamp's 'vice' for 'ugly mistresses'.[3] Arranged by **Francis Picabia** (1879–1953), who had in mind his best friend's financial independence, the marriage went sour the moment Lydie's dowry did not materialize. Her memoir, *A Marriage in Check: The Heart of the Bride Stripped Bare by Her Bachelor, Even,*[4] is a heart-rending account of a young woman who felt insecure and unintelligent, and a grim, narcissistic yet self-doubting loner who also happened to be one of the greatest minds of the 20th century. For years after the break-up she signed her letters 'Lydiote'. Duchamp cruelly did nothing to make her feel welcome, comfortable or even appreciated, let alone loved (**marriage, hair**).

ALEXINA SATTLER (TEENY)

After a short first **marriage** in the late
1920s, Duchamp married Alexina Sattler
(1906–95), often known as Teeny, in
1954. She can safely be considered the
best thing that happened to the artist
during the last two decades of his life.
Duchamp and Teeny first met in 1923
in Paris, where she studied sculpture
and befriended **Constantin Brâncuşi**
(1876–1957). Six years later she became
the wife of New York-based art dealer
Pierre Matisse (1900–89), the son of
the artist Henri Matisse (1869–1954),
but she divorced him in 1949 after his
affair with a younger woman. A couple
of years later Teeny again met Duchamp,
somewhat down on his **luck** and recu-
perating from an intense love affair with
Maria Martins (1894–1973). 'There was
something about Marcel Duchamp that
people found attractive', Teeny's daugh-
ter Jacqueline Matisse Monnier (b. 1931)
remembered much later, 'my mother
thought he had a charismatic allure. She
told me a story that at one point Henry
Miller had a crush on her, but he was
rather vulgar and had no grace in what
he was proposing, whereas Marcel just
knew how to say and do things. He had
a very light touch.'[5] As a wedding gift,
Duchamp gave Teeny the mini-sculpture
Wedge of Chastity (1954), subsequently
presented in an edition as one of his
erotic objects. The wedge section of the
piece is the central part of the negative
cast of the female sex.

The newlyweds both loved **chess** and
the last fourteen years of Duchamp's life
at Teeny's side were amazingly produc-
tive. As she had previously been the wife
of a dealer for a quarter of a century, she
was fully aware of how to inspire and
bring out the best in artists. She was
charming, beautiful, intuitive, intelligent
and lovingly protective, carefully guard-
ing her husband's estate and legacy with
great devotion (**Association Marcel
Duchamp**). This author wrote to her at
the age of eighteen, as a fan infatuated
with her husband's work. She responded
and invited me to visit her in France. In
her letters she took 'delight' in our cor-
respondence and expressed her feeling of
being 'real friends'.[6] To a very young man,
this meant the world and it is a memory
that I still hold dear.

ARTURO SCHWARZ

Born in 1924, the Italian philosopher,
writer and art dealer Arturo Schwarz
was introduced to **Dada** and **Surrealism**
through **André Breton** (1896–1966) and
in the 1950s befriended Duchamp. Proud
of his 'psychic relationship'[7] with the
artist, as the biographer Alice Goldfarb
Marquis (1930–2009) notes, Schwarz
offered theories about Duchamp revolv-
ing around an incestuous longing for his
sister Suzanne (1889–1963), **alchemy**,
and Freudian and Jungian concepts of the
subconscious, among other things, that
have been largely discredited and remain

controversial. From the early 1950s, Schwarz collaborated with Duchamp on numerous exhibitions, publications and limited editions, most importantly the **edition of 1964–65** of fourteen readymades. Five years later, *Art in America* announced an anthology of interviews and conversations between Schwarz and Duchamp, but this has still not been published.

Schwarz has donated over a thousand works of mostly Dada and Surrealist art to museums in Rome and Israel. Even Francis M. Naumann (b. 1948), one of Schwarz's most outspoken critics, concedes that 'whereas Schwarz has made many important contributions to the literature on Duchamp and Dada, it is my belief that these magnanimous gifts will represent his most enduring legacy.'[8] Schwarz's catalogue raisonné of the works of Duchamp, a massive, well-researched tome first published in 1969 and currently in its third edition, may be added to that legacy.

SCIENCE

When asked about the influence of science on his work, Duchamp admitted only an 'ironic'[9] one: 'I don't believe in the explanation, so I have to give a pseudo one: pseudoscientific. I'm a pseudo, all in all.'[10] Science was a tool that was useful to him from the early 1910s onwards, when he was exploring ways of abandoning all artistic schools and movements in order to arrive at his own means of expression. Duchamp strived to be 'precise and exact',[11] and **mathematics** and science, their vocabulary as well as their principles, were like a mould into which Duchamp could pour his understanding of **eroticism, chance** and **humour.** The sexual language and associations of the rapid advances in science and technology with physical processes at the turn of the 20th century must have appealed to Duchamp, a practising 'pataphysician who maintained that he 'never was the scientific type'[12] ('**pataphysics**). His many **notes** about the *Large Glass* (1915–23) mention 'Playful Physics'[13] and 'slightly distending the laws of physics and chemistry'.[14] His forays into the world of science were meant to be subversive: 'It wasn't for love of science that I did this', he observed, 'on the contrary, it was rather in order to discredit it, mildly, lightly, unimportantly.'[15]

Richard Hamilton (1922–2011) and Ecke Bonk (b. 1953), in a joint preface to their typographical edition of the *White Box* notes (**boxes**), summed up Duchamp's visionary take on science: 'Duchamp's science was self-taught. Taking information from any source – mathematical treatises, illustrated magazines, or the observation of a curious man trying to make existence intelligible – he processed his enquiry into a visualization. Amateur he may have been but his disregard for dogma, his acceptance of the random nature of both the physical world and personal relationships, his systematic

application of chance techniques into his work, and not least, his exploration of language and meaning anticipated ideas that were to revolutionize science in the twentieth century.'[16] During the last decades of his life, Duchamp became keenly aware, and critical, of the unparalleled significance society bestowed on science and its advances. To him, science had turned out to be yet another myth. In a 1960 lecture, he chastised the 'blind worship', whose solutions 'do not even touch the personal problems of a human being'.[17] Duchamp never believed in laws, **causality** or deductions of any kind, scientific or otherwise. As early as 1945, he felt that all efforts to counterbalance developments in science and technology within an increasingly materialistic world that does not allow for **individualism** should be geared towards inventing anew 'silence, slowness and solitude'.[18]

RROSE SÉLAVY

In 1920, Rose Sélavy made her debut with her name arranged in black capital letters along the sill of a miniature French window punningly titled *Fresh Widow*. A year later, the spelling changed to Rrose Sélavy, according to her signature on **Francis Picabia**'s (1879–1953) collage on canvas *L'Oeil cacodylate*, or *The Cacodylic Eye*. Around the same time, the photographer **Man Ray** (1890–1976) portrayed her in various women's attire, including a fur collar, jewelry and rather

heavy make-up. Rrose Sélavy remained active throughout Duchamp's life, signing many works and readymades, creating the **film** *Anémic Cinéma* in 1926, auctioning off eighty works by Picabia and co-publishing the *Box-in-a-Valise* of 1941. In the accompanying catalogues, Rrose Sélavy, together with Duchamp, presented herself as the artist honoured with retrospectives in Pasadena and New York during the 1960s. She signed much of Duchamp's correspondence and made sure that her numerous **puns** were published. Having herself been born out of a pun, the second volume of **Arturo Schwarz**'s (b. 1924) limited edition, *The Large Glass and Related Works* (1968), reveals her origins as 'éros c'est la vie / Rrose Sélavy', or 'Eros is life', boldly written by Duchamp three times across the cover of the book's slipcase. When the artist created his female alter ego, as a Catholic his first thought was to adopt a Jewish name, but he could not find an appropriate one. He decided on Rrose, which, according to Duchamp, had a truly tacky sound in 1920. Half a century before gender studies existed, he swapped at will from male to female and back again. Yet transsexual gender play was not exactly what he had in mind. He wanted to create an altogether different identity. It was the ancient Greek playwright Aristophanes (*c.* 446–*c.* 386 BC), mentioned by the artist in a couple of his interviews, who picked up on the mythological figure of the hermaphrodite to introduce a third gender that eluded

the binary system of male and female. Duchamp took a special delight in the number **three** and much of his work, just as the title of his book on **chess** suggests, is about reconciling opposites.

<u>SHADOWS</u> [illustration p. 171]

In 1918, Duchamp took a photograph of the shadows that at least four of his **readymades** cast onto the white wall of his New York studio at 33 West 67th Street in **New York**. The same year, he included more shadows of readymades in his last painting, *Tu m'* (1918). One elongated shadow is clearly of a corkscrew, an unknown readymade, at least when it came to its physical manifestation. 'One may consider the shadow of the corkscrew a readymade rather than the corkscrew itself',[19] Duchamp answered **Arturo Schwarz** (b. 1924) in 1968, when he enquired about the object. The artist often referred to shadows when attempting to explain the **fourth dimension** and incorporated cast shadows of objects, letters and of his own profile in many of his designs and artworks. Shadows also loom large throughout the **notes**, including many of those about the **infrathin**: 'he shadow casters / in the infrathin',[20] 'cast shadows / oblique / infrathin',[21] or 'he quarrel / of the cast / shadow in its relationship with the / infra-thin.'[22] There is, of course, a pattern here: what **puns** are to words, shadows are to the actual object. They distort meaning,

remain unpredictable, seem to go against any logic or perceived knowledge, and play out in another dimension. On yet another level and, in this case, entirely coincidentally, Duchamp admitted in 1958 that his life had been 'completely overshadowed' by the omnipresent visibility of his painting *Nude Descending a Staircase No. 2* (1912), 'which took all the credit and notoriety'.[23]

<u>SMOKING</u>

While Duchamp's friends seem divided over precisely what brand of tobacco he smoked, all agree that he did smoke a lot. Robert Motherwell (1915–91) speaks of about ten Havana cigars a day, Gianfranco Baruchello (b. 1924) witnessed fourteen Rumbo Regalia cigars enjoyed during the same period, Robert Barnes (b. 1934) remembers cheap 'Blackstones', and Joseph Cornell's (1903–72) carefully collected Duchamp paraphernalia suggests a ceaseless need for Philip Morris Bond Street Pipe Tobacco. From the 1950s onwards it is difficult to find a photograph of Duchamp in which he is not smoking. It is no wonder, then, that smoke infiltrates his work. From smoke clouds real or imagined to a design for a Spanish chimney, from cigarettes stripped of their wrappers to an urn with the ashes of his cigar, and an autographed pipe for an artist friend, Duchamp obviously took great delight in introducing smoke and tobacco into his oeuvre. A famous **note**

makes use of the subject to introduce his complex thoughts on the **infrathin**: 'When the smoke of the tobacco smells also of the mouth from which it comes, the two smells marry by infrathin.'[24]

SOCIÉTÉ ANONYME

Upon its inception in 1920, Duchamp and **Man Ray** (1890–1976) were named vice-presidents of the Société Anonyme, founded by their friend and patron **Katherine S. Dreier** (1877–1952). Man Ray came up with the name, assuming that the French words meant 'Anonymous Society', whereas they actually translate into 'Incorporated'. The Société Anonyme, Inc., as it was also called, thus proved to be a redundant **pun** in the spirit of **Dada**. This must have pleased Duchamp in his lifelong quest to relieve art of its seriousness and introduce **humour** instead as a guiding principle. His design of a **chess** knight became the logo of the organization. In the late 1920s, the Société Anonyme's subtitle – Museum of Modern Art – was adopted by the New York institution that still bears the name today. As Duchamp later recalled, he joined out of 'friendship' and 'camaraderie' as 'it was a good thing to help artists be seen somewhere'.[25] In his words, the mission of the organization was 'to create a permanent international collection that would later be left to a museum'.[26] In 1941, after thoughts of establishing a museum of its own were abandoned due

to a lack of finance, the Société Anonyme donated over 1,000 artworks to the Yale University Art Museum – among them works by Alexander Archipenko (1887–1964), **Constantin Brâncuși** (1876–1957), **Wassily Kandinsky** (1866–1944), Paul Klee (1879–1940), Fernand Léger (1881–1955), Piet Mondrian (1872–1944) and Kurt Schwitters (1887–1948). In 1946, Duchamp praised the Société Anonyme as 'the only sanctuary of **esoteric** character, contrasting sharply with the commercial trend of our times.'[27] (**commercialism**). The organization was officially dissolved in 1950. It had put together over eighty-four exhibitions, among them the International Exhibition of Modern Art at the Brooklyn Museum where, from November 1926 to January 1927, Duchamp's **Large Glass** (1915–23) was exhibited complete for the first and only time before it was shattered while being transported from the museum to Katherine S. Dreier's residence.

THE STETTHEIMER SISTERS

Today, these three socialites from the Upper West Side, often dressed in stiff and outlandish attire, would probably be considered performance artists. In 1916, the unmarried sisters were content to hold court and throw lavish parties bankrolled by an older brother's fortune. Florine (1871–1944) was a painter and Ettie (1875–1955) a writer and philosopher, while Carrie (1869–1944) – over the

course of two decades – created the most opulent doll's house in America. All three were in love with Duchamp. They met him in the autumn of 1916 and, although they had lived in France and knew the language well, were eager to support the artist by asking him to teach them French. 'The sisters were inveterate celibates entirely dedicated to their mother. They were so funny, and so far out of what American life was like then'[28] is how the artist remembered them. In her colourful and naive paintings and portraits of twisted perspectives, Florine established Duchamp as a god-like figure. In 1946, Duchamp, who also made a charcoal portrait of Florine, was the guest curator for her posthumous retrospective at the Museum of Modern Art. It was the forthright Ettie, however, to whom Duchamp was most drawn. In turn, she included him as a character in some of her novels. When he left New York for **Buenos Aires** in 1918, he apparently asked Ettie three times to join him, but without success. We will never know whether he was sincere as he had already asked somebody else. It is thanks to Carrie that New York City is the proud owner of an original *Nude Descending a Staircase*, presented to Carrie by Duchamp on her birthday in 1918. Permanently exhibited at the Museum of the City of New York, it is placed on a wall of Carrie's doll's house, to the lower right of the ballroom's fireplace, barely larger than a postage stamp.

ALFRED STIEGLITZ

See **Dada**, *Fountain*, **photography**.

MAX STIRNER

Duchamp was introduced to the German philosopher Max Stirner (1806–56) by his friend **Francis Picabia** (1879–1953) sometime after 1910, when the second French edition of his *The Ego and Its Own* (1845) had just been published. The book proposes individual self-realization while keeping societal restraints at bay as much as possible. Stirner was a great influence on Duchamp, who regarded the philosopher as a 'grand bonhomme' who promoted 'something other than anarchism'.[29] To Stirner, 'egoism and humanity ought to mean the same' while rigid individualism must nonetheless adhere to the concept that '*I* am my species, am without norm, without law without model.'[30] Duchamp called *The Ego and Its Own* 'a remarkable book',[31] in which the philosopher had 'very clearly established the distinction' between the 'characteristics common to all individuals en masse' and 'the solitary explosion of an individual facing himself alone'.[32]

STUPIDITY

Rather unusually for an otherwise non judgmental Duchamp, in 1959 he lashed out against 'the stupidity of Russian

painting',[33] speaking of contemporary Socialist Realist work. This remark, however, did not have anything to do with Cold War prejudices as the artist considered **politics** a 'really stupid activity' too.[34] For someone who had abandoned **painting** in his youth, he wanted art to become more of an 'intellectual expression' instead of 'an animal expression'. While he declared he was 'sick of the expression "stupid as a painter"',[35] he maintained that he would 'apply it willingly to artists who believe that they can say something otherwise than in their ideographical language.'[36] What Duchamp found most 'idiotic' above all was 'working for a living'[37] (**work**).

installation of many of their exhibitions (**curating**), even as late as 1960, when many had abandoned the movement or thought it long dead. Its survival, according to Duchamp, had to do with the fact that it was not just 'a school of visual art, like the others' and 'no ordinary "ism"', but because it also encompassed 'philosophy, sociology, literature, etc.'[38] Looking back, Duchamp thought Surrealism 'embodied the most beautiful dream of a moment in the world'.[39]

SURREALISM

Of all the art movements in which Duchamp dabbled as a young man, and as much as he was involved in and spoke highly of **Dada** whenever the occasion arose, Surrealism, founded in 1924, was very much his home turf. While he never signed a manifesto, and certainly had his differences with its founder **André Breton** (1896–1966), he was close friends with many of the movement's most outspoken proponents, including **Max Ernst** (1881–1976) and **Salvador Dalí** (1904–89). He often embraced Surrealism's take on exploring areas beyond the realm of the visual, bringing to a halt the long tradition of painting's solely **retinal** approach. He promoted Surrealist artists, securing loans for and overseeing the

TASTE

Max Ernst (1881–1976) quipped that 'art has nothing to do with taste as art is not there to be "tasted".'[1] For Duchamp, the matter of taste was a more serious matter. As taste was only 'temporary' and a 'fashion',[2] it posed an inherent 'danger'[3]: 'I consider taste – bad or good – the greatest enemy of art.'[4] Taste as 'a habit'[5] was something to be avoided, especially for someone who spoke out against **repetition** as much as Duchamp did. 'Taste gives a sensuous feeling, not an esthetic emotion. Taste presupposes a domineering onlooker who dictates what he likes and dislikes, and translates it into "beautiful" and "ugly" when he is sensuously pleased or displeased.'[6] He made it clear elsewhere that the onlooker plays a major role on a par with the artist when it comes to **the creative act**. However, instead of exerting taste, this interplay has more to do with an 'esthetic echo', which is 'felt through an emotion presenting some analogy with a religious faith or a sexual attraction'.[7] In order to differentiate between the two concepts, Duchamp emphasized his distaste for taste: 'The great aim of my life has been a reaction against taste.'[8]

When it came to choosing the **ready-mades**, at least in Duchamp's later thoughts on the subject, personal taste had to be resisted through both **chance** and **indifference**. To avoid contemporary taste, Duchamp found solace in mechanical drawings as well as in means of expression that were difficult to judge on their aesthetic merit. To maintain this mode of work through many decades, he had to set clear parameters: 'I have forced

myself to contradict myself in order to avoid conforming to my own taste.'[9] (**contradictions**). The measure seemed necessary to circumvent the traps of taste while the motives for doing so were clear to Duchamp, even if it meant being constantly on guard: 'My intention was always to get away from myself, though I knew perfectly well that I was using myself. Call it a little game between "I" and "me".'[10]

TAUTOLOGY

See **tautology**.

TEENY

See **Alexina Sattler**.

THREE

Many of his Surrealist friends, including **André Breton** (1896–1966) and Kurt Seligmann (1900–62), were strong believers in numerology. Duchamp himself had a penchant for the number three: 'The number 3 is important to me. 1 stands for unity, 2 is the double, duality, and 3 is the rest.' and '1 is unity / 2 opposition / 3 a series.'[11]

The artist often referred to himself simply as an 'individual' or a 'breather' (**work**), and never called himself 'artist' or 'anti-artist', but rather 'an-artist'[12]

– in phonetic proximity to anarchist – placing himself firmly in the realm of the 'series' or the 'rest'. From the nine 'malic moulds' (three times three) in the Bachelors' Apparatus to the three 'draft pistons' and the 'nine shots' in the upper part of the Bride's Domain, the number three is present throughout the *Large Glass* (1915–3), as well as in many of Duchamp's other works, such as *Three Standard Stoppages* (1913–14). 'Three is everything',[13] he told a BBC reporter in 1968.

THREE STANDARD STOPPAGES

In Paris in 1913–14, Duchamp devised the *3 stoppages etalon*, or *Three Standard Stoppages*, a work he later valued as among his most important. Enclosed in a croquet case, the assemblage contains three 1-metre lengths (approximately 39 in.) of thread, fixed on strips of canvas pasted onto glass. Wooden yardsticks, shaped according to the outlines of the threads, were also included in the case. A **note** describes the process of letting the three threads fall from a height of 1 m 'straight onto a horizontal plane twisting as it pleases', to 'create a new image of the unit of length'.[14]

Duchamp was fond of the number **three** and *Three Standard Stoppages* is now regarded as having introduced the principle of **chance** to modern art. The artist created the work for his own 'amusement', to escape from the hand

and the merely **retinal**, and to pursue his liberating quest 'against logical reality'.[15] He described it as a 'joke about the meter – a humorous application of Riemann's post-Euclidean geometry which was devoid of straight lines.'[16] The French 'stoppage' translates as 'invisible mending', and upon close examination of the original *Three Standard Stoppages* at New York's Museum of Modern Art in 1999, the scholars Stephen Jay Gould (1941–2002) and Rhonda Roland Shearer (b. 1954) discovered that, contrary to the artist's statements, the threads are longer than 1 m. The threads were sewn through a needle hole at each end of the canvas to help shape the curved lines visible from the front of the strips that are fixed onto glass.[17] Therefore, while the threads appear to be 1 m in length, they are in fact slightly longer as several centimetres remain invisible, hidden underneath the canvas through which they are sewn. Did Duchamp anticipate that the intricacies of the work would eventually be found out when, in 1914, he referred to his *Three Standard Stoppages* as 'canned chance'?[18]

TIME

'His finest work is his use of time'[19] is how **Henri-Pierre Roché** (1879–1959) described Duchamp's creativity, and **Robert Lebel** (1901–86) is alluding to the artist in his story entitled *The Inventor of Free Time*.[20] In 1964, Duchamp created *Clock in Profile* in a small cardboard pop-up edition. As he had explained earlier, 'when a clock is seen from the side (in profile) it no longer tells the time'.[21]

TITLES

From the moment that Duchamp began to place the titles of his paintings in impersonal capital letters somewhere at the bottom of the front of the canvas, he consciously added another layer of meaning that would alter, and to some degree determine or guide, the onlooker's perception of what was presented in the picture. Mechanomorphic shapes – semi-abstract compositions with traces of human forms created mostly within a limited brownish colour range – were titled **Nude Descending a Staircase No. 2**, *The Passage from Virgin to Bride* or **Bride** (all 1912). Although the enigmatic title *The Bride Stripped Bare by Her Bachelors, Even* fails to explain the abstract machinery in the **Large Glass** (1915–23), Duchamp makes the viewer ponder more than if the work had been left untitled.

The same holds true for many of his **readymades**, from the porcelain urinal named **Fountain** to the coat rack nailed to the floor titled *Trébuchet*, or *Trap* (both 1917). The title provides extra 'verbal color',[22] as Duchamp once said, 'in the figurative sense of the word'.[23] It creates suspense, even tension, and adds an extra dimension to the meaning. To Duchamp, the 'title was meant to carry

the mind of the spectator towards other regions more verbally',[24] away from the **retinal** and towards the mental, or **grey matter**, where, as Ludwig Wittgenstein (1889–1951) knew, thought could not exist without language.

TRADITION

'Copies of copiers'[25] is how Duchamp defined the trajectory of tradition, believing it to be 'the prison in which you live'[26] and 'the great misleader because it's too easy to follow what has already been done.'[27]

TRAINS [opposite]

In 1912, the year after he painted his Cubo-Futurist self-portrait, *Jeune homme triste dans un train*, or *Sad Young Man on a Train*, during a return trip to Munich by train, Duchamp travelled hundreds of kilometres across Europe in a melancholic state of mind. Duchamp's journey took him via Lake Constance to Austria and into Switzerland, past Lake Geneva and through the French Jura Mountains.

While on this trip Duchamp went to meet **Gabrielle Buffet-Picabia** (1881–1985), the woman with whom he was in love at the time, in the small waiting room of a train station in Andelot-en-Montagne, which still exists today. Buffet-Picabia deliberately missed her planned connection to Paris for a conversation that left Duchamp with no hope at all, before boarding the next train for the French capital. 'Incurable **laziness** of the railroad tracks / between the passing of the trains / use of the railroad tracks between the passing of the trains', he would later write, and 'electric wires seen / from a moving / train – Make / a film'.[28] Duchamp's ninth bachelor in the lower half of the *Large Glass* (1915–23) is the 'chef de gare', or 'station master', who, together with the others, with 'regrets' 'listen[s] to the litanies sung by the chariot, refrain of the whole celibate machine'.[29]

TRANSFORMER [illustration p. 180]

At least on paper, Duchamp invented a 'Transformer designed to utilize wasted energies', among them 'the excess of pressure on an electric switch', 'the exhalation of tobacco smoke' (**smoking**), 'the fall of urine and excrement' (**merde**), 'forbidding glances', 'ejaculation' (**ejaculate**) and 'the dropping of tears'.[30] More than fifty years later, in 2008, Max Donelan Professor of Kinesiology at the Simon Fraser University in Vancouver, Canada and director of the S.F.U. Locomotion Lab, invented the Biomechanical Energy Harvester. He shares his initials with those of Marcel Duchamp.

TRUTH

'Words such as truth are stupid in themselves.'[31]

TU M'

Commissioned by **Katherine S. Dreier** (1877–1952) in 1918 to fit above the bookshelves in her New York apartment's library, the large-scale work *Tu m'* was the last **painting** Duchamp ever made. Its title is believed to be an abbreviation of *Tu m'embêtes* ('you bore me'), or even worse *Tu m'emmerdes* ('you get on my nerves'), describing Duchamp's mood towards his wealthy patron while working on her oil on canvas. As well as presenting an inventory of many of the artist's previous works, *Tu m'* incorporates three safety pins stuck through a painted tear, a bolt, a long bottle brush protruding from the picture at a 90-degree angle, and a right hand with a pointing index finger painted by a professional sign painter. **Shadows** of **readymades**, a hat rack, a **bicycle wheel** and a corkscrew also feature, as do colour charts receding into space, parts of ***Three Standard Stoppages*** (1913–14), and all sorts of abstract curved and linear bands of colour surrounded by small circles (**optics**).

After six months of tedious work, Duchamp produced a painting that seems as impersonal as possible, a work that had to some extent painted itself – by tracing cast shadows onto the canvas. If, on the other hand, *Tu m'* is considered a dictionary or résumé of the artist's oeuvre, it follows that it is a very personal testimonial to the futility of painting as opposed to the intellectually rewarding spheres of the non-retinal.

UNDERGROUND [illustration p. 184]

In his lecture 'Where do we go from here?', given at a symposium at the Philadelphia College of Art in March 1961, Duchamp ended with the memorable sentence: 'The great artist of tomorrow will go underground.'[1] Pre-dating by almost a decade poet-songwriter Gil Scott-Heron's (1949–2011) famous line that 'The revolution will not be televised'[2], Duchamp too spoke out against a materialistic consumer society. Critical of **retinal** art created only for 'aesthetic pleasure', and of 'isms' of all kinds that do not allow for the expression of the individual, to Duchamp 'the visual arts have become a "commodity"; the work of art is now a commonplace product like soap and securities.'[3] While the 'general public seeks aesthetic satisfaction wrapped up in a set of material and speculative values', Duchamp hoped for 'a revolution on the ascetic level, of which the general public will not even be aware and which only a few initiates will develop on the fringe of a world blinded by economic fireworks.'[4] At the time of the lecture, not even his closest friends were aware that the man who had abandoned painting in his youth and who had later decided to play **chess** rather than create works of art, had been working secretly, 'underground', for about seventeen years. He did not finish *Étant donnés* until 1966 and it was first shown posthumously at the **Philadelphia Museum of Art** in 1969.

UNREALIZED PROJECTS [below]

As well as leaving the **Large Glass** (1915–23) unfinished, Duchamp left papers containing a package with many **notes** that describe unrealized projects, including ideas for **films** and **music**.[5] While some notes published during his lifetime mention operations that did not necessarily need to be acted upon – signing the Woolworth building in New York or using a work by Rembrandt van Rijn (1606–1669) as an ironing board – the notes that became available posthumously include an array of possibilities for creative action: 'take one cubic centimeter of tobacco smoke and paint the exterior and the interior surfaces a waterproof color'[6] (**smoking**); 'buy or take known or unknown paintings and sign them with the name of a known or unknown painter – the difference between the "style" and the unexpected "name" for the experts is the authentic work of **Rrose Sélavy** and defies forgeries'[7]; 'make large sculptures in which the listener would be a center – for example an immense Venus de Milo made of sounds around the listener'[8]; 'trace a straight line on "Rodin's The Kiss" as seen from a sight.'[9]

VAGINA

'I want to grasp things with the mind the way the penis is grasped by the vagina.'[1] (**penis**)

VANITY [illustration p. 189]

In 1966, about two years before his death, on the opening of his major retrospective at the Tate Gallery in London, Duchamp told an interviewer: 'Vanity is my one weakness you know, or otherwise I would have left the world years ago.'[2]

EDGARD AND LOUISE VARÈSE

As he had already done with **Francis Picabia** (1879–1953) in 1953, shortly after composer Edgard Varèse (1883–1965) passed away Duchamp wrote him a telegram saying 'Dear Edgard, see you soon.'[3] Both exiled in New York during the First World War, they maintained a lifelong friendship. Duchamp appreciated the 'violence' and noise of Varèse's compositions. Although he found him at times an 'egomaniac' without a 'sense of humor', 'a pain in the ass' as well as 'completely dedicated to his music',[4] he cherished their discussions: 'You know, painters don't listen to much music and musicians don't look at many pictures. But still there was a tacit understanding, if I may say so.'[5] Varèse's wife Louise (1890–1989; formerly Louise Norton)

was also a close friend of Duchamp's. She got to know him in late spring of 1915, at a time when he was 'lionized by *tout New York* and courted by most of the female population.'[6] He took pleasure in teaching her French words 'no lady needs to know', and Louise, although inspired by his readymades, 'hardly appreciated their paradoxical multiplicity of intent'.[7] Nevertheless, she is best known for her fervent defence of **Fountain** (1917) in her article 'Buddha of the Bathroom', which was published in May 1917 in the second issue of Duchamp's *New York Dada* magazine **The Blind Man**. Around this time she misplaced a chimney cowl on which the artist had written 'pulled at four pins' (a literal English translation of the French expression for being 'dressed to the nines'). The original readymade, lost forever, was depicted in a 1964 etching by Duchamp of the same name.

VIEW

In March 1945, the New York-based avant-garde magazine *View* launched a special issue devoted entirely to Duchamp. It was the first monograph about the artist and contains some of the best writing on him to this day, with many essays contributed by his closest friends. Duchamp spent much time designing the front and back cover (on the latter is a reproduction of one of his **notes** that makes a rare mention of his concept of **infrathin**), as well as a triptych centrefold with cutout flaps devised in collaboration with his architect friend Frederick J. Kiesler (1890–1965). The elaborate design, according to *View*'s publisher Charles Henri Ford (1913–2002), 'cost a lot of money. It almost broke our budget.'[8] *View* introduced many international modernist and avant-garde artists to an English-speaking audience.

Ford's influence on, and his importance for, European as well as American art of the 20th century is not to be underestimated. Jean Cocteau (1889–1963) praised him highly ('He is a poet in everything he does'[9]), and Ford later assisted **Andy Warhol** (1928–87) in purchasing his first camera. William S. Burroughs (1914–97) assessed him as follows: 'As a member of a spectral elite he possesses an enigmatic as well as a unique charm. He has the "sign".'[10] Ford wrote an equally hyperbolic ode to Duchamp for publication in *View*, titled 'Flag of Ecstasy', which includes the lines: 'Over the towers of autoerotic honey / Over the dungeons of homicidal drives / ... / Over the rattlesnake sexlessness of art lovers / Over the shithouse enigmas of art haters / ... / Over signs foretelling the end of the world / Over signs foretelling the beginning of a world / Like one of those tender strips of flesh / On either side of the vertebral column / Marcel, wave!'[11]

ANDY WARHOL

Andy Warhol (1928–87) was one of the first artists on record to have been inspired by Duchamp's *Étant donnés* (1946–66). In 1971, less than two years after its first public showing, Warhol imagined a gallery exhibition consisting only of binoculars through which visitors could watch superstar Bridget Berlin performing lewd acts at the window of a distant building. Duchamp, in his late seventies, first met Warhol, then in his mid-thirties, while visiting MoMA in 1963. Later that year they saw each other again, during the opening of Duchamp's first retrospective in Pasadena. Throughout their lives, both continued to sign mass-produced objects for those who asked and, by the end of his, Warhol had collected over thirty works by Duchamp.

While the Brillo boxes and Campbell Soup cans would not have been possible without Duchamp's introduction of the **readymades** fifty years earlier, Warhol's visual vocabulary owes something to Duchamp too, from his *Mona Lisa* series to the depiction of bathroom fixtures. Duchamp held Warhol in high regard as a conceptual painter: 'If you take a Campbell Soup can and repeat it 50 times, you are not interested in the **retinal** image. What interests you is the concept that wants to put 50 Campbell soup cans on a canvas.'[1] He also admired the **boredom** some **films** by Warhol generated in the viewer, visited his Factory and allowed the Pop Artist to film him for one of his *Screen Tests* in 1966. 'Warhol had brought his camera and he asked me to pose, on the condition that I kept my mouth shut for twenty minutes. A very

cuddly little actress came and sat by me practically lying on top of me, rubbing herself up against me. I like Warhol's spirit. He's not just some painter or movie-maker. He's a filmeur, and I like that very much.'[2]

WATER AND GAS

Of the four classical elements – earth, water, air and fire – water and gas are the two that feature most often in Duchamp's oeuvre. *Eau et gaz à tous les étages*, or *Water and Gas on All Floors*, is not only the name of the 1958 de luxe edition of Duchamp's first biography and catalogue raisonné by **Robert Lebel** (1901–86), but also of Duchamp's **readymade** of white lettering on a blue enamel plate for the cover, which imitated the design of the signs that started to be seen on apartment houses throughout France in the 1880s. A stroll through Paris today still reveals dozens of the signs, which in the late 19th century indicated that the house was fully equipped with running water as well as having modern lighting and heating.

Water and gas are central elements within the intricate environments of both of Duchamp's major works, the *Large Glass* (1915–23) and *Étant donnés* (1946–66), the full title of the latter being *Given: 1. The Waterfall / 2. The Illuminating Gas.* Duchamp's **notes** about the *Large Glass* include frequent references to water and gas, especially in his descriptions of the Bachelors' Apparatus, from the

'illuminating gas ... solidified in the form of elemental rods'[3] to the 'water mill', the 'splash'[4] and the 'sculpture of drops'.[5] His earliest surviving charcoal drawing is of a gas lamp and in 1911 he experimented with painting on canvas in his studio lit only by green gas light. Coincidentally at the beginning of his visit to **Munich** in 1912, members of the 53rd General Assembly of the German Gas and Water Professionals' Association were convened just around the corner from Duchamp's residence.

WINDOWS

Windows feature prominently throughout Duchamp's oeuvre, as do **doors**. For an artist who often worked on glass (*Large Glass*, 1915–23), this is not surprising. Yet, while a window suggests transparency or clarity, what we get from Duchamp is, as always, rather opaque. *Fresh Widow* (1920), a work created by his female alter ego **Rrose Sélavy**, has its eight panes of glass covered with black leather. Another miniature window, *The Brawl at Austerlitz* (1921), is also signed by Rrose Sélavy and has white marks like those left by glaziers on all four of its glass panes.

Duchamp referred to himself as a 'fenêtrier', or 'window maker', in his attempts 'to make something which could not be called a picture (in this case "make windows").'[6] For the promotion of his own or his friends' books, he designed

several shop windows. In his youth, he was drawn to such windows, be it those of a chocolatier in Rouen (**chocolate**) or the old French pharmacies with red and green traditional flasks on display. Although opposed to **commercialism**, shop windows held a certain erotic allure for Duchamp, as a **note** from 1913 makes us aware: 'The interrogation by shop windows', 'their necessity', 'demands' and 'proof of existence of the world' may lead to an actual 'coition through a sheet of glass / with one or more of the objects in the / shop window. The penalty consists in cutting the glass and in kicking yourself / as soon as possession is consummated.'[7]

BEATRICE WOOD

It is hard to imagine a more gentle soul than the American artist and potter Beatrice Wood (1893–1998) whom this author interviewed when she was 103 years old. Internationally renowned as a ceramicist, her lustrous works featured prominently throughout her home and studio in Ojai, California. Wood and Duchamp first met in New York in 1916 and remained lifelong friends. It was Duchamp who introduced her to the **Arensbergs**, shared her with **Henri Pierre Roché** (1879–1959) in a love triangle, made her an editor of his publications *The Blind Man* and *Rongwrong* and, most importantly, encouraged in her the will to continue as an artist by making

her aware of the strength of those drawings that she underestimated.

When Wood was in financial difficulty, Duchamp helped her out and offered her work in his studio. While she remarked on his startling beauty, humour and 'charming mischief',[8] she would have loved him to be more emotional, recognizing 'a certain deadness' as if he had 'suffered an unspeakable trauma in his youth'.[9] However, it is clear that Wood held a deep affection for Duchamp: 'It was his humanity, his intelligence that saw beyond the immediate into the whole, which made him an individual of rare gentleness and integrity.'[10] Could it be that Duchamp's **readymade** *Traveller's Folding Item* (1916), a typewriter cover with the brand name Underwood emblazoned in golden letters across its soft black fabric, was also meant as a sensual pun expressing his appreciation of Beatrice Wood?

WORDPLAYS

See **puns**.

WORK [illustration p. 194]

'I would have wanted to work, but deep down I'm enormously lazy. I like living, breathing, better than working. I don't think that the work I've done can have any social importance whatsoever in the future. My art is that of living: each

second, each breath is a work which is inscribed nowhere, which is neither visual nor cerebral. It's a sort of constant euphoria.'[11] (**laziness**). In fact, 'one could say that I spend my time breathing. I am a réspirateur – a breather. I enjoy it tremendously.'[12] Just over a year before his death, Duchamp was asked what he was working on: 'You have to realize that there comes an age when you no longer need to do anything, unless you want to. I don't want to. I don't want to work or do something. I'm fine as I am. I think **life** is so great when you have nothing to do, no work. Even painting! Art questions are of absolutely no interest to me now.'[13] As with many of Duchamp's declarations, his embracing of laziness came with a twist. While proclaiming all of the above, he was in fact secretly creating *Étant donnés* (1946–66). After all, he agreed wholeheartedly with his friend **Henri-Pierre Roché** (1879–1959) when he remarked that Duchamp's best work was the use of his **time**.

X

When looking through the peepholes at the assemblage behind, it is possible for visitors encountering *Étant donnés* (1946–66) at the Philadelphia Museum of Art to observe a white X in the centre of the uppermost part of the blue sky above the background landscape. Although Duchamp wanted to make sure, as stipulated in his installation manual for the work, that the X could not be detected by the onlooker, it is in fact visible to those who bend down and glance upward, with their faces pressed against the large wooden **door**.

Taking into account Duchamp's keen interest in **science** and technology, the art historian Linda Dalrymple Henderson (b. 1948) has made a convincing case for Duchamp being inspired by images of X-radiography. Halos, overlays, transparent dissecting, monochromatic colouring, and the movement and cutting of human forms are all found in his works. Moreover, not only did the discoverer of X-rays, Wilhelm Röntgen (1845–1923), teach at **Munich**'s university close to where Duchamp lived in 1912, but also X-ray imagery was ubiquitous in the media at the time. One of Duchamp's brothers came into contact with an early champion of X-ray research while working at a hospital and a classmate later became a prominent radiologist.

'X Rays / (?) / infrathin / Transparency or cuttingness',[1] Duchamp wrote in one of his **notes**. For someone preoccupied with **anatomy** and 'visceral forms',[2] it is likely that the use of X-rays to make internal processes apparent while dissolving solid surfaces played a part in encouraging Duchamp to abandon figurative painting to focus on mechanical and mechanomorphic works, which he then incorporated into completely different and complex modes of expression. Indeed, in 1937 Frederick J. Kiesler (1890–1965) referred to Duchamp's **_Large Glass_** (1915–23) as 'the first x-ray-painting of space'.[3]

YARA

When Duchamp installed the *Large Glass* (1915–23) in the **Philadelphia Museum of Art** in 1954, he made sure that a doorway was built into the wall behind it, beyond which there was a balcony. As first pointed out by Dieter Daniels (b. 1957),[1] this opening gave a view of a marble fountain in the courtyard and of a sculpture of the river goddess *Yara* (*c.* 1940) created by Duchamp's lover, **Maria Martins** (1894–1973). Michael R. Taylor (b. 1966) suggests that its female figure may have been based on Martins's own body, echoing Duchamp's female torso in *Étant donnés* (1946–66), in part also modelled on Martins.[2] By incorporating the museum's exterior into his work, Duchamp broke free from the constraints of the exhibition space and added another sophisticated dimension to what has become known as site-specificity.

YOUNG MAN AND GIRL IN SPRING

This 1911 allegorical painting celebrating **love** between man and woman was presented as a wedding gift by Duchamp to his sister Suzanne (1889–1963). It depicts the elongated nude bodies of a male and a female reaching upwards in a paradisaical setting. While **Arturo Schwarz's** (b. 1924) analysis of the work includes allusions to homosexual intercourse, Kabbalism and tantrism, Francis M. Naumann (b. 1948) and Calvin Tomkins (b. 1925) convincingly propose that, for once, Duchamp's work may be read by what the eye actually sees: 'a lyrical ode to the joys of marriage'.[3]

MARIUS AND GEORGE DE ZAYAS

The Mexican-born artist, caricaturist, writer and art critic Marius de Zayas (1880–1961) played a vital role in introducing modern and contemporary art to the United States. After curating important shows for Alfred Stieglitz's (1864–1946) 291 Gallery, in 1915 he began mounting exhibitions at his own Modern Gallery (later the De Zayas Gallery) in Manhattan, just across the street from the New York Public Library. The Modern Gallery would have been the perfect place to show Duchamp's works had he been less reluctant to do so. Just once, in 1919, and only upon the insistence of **Walter Arensberg** (1878–1954), did Duchamp present three works at one of de Zayas's shows, *The Evolution of French Art – From Ingres and Delacroix to the Latest Modern Manifestations*, at New York's Arden Gallery. The catalogue listed the works under the name 'Marcelle Duchamb', however.

De Zayas's brother George (1898–1967), also a caricaturist, may have had a greater rapport with the artist. While some date photographs of Duchamp's shaved head and tonsure (**hair**) to 1919, others believe that George administered the haircut in Paris in 1921.

NOTES

INTRODUCTION: A B C DUCHAMP

1. Gustave Flaubert, *Dictionnaire des idées reçues; Album de la Marquise; Catalogue des idées chic,* vols V, VI (Oeuvres complètes), Paris: Société des Études Littéraires, 1972.
2. Motherwell, 'Introduction by Robert Motherwell', in Cabanne, 1987, p. 12.
3. Ibid.
4. Quoted in an interview with William Seitz, in Gough-Cooper and Caumont, in Hultén (ed.), 1993, within the entry for 15 February 1963, n.p.
5. Buffet-Picabia, 'Marcel Duchamp: Fluttering Hearts' (1936), in Hill (ed.), 1994, pp. 15–18, p. 16.
6. Hare, quoted in Tomkins, 1996, p. 430.
7. Sanouillet and Peterson (eds), 1989, p. 77–79.
8. Ibid., p. 31–32.
9. Apollinaire, 1970, p. 48.
10. George Heard Hamilton and Richard Hamilton in conversation with Duchamp, 'Marcel Duchamp Speaks', *BBC Third Programme* (October 1959); published as a tape by Furlong (ed.), 1976.

A

1. Gough-Cooper and Caumont, in Hultén (ed.), 1993, within the entry for 9 November 1959, n.p.
2. Ibid., 8 April 1959, n.p.
3. Duchamp, 'Pop's Dada', *Time* (5 February 1965), p. 65, quoted in Naumann, 1999, p. 257.
4. O'Neill (ed.), 1990, pp. 39, 208.
5. Dickerman, 2012–13, p. 34.
6. Sweeney, 1946, pp. 19–21, p. 19.
7. Lebel, 1959, p. 73.
8. Hamilton, 1965, n.p.
9. Quoted in McBride, 1915, p. 2.
10. George Heard Hamilton and Richard Hamilton in conversation with Duchamp, 'Marcel Duchamp Speaks', *BBC Third Programme* (October 1959); published as a tape by Furlong (ed.), 1976.

11. Quoted in d'Harnoncourt and McShine (eds), 1989, p. 263.
12. Sanouillet and Peterson (eds), 1989, p. 43.
13. Exhibition guide for *Hammer's anatomische Original Ausstellung,* Munich, 1916, p. 11.
14. Taylor, 2009, p. 194.
15. Cabanne, 1987, p. 29.
16. Tomkins, 2013, p. 83.
17. Ibid.
18. Kuh (1961), 2000, pp. 81–93, p. 88.
19. Breunig, 2001, pp. 71, 184.
20. Apollinaire, 1970, p. 48.
21. Duchamp quoted in Regás, 1965, p. 85.
22. Gabrielle Buffet-Picabia quoted in Watson, 1991, p. 260.
23. Brown, 1988, p. 43.
24. Sanouillet and Peterson (eds), 1989, p. 74. A more recent and accurate translation by Richard Hamilton and Ecke Bonk suggests: 'Can works be made which are not "of art"', in Hamilton and Bonk (eds), 1999, n.p.
25. 'The Western Roundtable on Modern Art, San Francisco, 1949', in Clearwater (ed.), 1991, pp. 106–14, p. 106.
26. George Heard Hamilton and Richard Hamilton in conversation with Duchamp, 'Marcel Duchamp Speaks', *BBC Third Programme* (October 1959); published as a tape by Furlong (ed.), 1976.
27. Quoted from Duchamp's lecture 'The Creative Act' (1957), in Sanouillet and Peterson (eds), 1989, pp. 127–37, p. 138.
28. Seitz, 1963, pp. 112–13, 129–31, p. 131.
29. Naumann and Obalk (eds), 2000, p. 321 (from a letter of 17 August 1952 to his sister Suzanne and her husband Jean Crotti).
30. Seitz, 1963, pp. 112–13, 129–31, p. 131.
31. Naumann and Obalk (eds), 2000, p. 321 (from a letter of 17 August 1952 to his sister Suzanne and her husband Jean Crotti).
32. Tomkins, 2013, p. 60.
33. Cabanne, 1987, p. 67.
34. Quoted in Hapgood, 1994, p. 85.
35. Naumann, 2012, p. 480.
36. Ibid., p. 211.

37. Jacqueline Matisse Monnier, e-mail to the author, 13 June 2013.
38. Marinetti, 'Manifesto of Futurism', in Harrison and Wood (eds), 1992, p. 147.
39. Sanouillet and Peterson (eds) 1989, pp. 26, 27.
40. Ibid., p. 39.
41. Ibid., p. 42.
42. Ibid., p. 43.
43. Ibid.
44. Matisse (ed.), 1983, n.p. (Note no. 178).
45. Moira and William Roth, 'John Cage on Marcel Duchamp: An Interview' (1973), in Basualdo and Battle (eds), 2012, pp. 126–38, p. 137.

B

1. Cabanne, 1987, p. 17.
2. Forthuny, 1912, p. 6.
3. Sanouillet and Peterson (eds), 1989, p. 160.
4. Tomkins, 2013, p. 53.
5. See, for example, Melik Kaylan, 'The Case of the Stolen Duchamp', in Forbes Online, 20 June 2001, www.forbes.com/2001/06/20/0620hot.html> (29 June 2013).
6. Wood, 1996, p. 31.
7. Ibid.
8. Ibid., p. 33.
9. See the drawing by Beatrice Wood titled Lit de Marcel (Après Webster Hall) (1917), in which the names of three women and two men, including Beatrice and Marcel, are listed.
10. Quoted in Gough-Cooper and Caumont, in Hultén (ed.), 1993, within the entry for 8 September 1966, n.p.
11. From a 'BBC Interview with Marcel Duchamp, conducted by Joan Bakewell' (London, 5 June 1968), quoted in Naumann, 1999, pp. 300–6, p. 306.
12. Quoted from an 'Interview by Colette Roberts', Art in America, vol. 57, no. 4 (July–August 1969), p. 39.
13. Kuh (1961), 2000, pp. 81–93, p. 83.
14. Duchamp quoted in Schwarz, 2000, p. 724.
15. Sanouillet and Peterson (eds), 1989, pp. 56, 57.
16. Quoted in Bonk, 1989, p. 257.
17. Ibid., p. 9.
18. Quoted in 'Brancusi Bronzes Defended by Cubist', New York Times (27 February 1927), p. 14.
19. Eglington, 1933, pp. 3, 11.
20. Naumann, 2012, p. 273.

21. Quoted in Gough-Cooper and Caumont, in Hultén (ed.), 1993, within the entry for 6 January 1961, n.p.
22. Stauffer, 1981, p. 287.
23. From a letter by Duchamp to Maria Martins of 6 October 1949, quoted in Taylor, 2009, p. 415.
24. Quoted in Gough-Cooper and Caumont, in Hultén (ed.), 1993, within the entry for 6 January 1961, n.p.
25. From a letter by Marcel Duchamp to Maria Martins of 24 May 1949, quoted in Taylor, 2009, p. 411.
26. Breton, 'Lighthouse of the Bride' (1935), in Ford (ed.), 1945, pp. 6–9, 13, p. 13.
27. Ibid., pp. 7–8.
28. Tomkins, 1996, p. 443.
29. André Breton et al., 'We Don't Ear it That Way', Surrealist tract of December 1960 in opposition to Dalí's inclusion in the exhibition Surrealist Intrusion in the Enchanter's Domain, D'Arcy Galleries, New York, 28 November 1960–14 January 1961.
30. Quoted in Robert Lebel, 'Marcel Duchamp and André Breton', from a 1966 interview with André Parinaud, in d'Harnoncourt and McShine (eds), 1989, pp. 135–41, p. 140.
31. D'Harnoncourt and McShine (eds), 1989, p. 263.
32. Buffet-Picabia, 'Marcel Duchamp: Fluttering Hearts' (1936), in Hill (ed.), 1994, pp. 15–18, p. 16.
33. Ibid.
34. Ibid., p. 15.
35. Buffet-Picabia, 'Some Memories of Pre-Dada: Picabia and Duchamp' (1949), in Motherwell (ed.), 1988 (1951), pp. 253–67, p. 260.

C

1. Ray, 1988, p. 192.
2. Taylor, 2009, p. 91.
3. John Cage, '26 Statements Re Duchamp' (1964), in d'Harnoncourt and McShine (eds), 1989, pp. 188–89.
4. Ibid.
5. Quoted in Gough-Cooper and Caumont, in Hultén (ed.), 1993, within the entry for 4 December 1961, n.p.
6. Ibid., within the entry for 5 February 1968, n.p.
7. Ibid., within the entry for 1 July 1966, n.p.
8. Ibid., and 8 September 1966.
9. Quoted in Hill (ed.), 1994, p. 67.

10. Cage, 'Preface to James Joyce, Marcel Duchamp, Erik Satie: An Alphabet' (1983), in Basualdo and Battle (eds), 2012, pp. 224–27, p. 224.
11. Quoted in Tomkins, 2013, p. 85.
12. Ibid., p. 86.
13. Ibid.
14. Cabanne, 1987, p. 76.
15. Tomkins, 2013, p. 51.
16. Ibid., p. 53.
17. Kuh (1961), 2000, pp. 81–93, p. 92.
18. From a brief speech held before the annual meeting of the New York State Chess Federation in 1952, quoted in Naumann and Bailey, 2009, p. 34.
19. Roché, 'Souvenirs of Marcel Duchamp', in Lebel, 1959, pp. 79–87, pp. 83, 84.
20. Sylvère Lotringer, 'Becoming Duchamp', in *Tout-Fait: The Marcel Duchamp Studies Online Journal*, vol. 1, issue 2 (May 2000) <www.toutfait. com/issues/issue_2/Articles/lotringer.html> (7 January 2013).
21. Raymond Keene, 'Marcel Duchamp: The Chess Mind', in Hill (ed.), 1994, pp. 121–30, p. 123.
22. Anonymous, 'Marcel Duchamp speaks about his work', <www.youtube.com/watch?v=FiO8xFlid90> (7 January 2013).
23. Strouhal, 1994, p. 76 (quoting from a 1961 interview with Frank R. Brady).
24. Beatrice Wood, 'Marcel', in Kuenzli and Naumann (eds), 1989, pp. 12–17, p. 12.
25. Quoted in James Johnson Sweeney, 'Marcel Duchamp', in Nelson (ed.), 1958, pp. 92–93.
26. Sanouillet and Peterson (eds), 1989, p. 68.
27. Ibid., p. 70.
28. Schwarz, 2000, p. 802.
29. Quoted in Marquis, 2002, p. 292.
30. Quoted in Harriet and Sidney Janis, 'Marcel Duchamp, Anti-Artist', in Mashek (ed.), 1975, pp. 30–40, p. 34.
31. Quoted in Gough-Cooper and Caumont, in Hultén (ed.), 1993, within the entry for 28 September 1937, n.p.
32. Tomkins, 2013, p. 27.
33. Quoted in Clearwater (ed.), 1991, p. 114.
34. Cabanne, 1987, p. 74.
35. Quoted in Sargeant, 1922, pp. 100–11, p. 108.
36. Quoted in Schonberg, 1963, p. 25.
37. Naumann and Obalk (eds), 2000, p. 385 (from a letter of 28 July 1964 to Douglas Gorsline).
38. Quoted in Harriet and Sidney Janis, 'Marcel Duchamp: Anti-Artist', in Ford (ed.), 1945, pp. 18–24, 53, p. 24.

39. Johns, 1969, p. 31.
40. James Johnson Sweeney, 'A Conversation with Marcel Duchamp', television interview, *NBC*, January 1956, in Sanouillet and Peterson (eds), 1989, pp. 127–37, p. 137.
41. Ibid.
42. Quoted in Gough-Cooper and Caumont, in Hultén (ed.), 1993, within the entry for 23 July 1964, n.p.
43. Cabanne, 1987, p. 89.
44. Whitman, 1996, p. 123.
45. Matisse (ed.), 1983, n.p. (Note no. 185).
46. Quoted in Naumann, 1999, p. 261.
47. Quoted in Harriet and Sidney Janis, 'Marcel Duchamp: Anti-Artist', in Ford (ed.), 1945, pp. 18–24, 53, p. 18.
48. Quoted in Sanouillet and Peterson (eds), 1989, p. 118.
49. Ibid.
50. Copley, 1969, p. 36.
51. Ibid.
52. Cabanne, 1987, p. 16.
53. Unless otherwise indicated, all quotes in this entry are from Duchamp, 'The Creative Act', in Hill (ed.), 1994, p. 87.
54. Dreier and Echaurren, 1944, n.p.
55. Ibid.
56. Tomkins, 2013, p. 62.
57. Naumann and Obalk (eds), 2000, p. 348 (from a letter of 8 March 1956 to Jehan Mayoux).
58. Quoted in 'The Western Roundtable on Modern Art, San Francisco, 1949', in Clearwater (ed.), 1991, pp. 106–14, p. 109.
59. Gough-Cooper and Caumont, in Hultén (ed.), 1993, within the entry for 23 July 1964, n.p.
60. Tomkins, 2013, p. 82.
61. Quoted from Stieglitz, 1917, p. 15.

D

1. Hugo Ball, 'Dada Fragments' (1916), in Harrison and Wood (eds), 1992, pp. 246–48, p. 246.
2. Quoted in Gough-Cooper and Caumont, in Hultén (ed.), 1993, within the entry for 21 November 1963, n.p.
3. Naumann and Obalk (eds), 2000, p. 125 (from a letter of October (?) 1922 to Tristan Tzara).
4. Ibid., p. 126.
5. The artist Timothy Phillips quoted in Girst, 2013 p. 209.

6. Salvador Dalí, 'The King and Queen Traversed by Swift Nudes' (1959), in Franklin (ed.), 2003, pp. 108–11, p. 108.
7. Salvador Dalí, 'L'échecs, c'est moi ['Chess, it's me.']' (1971), in Franklin (ed.), 2003, pp. 119–21, p. 121.
8. Varia, 1986, p. 47.
9. Cabanne, 1987, p. 73.
10. Quoted in Tomkins, 1976, p. 67.
11. Quoted in Tomkins, 2013, p. 34.
12. Quoted in Seitz, 1963, pp. 110, 112–13, 129–31, p. 130.
13. Cabanne, 1987, p. 107.
14. Ibid.
15. Ray, 1988 (1963), p. 315.
16. Jacqueline Matisse Monnier, e-mail to the author, 13 June 2013.
17. Richter, 1969, pp. 40–41, p. 41.
18. Quoted in Gough-Cooper and Caumont, in Hultén (ed.), 1993, within the entry for 16 June 1936, n.p.
19. Matisse (ed.), 1983, n.p. (Notes nos. 252, 256).
20. Quoted in Sanouillet and Peterson (eds), 1989, p. 26.
21. Quoted in Gold, 1958, pp. xviii, 54.
22. Quoted in Nin, 1966, p. 357.
23. Friedrich Nietzsche, Briefwechsel, Kritische Gesamtausgabe, III, 7/1, Berlin: De Gruyter, 2003, p. 995.
24. Tomkins, 2013, p. 64
25. Johns, 1969, p. 31.
26. Quoted in an interview with Otto Hahn, in Gough-Cooper and Caumont, in Hultén (ed.), 1993, within the entry for 23 July 1964, n.p.
27. Watson, 1991, p. 271.
28. Ibid., pp. 147–48.
29. James Johnson Sweeney, 'A Conversation with Marcel Duchamp', television interview, NBC, January 1956, in Sanouillet and Peterson (eds), 1989, pp. 127–37, p. 137.
30. Tomkins, 2013, pp. 55, 57.
31. Cabanne, 1987, p. 54.
32. Teeny Duchamp in a conversation with the author, 1 November 1990.
33. Sanouillet and Peterson (eds), 1989, p. 53.

E

1. Moira and William Roth, 'John Cage on Marcel Duchamp: An Interview' (1973), in Basualdo and Battle (eds), 2012, pp. 126–38, p. 133.
2. Ernst and Duchamp quoted in Naumann, 1999, p. 23.
3. Hahn quoted in Otto Hahn, 'Marcel Duchamp Interviewed' (1966), in Hill (ed.), 1994, pp. 67–72, p. 71.
4. Duchamp quoted in Hahn, ibid.
5. Quoted in Philippe Collin, Marcel Duchamp, television interview for the programme 'Nouveaux Dimanches' at the Galerie Givaudan, Paris, 21 June 1967; English translation published as 'Marcel Duchamp Talking about Ready-mades', in Museum Jean Tinguely Basel (ed.), 2002, pp. 37–42, p. 38.
6. Sanouillet and Peterson (eds), 1989, p. 71.
7. De Zayas, 1919, n.p.
8. Sanouillet and Peterson (eds), 1989, pp. 127–37, pp. 148, 149.
9. Quoted in John Russell, 'Assembling Scattered Works by the Cognescenti's Painter', in New York Times (28 November 2001), pp. E1, E4, p. E4.
10. Sanouillet and Peterson (eds), 1989, p. 149.
11. Robert Motherwell, 'Introduction', in Cabanne, 1987, pp. 7–12, p. 10.
12. See Hopkins, 1998.
13. Cabanne, 1987, p. 88.
14. Stauffer, 1981, p. 276.
15. Cabanne, 1987, p. 88.
16. Preston, 1953, p. 12.
17. Fitzsimmons, 'Art', Arts & Decoration (February 1953), p. 31.
18. Helen Meany, 'Duchamp's influence on US artists', The Irish Times (24 December 2012) <www.irishtimes.com/newspaper/features/2012/1224/1224328148575.html> (7 January 2013).
19. Georges Charbonnier, Six entretiens avec Marcel Duchamp, RTF France Culture radio broadcast, 9 December 1960–13 January 1961.
20. Ibid.
21. Quoted in Gough-Cooper and Caumont, in Hultén (ed.), 1993, within the entry for 9 August 1967, n.p.
22. Quoted in Venter, 2001.
23. Canaday, 1969, reprint 1973, n.p.
24. Duchamp, in a letter to Maria Martins of 19 November 1949 (?), quoted in Taylor, 2009, p. 419.
25. Levy, 1977, p. 20.

26. Copley, 1969, p. 36.
27. Duchamp, in a letter to Maria Martins of 12
 October 1948, quoted in Taylor, 2009, p. 409.
28. Matisse (ed.), 1983, n.p. (Note no. 24).

F

1. Baruchello and Martin, 1985, p. 43; Lydie Fischer
 Sarazin-Levassor, 2007, p. 71.
2. Matisse (ed.), 1983, n.p. (Note no. 190).
3. Ibid. (Note no. 191).
4. Ibid. (Note no. 192).
5. Ibid. (Note no. 199).
6. Gabrielle Buffet-Picabia, 'Marcel Duchamp:
 Fluttering Hearts' (1936), in Hill (ed.), 1994,
 pp. 15–18, p. 15.
7. Ray, 1988 (1963), p. 73.
8. Quoted from Moira and William Roth, 'John
 Cage on Marcel Duchamp: An interview', in
 Basualdo and Battle (eds), 2012, pp. 224–27,
 pp. 126–37, p. 127.
9. E-mail to the author, 13 June 2013.
10. M. Naumann and Obalk (eds), 2000, p. 29 (from a
 letter of 9 August 1917 to Ettie Stettheimer).
11. Ibid, p. 135 (from a letter of 26 July 1923 to Ettie
 and Carrie Stettheimer).
12. Barr and Sachs (eds), 1961, pp. 138–39.
13. Quoted from Stieglitz, 1917, p. 15.
14. Blake Gopnik, 'Duchamp's Fountain Was
 Subversive – but Subverting What?', *The Daily
 Beast* (15 December 2011),
 <www.thedailybeast.com/articles/2011/12/15/
 duchamp-s-fountain-was-subversive-but-
 subverting-what.html> (21 April 2013). Gopnik
 is quoting the finding of scholar Ezra Shales.
15. Camfield, 1989, p. 37.
16. Ibid., p. 38.
17. Quoted in Steefel Jr, 1977, p. 312, fn. 39.
18. Quoted in Stauffer, 1981, p. 276 (letter of 28 May
 1961).
19. Cabanne, 1987, p. 40.
20. Quoted in Sanouillet and Peterson (eds), 1989,
 p. 145.
21. Freytag-Loringhoven, quoted in Watson, 1991,
 p. 271.
22. Quoted in Naumann, 1994, p. 72.
23. Kuh (1961), 2000, pp. 81–93, p. 83.
24. Cabanne, 1987, p. 35.
25. Sanouillet and Peterson (eds), 1989, p. 145.

G

1. Marquis, 2002, p. 284.
2. Quoted in Tomkins, 1976, p. 67.
3. Quoted in Gough-Cooper and Caumont, in
 Hultén (ed.), 1993, within the entry for 12 April
 1960, n.p.
4. Quoted in an interview with Otto Hahn, in ibid.,
 within the entry for 23 July 1964, n.p.
5. Marcel Duchamp in an interview with Otto Hahn,
 'Passport No. G255300', *Art and Artists*, vol. 1, no.
 4 (New York, July 1966), pp. 6–11, p. 10.
6. Tomkins, 2013, p. 29.
7. Quoted in Linde, 1965, p. 5.
8. Cabanne, 1987, p. 106.
9. Tomkins, 2013, p. 85.
10. Naumann and Obalk (eds), 2000, p. 344 (from a
 letter of 4 October 1954 to André Breton).
11. George Heard Hamilton and Richard Hamilton
 in conversation with Duchamp, 'Marcel Duchamp
 Speaks', *BBC Third Programme* (October 1959);
 published as a tape by Furlong (ed.), 1976.
12. Ibid., p. 348 (from a letter of 8 March 1956 to
 Jehan Mayoux).
13. Quoted in Gough-Cooper and Caumont, in
 Hultén (ed.), 1993, within the entry for 13 May
 1960, n.p.
14. Sanouillet and Peterson (eds), 1989, p. 75.
15. Matisse (ed.), 1983, n.p. (Note no. 179).
16. Steven Heller, e-mail to the author (5 February
 2013).
17. Quoted in Gough-Cooper and Caumont, in
 Hultén (ed.), 1993, within the entry for 15
 January 1956, n.p.
18. Philippe Collin, *Marcel Duchamp*, television
 interview for the programme 'Nouveaux
 Dimanches' at the Galerie Givaudan, Paris, 21
 June 1967; English translation published as
 'Marcel Duchamp Talking about Ready-mades',
 in Museum Jean Tinguely Basel (ed.) 2002,
 pp. 37–42, p. 38.
19. Quoted in Clearwater (ed.), 1991, p. 108.
20. Cabanne, 1987, p. 19.
21. Guggenheim, 2006 (1979), p. 50.
22. Ibid., p. 66.
23. Ibid.
24. See the entry on the website of the University
 of Iowa Museum of Art, whose collection now
 includes Pollock's mural, <http://uima.uiowa.
 edu/mural> (28 June 2013).
25. Quoted in Gough-Cooper and Caumont, in
 Hultén (ed.), 1993, within the entry for 6 May
 1966, n.p.

H

1. Naumann and Obalk (eds), 2000, p. 368 (from a letter of 26 November 1960 to Richard Hamilton).
2. Richard Hamilton, 'Introduction', in Arts Council of Great Britain (ed.), 1966, n.p.
3. Richard Hamilton, 'The Large Glass', in d'Harnoncourt and McShine (eds), 1989, pp. 57–68, p. 58.
4. Ibid., p. 67.
5. Tomkins, 2013, p. 63.
6. This and the following quotes in this entry are from Matisse (ed.), 1983, n.p. (Note no. 80).
7. Sanouillet and Peterson (eds), 1989, p. 30.
8. Kuh (1961), 2000, pp. 81–93, p. 90.
9. Quoted in Guy Viau, 'To Change Names, Simply', interview with Marcel Duchamp on Canadian Radio Television, 17 July 1960 (translated by Sarah Skinner Kilborne) in <www.toutfait.com/issues/volume2/issue_4/interviews/md_guy/md_guy_f.html> (31 March 2013).
10. Quoted in Schwarz, 2000, p. 558.
11. Duchamp quoted in Jouffroy, 1964, p. 118.
12. Quoted in Gough-Cooper and Caumont, in Hultén (ed.), 1993, within the entry for 8 December 1961, n.p.
13. Gabrielle Buffet-Picabia, 'Marcel Duchamp: Fluttering Hearts' (1936), in Hill (ed.), 1994, pp. 15–18, p. 17.
14. Sarazin-Levassor, 2010 (1975/1976), p. 208.

10. Duchamp quoting T.S. Eliot in 'The Creative Act' (1957), in Sanouillet and Peterson (eds), 1989, pp. 138–40, p. 138.
11. Quoted on *Caroline Wiseman Modern & Contemporary*, <www.carolinewiseman.com/exhibition/cage-onehundredyearslater > (20 January 2013).
12. Ibid.
13. Matisse (ed.), 1983, n.p. (Note no. 35).
14. Ibid. (Note no. 15).
15. Ibid. (Note no. 13).
16. Duchamp, from a conversation of 7 August 1945, quoted in de Rougemont, 1968, pp. 562–71, p. 568.
17. Matisse (ed.), 1983, n.p. (Note no. 9).
18. Ibid. (Note no. 28).
19. Ibid. (Note no. 20).
20. Ibid. (Note no. 9).
21. Cabanne, 1987, p. 16.
22. Jouffroy, 1954, p. 13.
23. Seitz, 1963, pp. 110, 112–13, 129–31, p. 130.
24. Thomas Girst, 'Prix Marcel Duchamp 2000: Seven Questions for Thomas Hirschhorn', in *Tout-Fait: The Marcel Duchamp Studies Online Journal*, vol. 2, issue 4 (January 2000), <www.toutfait.com/issues/volume2/issue_4/interviews/hirschhorn/hirschhorn.html> (18 August 2012).
25. Duchamp, as quoted by Henri-Pierre Roché, 'Souvenirs of Marcel Duchamp', in Lebel, 1959, pp. 79–87, p. 85.

I

1. Quoted in Lebel, 1959, p. 85.
2. Cabanne, 1987, p. 69.
3. Quoted in Gough-Cooper and Caumont, in Hultén (ed.), 1993, within the entry for 5 May 1966, n.p.
4. Duchamp, 'Apropos of "Ready-mades"' (1961), in Sanouillet and Peterson (eds), 1989, pp. 141–42, p. 141.
5. Cabanne, 1987, p. 98.
6. Ibid., p. 102.
7. Sanouillet and Peterson (eds), 1989, p. 30.
8. Duchamp quoted in 'Une lettre de Marcel Duchamp' (to André Breton, 4 October 1954), quoted Naumann and Obalk (eds), 2000, p. 344; first printed in *Medium*, no. 4 (Paris, January 1955).
9. Ibid.

J

1. Quoted in Harriet and Sidney Janis, 'Marcel Duchamp: Anti-Artist', in Ford (ed.), 1945, pp. 18–24, 53, p. 18.
2. Duchamp in *The Temptation of St. Anthony*, 1946, p. 3.
3. Jouffroy, 1954, p. 13.
4. Ibid.
5. Cabanne, 1987, p. 89.
6. Duchamp quoted in Gough-Cooper and Caumont, in Hultén (ed.), 1993, within the entry for 25 February 1952, n.p.
7. Gough-Cooper and Caumont, in Hultén (ed.), 1993, within the entry for 12 August 1961, n.p.
8. Cabanne, 1987, p. 58.
9. Ibid.

notes

K

1. Sanouillet and Peterson (eds), 1989, pp.150–51, p. 150.
2. Ibid., p. 151.

L

1. Rousseau quoted in Dash, 2010, p. 141.
2. Gustave Flaubert from *Madame Bovary* (1856), quoted in Zamora, 1997, p. 178.
3. Quoted in an interview with Otto Hahn, in Gough-Cooper and Caumont, in Hultén (ed.), 1993, within the entry for 23 July 1964, n.p.
4. Ibid.
5. Quoted in an interview with William Seitz, in ibid., within the entry for 15 February 1963, n.p.
6. Quoted in an interview with Otto Hahn, in ibid., within the entry for 23 July 1964, n.p.
7. Duchamp, from a conversation with Schuster, 1957, pp. 143–45, p. 144.
8. Cabanne, 1987, p. 40.
9. Tomkins, 2013, p. 78.
10. Sanouillet and Peterson (eds), 1989, p. 39.
11. Ibid., p. 44.
12. Sanouillet, 1954, p. 5.
13. Lebel, 'Portrait of Marcel Duchamp as a Dropout', in Franklin (ed.), 2006, pp. 72–85, pp. 72, 73.
14. Quoted in Henderson, 1998, p. 72.
15. Levy, '"Duchampiana"', in Ford (ed.), 1945, pp. 33–34, p. 34.
16. Levy, 1977, p. 20.
17. Levy, 1936, p. 17.
18. Levy, '"Duchampiana"', in Ford (ed.), 1945, pp. 33–34, p. 33.
19. Ibid.
20. Duchamp, 'The Great Trouble with Art in This Country' (1946), in Moure, 2009, pp. 115–17, p. 117.
21. Quoted in Tomkins, 1996, p. 73.
22. De Zayas, 1919, n.p.
23. Sanouillet and Peterson (eds), 1989, p. 43.
24. Ibid., p. 44.
25. Quoted in Taylor, 2009, p. 421.
26. Henri-Pierre Roché quoted in Tomkins, 1996, p. 174.
27. Marquis, 2002, p. 200.
28. Quoted in Naumann, 2012, p. 161.

29. Schwarz, 2000, p. 875.
30. Duchamp in an interview with Pierre Cabanne, 'Marcel Duchamp – je suis un défroque', *Arts & Loisirs*, 35 (31 May 1966), pp. 16–17, p. 17.
31. Cabanne, 1987, p. 15.

M

1. Wood, 'Marcel', in Kuenzli and Naumann (eds), 1989, pp. 12–17, p. 17.
2. Cabanne, 1987, p. 76.
3. Ibid.
4. Ibid.
5. Anonymous, 1959, pp. 118–19, p. 119.
6. Quoted in Taylor, 2009, p. 409.
7. Ibid., p. 412.
8. Ibid., p. 425.
9. Ibid., pp. 407, 417, 419.
10. Naumann and Deitch (eds), 1998, pp. 22–23.
11. Quoted in Clearwater (ed.), 1991, p. 111.
12. Gray, 1969, pp. 20–23, p. 21.
13. Ibid.
14. Tomkins, 2013, p. 84.
15. Quoted in Gough-Cooper and Caumont, in Hultén (ed.), 1993, within the entry for 24 November 1954, n.p.
16. Sanouillet and Peterson (eds), 1989, p. 191.
17. Ibid., p. 24.
18. Ibid.
19. Ibid., p. 115.
20. Naumann and Obalk (eds), 2000, p. 144 (in a letter from Monte Carlo to Francis Picabia, 17 April 1924).
21. Ibid., p. 151 (in a letter to Ettie Stettheimer of 27 March or May 1925).
22. Quoted in Gough-Cooper and Caumont, in Hultén (ed.), 1993, within the entry for 30 March 1968, n.p.
23. See 'Marcel Duchamp, Munich 1912: Miscellanea', in Friedl, Girst, Mühling and Rappe (eds), 2012, pp. 87–108.
24. Quoted in d'Harnoncourt and McShine (eds), 1989, p. 263.
25. Neill, 2003.
26. All quotes from Gavin Bryars, 'Notes on Marcel Duchamp's Music', in Hill (ed.), 1994, pp. 145–51, p. 146.
27. Matisse (ed.), 1983, n.p. (Note no. 199).
28. Ibid. (Note no. 183).
29. Ibid. (Note no. 181).

30. Quoted from an interview with Otto Hahn in Gough-Cooper and Caumont, in Hultén (ed.), 1993, within the entry for 1 July 1966, n.p.
31. Sanouillet and Peterson (eds), 1989, p. 23.

N

1. Quoted in 'French Artists Spur on an American Art', *The New York Tribune*, 24 October 1915, sec. IV, pp. 2–3, p. 3.
2. Quoted in Hill (ed.), 1994, p. 80.
3. Quoted in Gough-Cooper and Caumont, in Hultén (ed.), 1993, within the entry for 8 April 1959, n.p.
4. Roché, 'Souvenirs of Marcel Duchamp', in Lebel, 1959, pp. 79–87, p. 86.
5. Buffet-Picabia, 'Some Memories of Pre-Dada: Picabia and Duchamp' (1949), in Motherwell (ed.), 1981 (1951), pp. 255–67, p. 260.
6. Ibid.
7. Buffet-Picabia, 'Marcel Duchamp: Fluttering Hearts' (1936), in Hill (ed.), 1994, pp. 15–18, p. 15.
8. Buffet-Picabia, 'Some Memories of Pre-Dada: Picabia and Duchamp' (1949), in Motherwell (ed.), 1981 (1951), pp. 255–67, p. 257.
9. Quoted in Blesh, 1956, p. 74.
10. Sanouillet and Peterson (eds), 1989, p. 78.
11. Matisse (ed.), 1983, n.p. (Notes nos. 185, 186).
12. Naumann and Obalk (eds), 2000, p. 348 (from a letter of 8 March 1956 to Jehan Mayoux).
13. Ibid., p. 348 (from a letter of 8 March 1956 to Jehan Mayoux).
14. Ibid.
15. De Duve, 1991.
16. Levy, '"Duchampiana"', in Ford (ed.), 1945, pp. 33–34, p. 33.
17. Ray (1945), 1974, p. 31.
18. Quoted in Titus (ed.), 1932, p. 189.
19. Quoted in d'Harnoncourt and McShine (eds), 1989, p. 296.
20. Naumann, 2013.
21. Both quotes from Leja, 2007, p. 233.
22. Fitzpatrick, 2009, p. 63.
23. Dorothea Kelley quoted in Francis M. Naumann, 'Frederic C. Torrey and Duchamp's *Nude Descending a Staircase*', in Clearwater (ed.), 1991, pp. 11–24, p. 18.
24. Cabanne, 1987, p. 30.

O

1. Sanouillet and Peterson (eds), 1989, p. 43.
2. Ibid., p. 56.
3. Quoted in Ades, Cox and Hopkins (eds), 1999, p. 75.
4. Quoted in Taylor, 2009 p. 421.
5. Quoted in Stauffer, 1981, p. 286.
6. Duchamp in a 1953 interview with Harriet and Sidney Janis, quoted in Blunck, 2008, p. 8.
7. Duchamp quoted from a 1955 interview with James Johnson Sweeney, 'A Conversation with Marcel Duchamp', which first aired in January 1956 on NBC's programme 'Elderly Wise Men of Our Day'.
8. Cabanne, 1987, p. 64.
9. Ibid.

P

1. Lebel, 1959, p. 15.
2. Quoted in Sweeney, 1946), p. 20.
3. Quoted in Gough-Cooper and Caumont, in Hultén (ed.), 1993, within the entry for 9 December 1960, n.p.
4. Ibid., within the entry for 13 May 1960, n.p.
5. Naumann and Obalk (eds), 2000, p. 36 (from a letter of 27 April 1915 to Walter Pach).
6. Tomkins, 1996, p. 73.
7. Sanouillet and Peterson (eds), 1989, p. 49.
8. Ibid., p. 71.
9. Quoted in Tomkins, 1996, p. 73.
10. Paz, quoted in ibid., p.11.
11. Paz, 1970, n.p.
12. Duchamp, quoted in Steefel Jr, 1977, p. 312, fn. 39.
13. Adcock, 'Duchamp's Perspective: The Intersection of Art and Geometry', in *Tout-Fait: The Marcel Duchamp Studies Online Journal*, March 2003, <www.toutfait.com/online_journal_details.php?postid=1908#> (1 April 2013).
14. Sanouillet and Peterson (eds), 1989, p. 25.
15. Frank Brookes Hubacheck quoted in Marquis, 2002, p. 294.
16. Duchamp quoted in Jean-Jacques Lebel, 'Mise au point (Picabia-Dynamo)', *La Quinzaine littéraire*, vol. I, no. 13 (Paris, 1–15 October 1966), pp. 4–6, p. 6.
17. Matisse (ed.), 1983, n.p. (Note no. 135).
18. Lyotard, 1990.
19. Duchamp quoted in Stieglitz, 1922, p. 2.

20. Interview with Grace Glueck, *New York Times* (14 January 1965), reprinted in Stauffer, 1992, p. 178.

21. Marcel Duchamp, 'Where do we go from here?' (lecture, 1961), in Hill (ed.), 1994, p. 89.

22. Tomkins, 2013, p. 43.

23. Ibid.

24. Gough-Cooper and Caumont, in Hultén (ed.), 1993, within the entry for 1 June 1961, n.p.

25. Hernri-Pierre Roché, 'Souvenirs of Marcel Duchamp', in Lebel, 1959, pp. 79–87, p. 80.

26. Quoted in Stauffer, 1992, p. 107.

27. Quoted in Otto Hahn, 'Marcel Duchamp Interviewed' (1966), in Hill (ed.), 1994, pp. 67–72, p. 68.

28. Buffet-Picabia, 'Some Memories of Pre-Dada: Picabia and Duchamp' (1949), in Motherwell (ed.), 1988 (1951), pp. 253–67, p. 256.

29. Ibid., p. 257.

30. Quoted in Bernard Macardé, 'The Unholy Trinity. Duchamp, Man Ray, Picabia', *Tate Etc.*, 12 (London, Spring 2008), < www.tate.org.uk/context-comment/articles/unholy-trinity > (8 April 2013).

31. Sanouillet and Peterson (eds), 1989, p. 157.

32. Ibid.

33. Motherwell, 'Introduction by Robert Motherwell', in Cabanne, 1987, pp. 7–12, p. 12.

34. Paz, 1970, n.p.

35. Cabanne, 1987, pp. 84, 93.

36. Eglington, 1933, pp. 3, 11.

37. From Edmund White, 'Moma's Boy', *Vanity Fair* (September 1996), p. 304, quoted in Naumann, 1999, p. 286.

38. Sanouillet and Peterson (eds), 1989, p. 157.

39. Pontus Hultén (ed.), 1993, p. 19.

40. Birnbaum and Gunarsson (eds), 2012, p. 17.

41. Ibid.

42. Hélène Parmelin, *Voyage en Picasso*, Paris: Robert Laffond, 1980, p. 71, as quoted in Macardé, 2007, p. 9.

43. 'Literatur und Wissenschaft: Jules Henri Poincaré', *Münchner Neueste Nachrichten* (18 July 1912), p. 2.

44. Duchamp quoted in Rivière, 1966, p. 9.

45. Baruchello and Martin, 1985, p. 29.

46. Quoted in Schwarz, 2000, p. 670.

47. Duchamp, from a conversation of 7 August 1945, quoted in de Rougemont, 1968, pp. 562–71, p. 569.

48. Cabanne, 1987, p. 103.

49. All quotes cited in Gough-Cooper and Caumont, in Hultén (ed.), 1993, within the entries for 21

November 1963, 17 May 1964 and 12 December 1963, n.p.

50. Naumann and Obalk (eds), 2000, p. 321 (from a letter of 17 August 1952 to his sister Suzanne and her husband Jean Crotti).

51. Ibid.

52. Duchamp quoted in Clearwater (ed.), 1991, p. 110.

53. Kuh (1961), 2000, pp. 81–93, p. 90 ff.

54. Sanouillet and Peterson (eds), 1989, p. 111.

55. Ibid., p. 117.

56. Matisse (ed.), 1983, n.p. (Note no. 217).

57. Ibid.

58. Ibid. (Note no. 211).

59. Ibid. (Note no. 244).

60. Ibid. (Note no. 287).

61. Ibid. (Note no. 233).

Q

1. Duchamp quoted in Tomkins, 1976, p. 67.

2. Quoted in Gough-Cooper and Caumont, in Hultén (ed.), 1993, within the entry for 22 June 1966, n.p.

3. Buffet-Picabia, 'Marcel Duchamp: Fluttering Hearts' (1936), in Hill (ed.), 1994, pp. 15–18, p. 16.

R

1. Ray, 1988 (1963), p. 62.

2. Ibid.

3. Sanouillet and Peterson (eds), 1989, p. 153.

4. Ibid. p. 165.

5. Ray, 1969, p. 43.

6. Kuh (1961), 2000, pp. 81–93, p. 92.

7. Tomkins, 2013, p. 17.

8. Kuh (1961), 2000, pp. 81–93, p. 90.

9. Breton, 'Lighthouse of the Bride' (1935), in Ford (ed.), 1945, pp. 6–9, 13, p. 7.

10. From a 1963 interview with Francis Roberts, quoted in Naumann, 2012, p. 175.

11. Cabanne, 1987, p. 47.

12. Sanouillet and Peterson (eds), 1989, p. 33.

13. Quoted in Philippe Collin, *Marcel Duchamp*, television interview for the programme 'Nouveaux Dimanches' at the Galerie Givaudan, Paris, 21 June 1967; English translation published as 'Marcel Duchamp Talking about Readymades', in Museum Jean Tinguely Basel (ed.), 2002, pp. 37–42, p. 37.

14. Duchamp, 'Apropos of "Readymades"' (1961), in
 Sanouillet and Peterson (eds), 1989, pp. 141–42.
15. Matisse (ed.), 1983, n.p. (Note no. 172).
16. Sanouillet and Peterson (eds), 1989, p. 33.
17. Naumann and Obalk (eds), 2000, p. 77 (from a
 letter of
 c. 13 January 1919 to Carrie, Ettie and Florine
 Stettheimer).
18. Anonymous, 1965.
19. Duchamp in an interview with Otto Hahn,
 'Passport No. G255300', Art and Artists, vol. 1, no.
 4 (New York, July 1966), pp. 6–11, p. 10.
20. Duchamp in an interview with Francis Roberts
 (1963), quoted in André Gervais, 'Note sur le
 terme readymade (ou ready-made)', in Chateau
 and Vanpeene (eds), 1999, pp. 118–26, p. 121.
21. Sanouillet and Peterson (eds), 1989, p. 32.
22. Ibid.
23. Lautréamont, 1966, p. 263.
24. Sanouillet and Peterson (eds), 1989, p. 32.
25. Stauffer, 1981, p. 283; Schwarz, 2000, p. 642.
26. Quoted in Naumann, 1999, p. 15.
27. Quoted in 'BBC Interview with Marcel Duchamp',
 conducted by Joan Bakewell (London, 5 June
 1968), from Naumann, 1999, pp. 300–6, p. 303.
28. Quoted in Gough-Cooper and Caumont, in
 Hultén (ed.), 1993, within the entry for 27
 September 1961, n.p.
29. Salvador Dalí, 'L'échecs, c'est moi ('Chess, it's
 me.')' (1968), in Cabanne, 1987, pp. 13–14, p. 13.
30. Lebel, 1966, pp. 16–19, p. 19.
31. Ibid.
32. Ibid.
33. Duchamp, 'Apropos of "Ready-mades"', in
 Sanouillet and Peterson (eds), 1989, pp. 141–42,
 p. 142.
34. Sanouillet and Peterson (eds), 1989, p. 75.
35. Lebel, 1966, pp. 16–19, p. 19.
36. Quoted in d'Harnoncourt and Hopps, 1969, p. 17.
37. Cabanne, 1987, p. 77.
38. Quoted in Clearwater (ed.), 1991, p. 108.
39. Quoted in 'Where do we go from here?' (1961), in
 Hill (ed.), 1994, p. 89.
40. Quoted in Sweeney, 1946, p. 20.
41. Marquis, 2002, p. 200.
42. Ray, 1988 (1963), p. 189.
43. Duchamp, 1956, pp. 5–6, p. 6.
44. Sanouillet and Peterson (eds), 1989, p. 168.
45. Richter, 1969, pp. 40–41, p. 41.
46. Ibid. p. 40.
47. Ibid.
48. Quoted in Richter, 1965, pp. 207–8.
49. Richter, 1982, p. 155 ff.

50. Cabanne, 1987, p. 75.
51. Quoted in Naumann, 1994, p. 110.
52. Roché, 'Souvenirs of Marcel Duchamp', in Lebel,
 1959, pp. 79–87, p. 79.
53. Ibid.
54. Ibid.
55. Quoted in Gough-Cooper and Caumont, in
 Hultén (ed.), 1993, within the entry for 15 April
 1959, n.p.
56. Roché quoted in Tomkins, 1996, p. 258.
57. Roché, 'Souvenirs of Marcel Duchamp', in Lebel,
 1959, pp. 79–87, p. 84 ff.
58. Quoted in Cabanne, 1987, p. 73.
59. Buffet-Picabia, 'Magic Circles', in Ford (ed.),
 1945, pp. 14–16, 23, p. 14.
60. Duchamp quoted by Lawrence D. Steefel Jr
 (September 1956), in Stauffer, 1992, p. 62.
61. Duchamp, 'The Great Trouble with Art in This
 Country' (1946), in Moure, 2009, pp. 115–17,
 p. 117.
62. Naumann and Obalk (eds), 2000, p. 288 (from a
 letter of 6 February 1950 to Michel Carrouges).
63. Ibid., p. 283 (from a letter of 25 December 1949
 to Jean Suquet).
64. Strouhal, 1994, p. 86 ff.

S

1. Naumann and Obalk (eds.), 2000, p. 162 (from a
 letter of 25 May 1927 to Katherine S. Dreier).
2. Guggenheim, 2006, p. 52.
3. Ibid., p. 51.
4. Dijon: Les Presses du Reel, 2007.
5. Quoted in George Baker, T. J. Demos, Kim
 Knowles and Jacqueline Matisse Monnier,
 'Graceful enigmas: Duchamp, Man Ray,
 Picabia', Tate Etc., 12 (London, Spring 2008)
 <www.mutualart.com/OpenArticle/Graceful-
 Enigmas/403C3D5B81D9D367> (7 April 2013).
6. Teeny Duchamp, letter to the author of 4
 November 1993.
7. Marquis, 2002, p. 286.
8. Naumann, 2012, p. 309.
9. Tomkins, 2013, p. 84.
10. Ibid.
11. Cabanne, 1987, p. 39.
12. Ibid.
13. Sanouillet and Peterson (eds), 1989, p. 49.
14. Ibid., p. 71.
15. Cabanne, 1987, p. 39.
16. Hamilton and Bonk (eds), 1999, n.p.

17. Quoted in Gough-Cooper and Caumont, in Hultén (ed.), 1993, within the entry for 13 May 1960, n.p.
18. Duchamp, quoted from the conversations with Denis de Rougemont (1945), in Stauffer, 1992, p. 30.
19. Quoted in Schwarz, 2000, p. 657.
20. Matisse (ed.), 1983, n.p. (Note no. 3).
21. Ibid. (Note no. 21).
22. Ibid. (Note no. 40).
23. Quoted in Gough-Cooper and Caumont, in Hultén (ed.), 1993, within the entry for 10 October 1958, n.p.
24. First published in French on the back cover of the Duchamp number of *View*, vol. V, no. 1 (New York, March 1945).
25. Cabanne, 1987, p. 58.
26. Ibid.
27. Sanouillet and Peterson (eds), 1989, p. 148.
28. Quoted in Tomkins, 1976, p. 35.
29. Stauffer, 1981, pp. 290, 301.
30. Leopold (ed.), 1995, p. 163.
31. Quoted in Gough-Cooper and Caumont, in Hultén (ed.), 1993, within the entry for 13 May 1960, n.p.
32. Ibid.
33. Quoted in Anonymous, 1959, pp. 118–19, p. 119.
34. Cabanne, 1987, p. 103.
35. Duchamp, 'The Great Trouble with Art in This Country' (1946), in Moure, 2009, p. 115–17, p. 117.
36. Quoted in Gough-Cooper and Caumont, in Hultén (ed.), 1993, within the entry for 31 March 1950, n.p.
37. Philippe Collin, *Marcel Duchamp*, television interview for the programme 'Nouveaux Dimanches' at the Galerie Givaudan, Paris, 21 June 1967; English translation published as 'Marcel Duchamp Talking about Ready-mades', in Museum Jean Tinguely Basel (ed.), 2002, pp. 37–42, p. 40.
38. Cabanne, 1987, p. 77.
39. Quoted in Tomkins, 1996, p. 443.

T

1. Elger, 2004, p. 68.
2. Quoted in an interview with Otto Hahn, in Gough-Cooper and Caumont, in Hultén (ed.), 1993, within the entry for 23 July 1964, n.p.
3. Quoted in Tomkins, 2013, p. 55.

4. Quoted in Kuh (1961), 2000, pp. 81–93, p. 92.
5. Ibid.
6. 'The Western Roundtable on Modern Art, San Francisco, 1949', in Clearwater (ed.), 1991, pp. 106–14, p. 107.
7. Ibid.
8. James Johnson Sweeney, 'Foreword', in *Jacques Villon, Raymond Duchamp-Villon, Marcel Duchamp*, Solomon R. Guggenheim Museum, New York (exh. cat.), 8 March–8 April 1957, n.p.
9. Quoted by Harriet and Sidney Janis, 'Marcel Duchamp, Anti-Artist' (1945), in Mashek (ed.), 1975, pp. 30–40, p. 31.
10. Kuh, (1961), 2000, p. 83.
11. Quoted from Francis M. Naumann, 'Marcel Duchamp: A Reconciliation of Opposites', in Kuenzli and Naumann (ed.), 1989, pp. 20–40, p. 30.
12. Walter Hopps, 'Marcel Duchamp: A System of Paradox in Resistance', in Hopps, 1963, n.p.
13. Quoted in 'BBC Interview with Marcel Duchamp, conducted by Joan Bakewell' (London, 5 June 1968), in Naumann, 1999, pp. 300–6, p. 303.
14. Sanouillet and Peterson (eds), 1989, p. 33.
15. Cabanne, 1987, p. 47.
16. Quoted in Henderson, 1998, p. 61.
17. Rhonda Roland Shearer and Stephen Jay Gould, 'Hidden in Plain Sight: Duchamp's *3 Standard Stoppages*, More Truly a "Stoppage" (An Invisible Mending) Than We Ever Realized', *Tout-Fait: The Marcel Duchamp Studies Online Journal*, vol. 1, no. 1 (December 1999), <www.toutfait.com/online_journal_details.php?postid=677> (15 March 2013).
18. Sanouillet and Peterson (eds), 1989, p. 33.
19. Roché, 'Souvenirs of Marcel Duchamp', in Lebel, 1959, pp. 79–87, p. 87.
20. Lebel, 'L'Inventeur du temps gratuit', in *Le Surréalisme, même*, vol. 1, no. 2 (Paris, Spring 1957), pp. 44–51. The text was written as early as 1942.
21. Quoted in Schwarz, 2000, p. 232.
22. Ibid., p. 189.
23. Quoted in an interview with Philippe Collin, in Gough-Cooper and Caumont, in Hultén (ed.), 1993, within the entry for 21 June 1967, n.p.
24. Quoted in an interview with William Seitz, in Gough-Cooper and Caumont, in Hultén (ed.), 1993, within the entry for 15 February 1963, n.p.
25. Naumann and Obalk (eds), 2000, p. 322 (from a letter of 17 August 1952 to his sister Suzanne and her husband Jean Crotti).
26. Tomkins, 2013, p. 83.

27. Kuh (1961), 2000, pp. 81–93, p. 83.
28. Matisse (ed.), 1983, n.p. (Notes nos. 228, 192).
29. Sanouillet and Peterson (eds), 1989, p. 51.
30. Ibid., p. 191.
31. Duchamp quoted in an interview with Otto Hahn, in Gough-Cooper and Caumont, in Hultén (ed.), 1993, within the entry for 15 February 1963, n.p.

U

1. Quoted in Hill (ed.), 1994, p. 89.
2. Scott-Heron, 1990, p. 77.
3. Quoted in Hill (ed.), 1994, p. 89.
4. Ibid.
5. Matisse (ed.), 1983, n.p. (Notes nos. 167–207).
6. Ibid. (Note no. 168).
7. Ibid. (Note no. 169).
8. Ibid. (Note no. 183).
9. Ibid. (Note no. 184).

V

1. Duchamp quoted in Steefel Jr, 1977, p. 312, fn. 39.
2. Quoted in Anonymous, 1966, p. 23.
3. Cabanne, 1987, p. 87.
4. Quoted in Hill (ed.), 1994, p. 67.
5. Quoted in Gough-Cooper and Caumont, in Hultén (ed.), 1993, within the entry for 1 July 1966, n.p.
6. Ibid., within the entry for 20 April 1966, n.p.
7. Louise Varèse, 'Marcel Duchamp at Play', in d'Harnoncourt and McShine (eds), 1989, pp. 224–25, p. 224.
8. Rhonda Roland Shearer and Thomas Girst, 'From Blues to Haikus: An Interview with Charles Henri Ford', Tout-Fait: The Marcel Duchamp Studies Online Journal, vol. 1, no. 2, 2000 <www.toutfait. com/online_journal_details.php?postid=1209> (31 January 2013).
9. Quoted from the exhibition flyer and press release for Alive and Kicking: The Collages of Charles Henri Ford, 1908–2002, The Scene Gallery, New York, 31 October–12 December 2002 (curated by the author).
10. Ibid.
11. From Ford, 'Flag of Ecstasy', in Ford (ed.), 1945, p. 4.

W

1. Gough-Cooper and Caumont, in Hultén (ed.), 1993, within the entry for 17 May 1964, n.p.
2. Ibid., within the entry for 1 July 1966, n.p.
3. Sanouillet and Peterson (eds), 1989, p. 48.
4. Ibid., p. 62 ff.
5. Ibid., p. 65.
6. Quoted in Schwarz, 1970, p. 480.
7. Hamilton and Bonk (eds), 1999, pp. 5–6.
8. Wood, 'Marcel', in Kuenzli and Naumann (eds), 1989, pp. 12–17, p. 14.
9. Ibid., p. 16.
10. Wood, 1992, p. 46.
11. Cabanne, 1987, p. 72.
12. Anonymous, 1959, pp. 118–19, p. 119.
13. From Philippe Collin, Marcel Duchamp, television interview for the programme 'Nouveaux Dimanches' at the Galerie Givaudan, Paris, 21 June 1967; English translation published as 'Marcel Duchamp Talking about Ready-mades', in Museum Jean Tinguely Basel (ed.), 2002, pp. 37–42, p. 40.

X

1. Matisse (ed.), 1983, n.p. (Note no. 23).
2. Duchamp quoted in d'Harnoncourt and McShine (eds), 1989, p. 263.
3. Kiesler, 'Design-Correlation' (1937), in Hill (ed.), 1994, pp. 111–18, p. 111.

Y

1. Daniels, 1992, p. 282 ff.
2. Taylor, 2009, pp. 27, 89.
3. Tomkins, 1996, p. 54.

SELECT BIBLIOGRAPHY

(* indicates Recommended Reading)

Dawn Ades, Neil Cox and David Hopkins (eds), *Marcel Duchamp*, London and New York: Thames & Hudson, 1999.

Anonymous, 'Art was a Dream' (interview with Marcel Duchamp), *Newsweek*, vol. 54, no. 19 (New York, 9 November 1959).

Anonymous, 'Artist Marcel Duchamp Visits U-classes, Exhibits at Walker', *Minnesota Daily* (22 October 1965).

Anonymous, 'Growing up absurd', *The Observer* (London, 19 June 1966).

Guillaume Apollinaire, *The Cubist Painters: Aesthetic Meditations*, New York: Wittenborn, 1970.

Arts Council of Great Britain (ed.), *The Almost Complete Works of Marcel Duchamp*, Tate Gallery, London (exh. cat.), June–July 1966.

Beryl Barr and Barbara Turner Sachs (eds), *Artist's and Writer's Cookbook*, Sausalito: Contact Editions, 1961.

Gianfranco Baruchello and Henry Martin, *Why Duchamp. An Essay on Aesthetic Impact*, New York: McPherson, 1985.

Carlos Basualdo and Erica F. Battle (eds), *Dancing Around the Bride. Cage, Cunningham, Rauschenberg, and Duchamp*, Philadelphia Museum of Art, 30 October 2012– 21 January 2013, and Barbican Art Gallery, London, 14 February–9 June 2013 (exh. cat.), New Haven: Yale University Press, 2012.

Daniel Birnbaum and Annika Gunarsson (eds), *Picasso/Duchamp. 'He was wrong!'*, Moderna Museet, Stockholm (exh. cat.), 25 August 2012–3 March 2013, London: Koenig Books, 2012.

Rudi Blesh, *Modern Art USA. Men, Rebellion, Conquest. 1900–1956*, New York: Alfred Knopf, 1956.

Lars Blunck, *Duchamps Präzisionsoptik*, Munich: Silke Schreiber, 2008.

* Ecke Bonk, *Marcel Duchamp: The Portable Museum*, London and New York: Thames & Hudson, 1989.

Leroy C. Breunig, *Apollinaire on Art. Essays and Reviews, 1902–1918*, Boston: MFA Publications, 2001.

Milton W. Brown, *The Story of the Armory Show*, New York: Abbeville, 1988.

* Pierre Cabanne, *Dialogues with Marcel Duchamp*, New York: Da Capo, 1987.

Pierre Cabanne, 'Marcel Duchamp – je suis un défroque', *Arts & Loisirs*, 35 (Paris, 31 May 1966).

William A. Camfield, *Marcel Duchamp. Fountain*, Houston: Houston Fine Art Press, 1989.

John Canaday, 'Philadelphia Museum Shows Final Duchamp Work', *New York Times* (7 July 1969), reprint Philadelphia Museum of Art: Education Division, 1973.

Georges Charbonnier, *Six entretiens avec Marcel Duchamp*, RTF France Culture radio broadcast, 9 December 1960–13 January 1961.

Dominique Chateau and Michel Vanpeene (eds), *Étant donné Marcel Duchamp No. 1*, Paris: Association pour l'Étude de Marcel Duchamp, 1999.

Bonnie Clearwater (ed.), *West Coast Duchamp*, Miami Beach: Grassfield, 1991.

William Copley, 'The New Piece', *Art in America*, vol. 57, no. 4 (New York, July–August 1969).

Dieter Daniels, *Duchamp und die Anderen,* Cologne: DuMont, 1992.

J. Michael Dash, *Edouard Glissant,* Cambridge: Cambridge University Press, 2010.

Leah Dickerman, *Inventing Abstraction, 1910–1925. How a Radical Idea Changed Modern Art,* Museum of Modern Art, New York (exh. cat.), 23 December 2012–15 April 2013.

Katherine S. Dreier and Matta Echaurren, *Duchamp's Glass. An Analytical Reflection,* New York: Société Anonyme, 1944.

Marcel Duchamp, 'The Mary Reynolds Collection', in Hugh Edwards (ed.), *Surrealism and its Affinities. The Mary Reynolds Collection,* Chicago: The Art Institute of Chicago, 1956 (1973).

* Marcel Duchamp, *Marcel Duchamp, Étant Donnés, Manual of Instructions,* Yale: Yale University Press, 2009.

Thierry de Duve, *Pictorial Nominalism: On Marcel Duchamp's Passage from Painting to the Ready-made,* Minneapolis: University of Minnesota Press, 1991.

Laurie Eglington, 'Marcel Duchamp, Back in America, Gives Interview', *Art News,* vol. 32, no. 7 (New York, 18 November 1933).

Dietmar Elger, *Dadaism,* Cologne: Taschen, 2004.

Tracy Fitzpatrick, *Art and the Subway: New York Underground,* New Brunswick: Rutgers University Press, 2009.

James Fitzsimmons, 'Art', *Arts & Decoration* (February 1953).

Charles Henri Ford (ed.), *View,* vol. 5, no. 1 (New York, March 1945).

Pascal Forthuny, 'Ein französisches Urteil über die Bayrische Gewerbeschau', *Münchner Neueste Nachrichten* (11 July 1912).

Paul B. Franklin (ed.), *Étant donné Marcel Duchamp,* no. 5 (Paris, 2003).

Paul B. Franklin (ed.), *Étant donné Marcel Duchamp,* no. 7 (Paris, 2006).

Helmut Friedl, Thomas Girst, Matthias Mühling and Felicia Rappe (eds), *Marcel*

Duchamp in Munich 1912, Lenbachhaus Munich (exh. cat.), Munich: Prestel, 2012.

William Furlong (ed.), *Audio Arts Magazine,* vol. 2, no. 4 (London, 1976).

Thomas Girst, *The Indefinite Duchamp,* Ostfildern: Hatje Cantz, 2013.

Laurence S. Gold, *A Discussion of Marcel Duchamp's Views on the Nature of Reality and Their Relations to the Course of His Artistic Career,* BA dissertation, Princeton University, May 1958.

Cleve Gray, 'Marcel Duchamp 1887–1968. The Great Spectator', *Art in America,* vol. 57, no. 4 (New York, July–August, 1969).

Peggy Guggenheim, *Out of this Century. Confessions of an Art Addict,* London: André Deutsch, 2006 (1979).

Richard Hamilton, 'Foreword', in *Not Seen and/or Less Seen of/by Marcel Duchamp/Rrose Sélavy 1904–1964* (exh. cat. for the Mary Sisler Collection), New York: Cordier & Ekstrom, 1965.

Richard Hamilton and Ecke Bonk (eds), *Marcel Duchamp, À l'infinitif. In the Infinitive. A Typotranslation,* Cologne: Walther König, 1999.

Susan Hapgood, *Neo-Dada. Redefining Art 1958–1962* (exh. cat.), New York: American Federation of Arts, 1994.

Anne d'Harnoncourt and Walter Hopps, 'Étant Donnés: 1. La chute d'eau, 2. Le gaz d'éclairage. Reflections on a New Work by Marcel Duchamp', *Philadelphia Museum of Art Bulletin,* vol. 64, nos. 299 and 300 (April–September 1969).

* Anne d'Harnoncourt and Kynaston McShine (eds), *Marcel Duchamp,* Munich: Prestel, 1989 (reprint exh. cat. Museum of Modern Art, New York and Philadelphia Museum of Art, 1973).

Charles Harrison and Paul Wood (eds), *Art in Theory 1900–1990,* Oxford: Blackwell, 1992.

* Linda Dalrymple Henderson, *Duchamp in Context. Science and Technology in the Large*

Glass and Related Works, Princeton: Princeton University Press, 1998.

Anthony Hill (ed.), *Duchamp: Passim*, Langhorne, PA: G+B Arts International, 1994.

David Hopkins, *Marcel Duchamp and Max Ernst. The Bride Shared*. Oxford: Clarendon, 1998.

Walter Hopps (ed.), *By or Of Marcel Duchamp or Rrose Sélavy. A Retrospective Exhibition*, Pasadena Art Museum (exh. cat.), 8 October–3 November 1963.

* Pontus Hultén (ed.), *Marcel Duchamp*, Cambridge: MIT Press, 1993 (including Jennifer Gough-Cooper and Jacques Caumont, 'Ephemerides on and about Marcel Duchamp and Rrose Sélavy, 1887–1968').

Jasper Johns, 'Thoughts on Duchamp', *Art in America*, vol. 57, no. 4 (New York, July–August 1969).

Alain Jouffroy, 'L'idée du jugement devrait disparaître …', *Arts*, no. 491 (Paris, 24–30 November 1954).

Alain Jouffroy, *Une Révolution du regard: à propos de quelques peintres et sculpteurs contemporains*, Paris: Gallimard, 1964.

Rudolf E. Kuenzli and Francis M. Naumann (eds), *Marcel Duchamp. Artist of the Century*, Cambridge: MIT, 1989.

Katherine Kuh, 'Marcel Duchamp' (1961), in *The Artist's Voice: Talks with Seventeen Modern Artists*, New York: Da Capo, 2000.

Comte de Lautréamont, *Les Chants de Maldoror*, New York: New Directions Books, 1966.

* Robert Lebel, *Marcel Duchamp*, New York: Grove Press, 1959 (1996).

Robert Lebel, 'The Ethic of the Object', *Art and Artist*, vol. 1, no. 4 (London, July 1966).

Michael Leja, *Looking Askance: Skepticism and American Art from Deakins to Duchamp*, California: University of California Press, 2007.

David Leopold (ed), *Max Stirner, The Ego and Its Own*, Cambridge: Cambridge University Press, 1995.

Julien Levy, *Surrealism*, New York: Black Sun Press, 1936.

Julien Levy, *Memoirs of an Art Gallery*, New York: Putnam, 1977.

Ulf Linde, 'Samtal med Marcel Duchamp', *Dagens Nyheter* (Stockholm, 10 September 1965).

Jean François Lyotard, *Duchamp's TRANS/-formers*, Venice, CA: Lapis, 1990.

Henry McBride, 'The Nude-Descending-a-Staircase Man Surveys Us', *The New York Tribune* (12 September 1915).

Bernard Macardé, *Marcel Duchamp. La vie à crédit*, Paris: Flammarion, 2007.

Alice Goldfarb Marquis, *Marcel Duchamp. The Bachelor Stripped Bare*, Boston: MFA Publications, 2002.

Joseph Mashek (ed.), *Marcel Duchamp in Perspective*, Englewood Cliffs: Prentice Hall, 1975.

* Paul Matisse (ed.), *Marcel Duchamp, Notes*, Boston: G. K. Hall, 1983.

Robert Motherwell (ed.), *The Dada Painters and Poets. An Anthology*, Cambridge: Harvard University Press, 1988 (1951).

Gloria Moure, *Marcel Duchamp. Works, Writings, Interviews*, Barcelona: Ediciones Polígrafa, 2009.

Museum Jean Tinguely Basel (ed.), *Marcel Duchamp* (exh. cat.), Ostfildern: Hatje Cantz, 2002.

Francis M. Naumann, *New York Dada, 1915–1923*, New York: Abrams, 1994.

* Francis M. Naumann, *Marcel Duchamp. The Art of Making Art in the Age of Mechanical Reproduction*, New York: Abrams, 1999.

Francis M. Naumann, *The Recurrent, Haunting Ghost. Essays on the Art, Life and Legacy of Marcel Duchamp*, New York: Readymade Press, 2012.

Francis M. Naumann (ed.), *Marcel Duchamp, 'Nude Descending a Staircase: An Homage'*, Francis M. Naumann Fine Art, New York, 15 February–29 March 2013.

Francis M. Naumann and Bradley Bailey, *Marcel Duchamp. The Art of Chess*, New York: Readymade Press, 2009.

Francis M. Naumann and Jeffrey Deitch (eds), *Maria. The Surrealist Sculpture of Maria Martins*, André Emmerich Gallery, New York (exh. cat.), 19 March–18 April 1998.

* Francis M. Naumann and Hector Obalk (eds), *Affect. Marcel. The Selected Correspondence of Marcel Duchamp*, London and New York: Thames & Hudson, 2000.

Ben Neill, 'Christian Marclay', *Bomb*, issue 84 (Summer 2003).

James Nelson (ed.), *Wisdom: Conversations with the Elder Wise Men of our Day*, New York: Norton, 1958.

Friedrich Nietzsche, *Briefwechsel, Kritische Gesamtausgabe*, III, 7/1, Berlin: De Gruyter, 2003.

Anaïs Nin, *The Diary 1931–1934*, New York: Harcourt, Brace and World, 1966.

John P. O'Neill (ed.), *Barnett Newman, Selected Writings and Interviews*, New York: Alfred A. Knopf, 1990.

Octavio Paz, *Marcel Duchamp or the Castle of Purity*, London: Cape Golliard, 1970.

Stuart Preston, 'Diverse Facets: Moderns in Wide Variety', *New York Times*, section 10 (20 December 1953).

Man Ray, 'On July 28, 1968 …', *Art in America*, vol. 57, no. 4 (New York, July–August 1969).

Man Ray, 'Bilingual Biography. I and Marcel: A Dual Portrait of Thirty Years' (1945), *Opus International*, no. 49 (Paris, March 1974).

Man Ray, *Self-Portrait*, London: Bloomsbury, 1988.

Rosa Regás, 'Entrevista con Marcel Duchamp', *Siglo*, vol. 20, no. 26 (Barcelona, 23 October 1965).

Hans Richter, *Dada: Art and Anti-Art*, London and New York: Thames & Hudson, 1965.

Hans Richter, 'In Memory of a Friend', *Art in America*, vol. 57, no. 4 (New York, July–August, 1969).

Hans Richter, *Begegnungen von Dada bis Heute*, Cologne: DuMont, 1982.

Claude Rivière, 'Marcel Duchamp devant le pop-art', *Combat* (Paris, 8 September 1966).

Denis de Rougemont, 'Marcel Duchamp, mine de rien', in *Journal d'une époque (1926–1936)*, Paris: Gallimard, 1968.

John Russell, 'Assembling Scattered Works by the Cognescenti's Painter', *New York Times* (28 November 2001).

Michel Sanouillet, 'Dans l'atelier de Marcel Ducahmp', *Les Nouvelles Littéraires*, no. 1424 (Paris, 16 December 1954).

* Michel Sanouillet and Elmer Peterson (eds), *The Writings of Marcel Duchamp*, New York: Da Capo, 1989.

Lydie Fischer Sarazin-Levassor, *A Marriage in Check: The Heart of the Bride Stripped Bare by Her Bachelor, Even*, Dijon: Les Presses du Reel, 2007.

Lydie Fischer Sarazin-Levassor, *Meine Ehe mit Marcel Duchamp*, Berne: Piet Meyer, 2010 (1975/1976).

Winthrop Sargeant, 'Dada's Daddy', *Life*, vol. 32, no. 17 (New York, 28 April 1922).

Harold C. Schonberg, 'Creator of Nude Descending Reflects After Half a Century', *New York Times* (12 April 1963).

Jean Schuster, 'Marcel Duchamp, vite', *Le Surréalisme, même*, no. 2 (Paris, Spring 1957).

* Arturo Schwarz, *The Complete Works of Marcel Duchamp*, New York: Delano Greenidge, 2000.

Gil Scott-Heron, *Now and Then. The Poems of Gil Scott-Heron*, Edinburgh: Payback, 1990.

William Seitz, 'What Happened to Art? An Interview with Marcel Duchamp on Present Consequences of New York's 1913 Armory Show', *Vogue*, vol. 141, no. 4 (New York, 15 February 1963).

Serge Stauffer, *Marcel Duchamp. Die Schriften*, Zürich: Regenbogen, 1981.

Serge Stauffer, *Marcel Duchamp, Interviews und Statements*, Ostfildern: Hatje Cantz, 1992.

Laurence D. Steefel Jr, *The Position of Duchamp's 'Glass' in the Development of his Art*, New York and London: Garland Publications, Inc., 1977.

Alfred Stieglitz, 'Letter to the Editor' (13 April 1917), *The Blind Man*, no. 2 (New York, May 1917).

Alfred Stieglitz, 'Can Photography have the Significance of Art?', *Manuscripts*, no. 4 (New York, December 1922).

Ernst Strouhal, *Duchamps Spiel*, Vienna: Sonderzahl, 1994.

James Johnson Sweeney, 'Eleven Europeans in America', *The Museum of Art Bulletin*, vol. 13, nos. 4–5 (New York, 1946).

* Michael Taylor, *Étant donnés*, Philadelphia: Philadelphia Museum of Art, 2009.

The Temptation of St. Anthony, Washington, DC: American Federation of Arts, 1946.

Edward W. Titus (ed.), *This Quarter. Surrealist Number*, Paris: The Black Manikin Press, 1932.

Calvin Tomkins, *The Bride and the Bachelors. Five Masters of the Avant-Garde: Duchamp, Tinguely, Cage, Rauschenberg, Cunningham*, New York: Penguin, 1976.

* Calvin Tomkins, *Duchamp. A Biography*, New York: Holt, 1996 (1998).

* Calvin Tomkins, *Marcel Duchamp. The Afternoon Interviews*, New York: Badlands Unlimited, 2013.

Radu Varia, *Brancusi*, New York: Rizzoli, 1986.

Thomas Venter, 'Der Look Passiert Nicht', *Süddeutsche Zeitung* (Munich, 27 August 2001).

Steven Watson, *Strange Bedfellows. The First American Avant-Garde*, New York: Abbeville Press, 1991.

Walt Whitman, *The Complete Poems*, London: Penguin, 1996.

Beatrice Wood, *I Shock Myself*, San Francisco: Chronicle Books, 1996.

Lois Parkinson Zamora, *The Usable Past. The Imagination of History in Recent Fiction of the Americas*, Cambridge: Cambridge University Press, 1997.

George de Zayas, *Caricatures: Huit peintres deux sculpteurs et musicien très modernes* (text by Curnonsky), Paris, 1919.

CHRONOLOGY

1887

Born on 28 July in Blainville, Normandy, France.

1902

First paintings.

1904

Graduates from the Ecole Bossuet, Rouen. Studies painting at the Académie Julian (until July 1905).

1905–1911

Cartoon drawings for French magazines (until 1910). Works at a printer's office in Rouen. One year of voluntary military service. Studio and residence at Neuilly, outside Paris. Begins lifelong friendship with Francis Picabia. Attends the Cubist circle of Puteaux. First exhibitions. *Coffee Mill* (1911), first machine imagery. Unknown to him, he fathers his only child.

1912

Three-month stay in Munich during the summer after rejection by his own brothers of *Nude Descending a Staircase No. 2* for a Cubist group show. Paints his most important works. Except for just a few works on canvas over the next six years, ceases painting altogether.

1913

Succès de scandale of his *Nude Descending a Staircase No. 2* at the Armory Show in New York. Begins work as a librarian at the Bibliothèque Sainte-Geneviève. Mounts a bicycle wheel and fork onto a kitchen stool. His *Three Standard Stoppages* introduces chance to art. First works on glass.

1914

Purchases a bottle dryer at a Paris department store as the first real readymade. Publication of his *Box of 1914*, containing sixteen photographic reproductions of his notes and one drawing.

1915

Arrives in New York (stays until 1918). Becomes part of the Arensberg circle of modernist and avant-garde painters and writers. Meets Man Ray.

1917

Together with Henri Pierre Roché and Beatrice Wood publishes Dada magazines *Rongwrong* and *The Blind Man*. His readymade urinal *Fountain* creates another scandal in New York's art world.

1918

As a commission for his patron and collector Katherine S. Dreier, paints his last painting, *Tu m'*. Moves to Buenos Aires.

1919

Returns to Paris. For his readymade *L.H.O.O.Q.*, draws a moustache and goatee on a reproduction of Leonardo da Vinci's *Mona Lisa*.

1920

First appearance of Duchamp's female alter ego Rrose Sélavy. Begins to create optical machines in New York. Co-founder of the Société Anonyme.

1921

Publishes single issue of *New York Dada*, together with Man Ray.

1923

Leaves unfinished his *La mariée mise à nu par ses célibataires, meme* (*The Bride Stripped Bare by Her Bachelors, Even*, or *Large Glass*), on which he had been working since 1915, with the first study and title dating back to 1912.

1923

Settles in Paris (until 1942). For the next ten years joins major European chess tournaments.

1924

Creates *Monte Carlo Bond* to finance a system of making a profit at roulette.

Meets Mary Reynolds with whom he remains close for the next two decades.

1926

With Man Ray creates the film *Anémic Cinéma*, based on puns and optical illusions.

1927

Brief marriage to Lydie Sarazin-Levassor.

1932

Together with Vitaly Halberstadt, publishes in French, English and German *Opposition and Sister Squares are Reconciled*, a book on a rare endgame in chess.

1934

Publication of the *Green Box*, bearing the same title as his *Large Glass* and containing ninety-three facsimile notes and other material related to his most important work.

1935

Begins work on his *Box-in-a-Valise* (1941–68), containing miniatures and reproductions of his most important works, editions of which would be assembled until after his death.

1942

Leaves Paris for New York, which remains his base until shortly before his death. Cooperates with exiled Surrealists, including a Surrealist exhibition that he co-curates with André Breton. Works with Peggy Guggenheim on her gallery

Art of This Century. Around this
time, begins an affair with the sculptor
Maria Martins, the wife of the Brazilian
ambassador to the United States, which
lasts until 1950.

1945
Charles Henri Ford's *View* magazine
dedicates a single issue to Marcel
Duchamp. For the next two decades,
he works in secret on his assemblage
Étant donnés.

1947
Co-curates and designs catalogue for *Le
Surréalisme en 1947*, Paris, together with
André Breton.

1950
Creates the first of his erotic objects
related to his work on *Étant donnés.*

1954
Marries Alexina Sattler (Teeny Duchamp).

1955
Becomes an American citizen.

1958
Publication of Duchamp's collected
writings in French, *Marchand du Sel.
Écrits de Marcel Duchamp*, compiled by
Michel Sanouillet.

1959
Publication in English and French
of *Sur Marcel Duchamp* by Robert Lebel,
the first comprehensive and definitive

book on Duchamp, including a
catalogue raisonné.

1960
English publication of Duchamp's
Green Box notes, a typotranslation by
Richard Hamilton.

1963
First major retrospective at the
Pasadena Art Museum.

1964–65
Fourteen readymades are reproduced in
a limited edition of eight.

1966
First major European retrospective at
Tate Gallery, London.

1967
Publication of *À l'infinitif* (*White Box*),
containing seventy-nine facsimile notes
related to the *Large Glass.*

1968
Dies on 2 October in Neuilly, near
Paris. Buried with other members of
the Duchamp family at the Cimetière
Monumental, Rouen. On 7 July 1969,
*Étant donnés: 1. la chute d'eau / 2. le
gaz d'eclairage* (*Given: 1. The Waterfall
/ 2. The Illuminating Gas*) (1946–66) is
posthumously revealed to the public at
the Philadelphia Museum of Art.

ACKNOWLEDGMENTS

No publication on Marcel Duchamp would be possible without the guidance and kind endorsement of Jacqueline Matisse Monnier and her son Antoine Monnier. I am grateful for the exchange of ideas with the Association Marcel Duchamp. My thanks go to Paul B. Franklin, whose impeccable *Étant donné* journal about Duchamp should be read by everyone even remotely interested in the artist. Carlos Basualdo and Ashley McKeown of the Philadelphia Museum of Art never tired of confirming or providing the most minuscule details essential for a book like this. Francis M. Naumann, above all, has been a great influence and friend for almost two decades now, sending countless e-mails back and forth for the preparation of this publication. I am grateful also to Anna Helfer for being there for me as well as for her support all the way to the finishing line; Jacky Klein, of Thames & Hudson, for all those many things far exceeding our fun work on this book; Therese Vandling, whose design I admire as much as her can-do spirit, and Luke Frost for their fabulous illustrations; Celia White for the magnanimity of her persistence; Linda Schofield for seeing the whole thing through without ever rolling her eyes; and Friederike, Balthazar, Konstantin and Helena for bearing with me once again.

ABOUT THE AUTHOR

Thomas Girst (b. 1971) has studied Art History, German Literature and American Studies at Hamburg and New York Universities. He holds a PhD in American Studies and has been Head of Cultural Engagement at the BMW Group since 2003. As a cultural correspondent, curator, publisher and academic lecturer, he has written widely on modern and contemporary art. Girst founded *Die Aussenseite des Elementes* (1992–2003), an international yearly anthology of literature and art. In 1996, he archived the collection of Duchamp scholar Serge Stauffer at the Staatsgalerie Stuttgart. Girst was editor in chief of *Tout Fait: The Marcel Duchamp Studies Online Journal* (1999–2003) while he was research manager at Harvard professor Stephen Jay Gould's and Rhonda Roland Shearer's Art Science Research Laboratory in New York. His publications include *Marcel Duchamp in Munich 1912* (Prestel, 2012), *The Indefinite Duchamp* (Hatje Cantz 2013), *Art, Literature, and the Japanese American Internment Experience* (Peter Lang, 2014) and *BMW Art Cars* (Hatje Cantz, 2014).